Mastering Landscape Photography

Mastering Landscape Photography

The Luminous-Landscape Essays

Alain Briot

Alain Briot, alain@beautiful-landscape.com

Editor: Gerhard Rossbach
Copyeditor: Joan Dixon
Layout and Type: Almute Kraus, www.exclam.de
Cover Design: Helmut Kraus, www.exclam.de
Cover Photo: Alain Briot
Printer: Friesens Corporation, Altona, Canada
Printed in Canada

ISBN 1-933952-06-7

1st Edition
© 2007 by Rocky Nook Inc.
26 West Mission Street Ste 3
Santa Barbara, CA 93101

www.rockynook.com

Library of Congress catalog application submitted

Distributed by O'Reilly Media
1005 Gravenstein Highway North
Sebastapool, CA 95472

This book is printed on acid-free paper.

Table of Contents

12 Preface

14 Introduction

16 How to See Photographically
17 Seeing Photographically
17 Making Abstract All Sensory Input Except for Visual Input
18 Focusing on the Visual Aspects of the Scene
18 Learning to See in Two Dimensions
18 Recreating Depth, the 3rd Dimension, in a 2-Dimensional Medium

22 How to Compose a Photograph
23 Introduction to Composition
24 The Strongest Way of Seeing
24 There is More Than One Way to Compose a Scene
25 One Composition Among Many
25 Walking the Scene
26 Using a "Cutout" Finder
27 Rules of Composition
31 Conclusion

32 How to Choose the Best Lens for a Specific Composition
33 The Importance of the Lens
33 Human Eyes and Camera Eyes
34 One Landscape: Three Main Lens Choices
42 Which Lens Should I Take?
42 Photographic Skills Enhancement Exercises
43 Conclusion

46 How to Find the Best Light for a Specific Photograph

47 And God said, Let there be light: and there was light (Genesis 1:3)

47 Drawing with Light

48 Three Governing Rules Regarding Light

48 How to Find the Best Light

50 Sunrise and Sunset – The Best Light

52 Other Light Choices

52 The Various Types of Natural Light

58 Photographic Skills Enhancement Exercises

60 Conclusion

62 How to Select the Best "Film" for a Specific Photograph

63 Introduction to Film Choice

63 A Look at Photography in History

64 Film and Seeing

65 The Importance of Raw Conversion

66 Color or COLOR

66 Let's Use Film (or digital capture); Let's Not Let Film Use Us!

67 Color or Black and White?

69 Duotones, Tritones and Quadritones

70 Film Speed

73 Photographic Skills Enhancement Exercises

75 Conclusion

76 How to Determine the Best Exposure for a Specific Photograph

77 Introduction to Exposure

77 The Importance of Proper Exposure

78 Gray Cards, Overexposure, and Underexposure

80 How to Determine the Contrast Range that the Film or Digital Camera Can Capture

82 The Power of the Histogram

83 Exposure for Digital Captures

84 The Importance of Shooting RAW
84 Exposing to the Right
85 Some Examples of Common Histograms
88 Bracket, Bracket, Bracket
90 Study the Scene Being Photographed
92 High Contrast Remedies
97 Familiarize Yourself with Hand Held Light Meters
98 Spot Meter Meets PDA
99 Photographic Skills Enhancement Exercises
102 Conclusion

104 Keepers or Non-Keepers?
105 Keepers or Non-Keepers?
105 Which Ones Are Good; Which Ones Are Bad?
108 My Personal Selection Criteria
110 Technical Excellence vs. Aesthetics
110 The Selection Criteria
111 Photographic Skills Enhancement Exercises
112 Conclusion

116 How to Create a Portfolio of Your Work
117 Introduction to Creating a Portfolio
117 What is a Portfolio?
117 Portfolios and *Portfolios*
120 Goal and Purpose
120 Audience
122 Portfolios Are Not Necessarily Aimed at Showcasing a
 Photographer's Best Work
123 The Contents of a Portfolio
123 Some Important Questions About Portfolios
125 Photographic Skills Enhancement Exercises
129 Conclusion

130 How to Establish a Personal Photographic Style

131 Introduction to Personal Style

131 Who Are We?

133 Who Am I?

133 A Personal Style is a Unique and Personal way of Seeing

135 Choosing a Subject is Not Developing a Personal Style

136 Choosing a Subject is Not the Same as Choosing a Genre

138 Personal Discovery is Not Personal Style

138 A Personal Style Is a Combination of Choices

142 A Personal Style Is Fine Tuning Choices to Fit Your Own Personality

146 My Personal Style

147 Fortuitous Attempts and Defining Images

148 Photographic Skills Enhancement Exercises

151 Conclusion

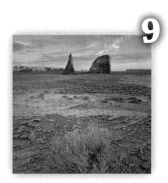

154 Being an Artist

155 Introduction to Being an Artist

157 Freedom of Expression: Let Us Be Artists

159 Being an Artist Is a Lifestyle; Not a Temporary Situation

161 Being an Artist Does Not Mean Making an Income from Your Art

162 Being an Artist Does Not Mean Exhibiting or Publishing Your Work

164 Being an Artist Means Having an Audience

166 Being an Artist Means Having an Appreciation for the Arts

168 Being an Artist is Knowing How to React When You are Told that "Artists are Lucky!"

171 Being an Artist Does not Mean Being an Art Critic

174 What About Talent?

176 Photographic Skills Enhancement Exercises

178 Conclusion

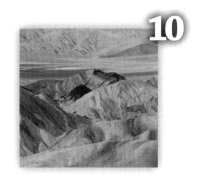

180 How to be an Artist in Business: My Story – Part 1

181 Introduction to Being an Artist in Business
181 Travels
183 Beginnings
184 An Attempt to Merge Art and Studies
187 The Beginning of a Career
190 The Straw that Broke the Camel's Back
192 Doing What I Love
193 Why Didn't I Think of this Before?
194 Opportunities Often Come Under the Guise of Hard Work
194 The Best Place to Start a Business Is on the Navajo Reservation

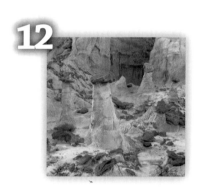

198 How to be an Artist in Business: My Story – Part 2

199 The Break
199 The People
203 The Approach
204 The Progression of the Grand Canyon Show
206 Quantity
209 Wearing Out
211 Transitions: How the End of One Opportunity Can Be the Beginning of Another
213 The Second Best Place to Start a Business is Phoenix, Arizona
215 Teaching Again
216 Quality, Not Quantity
220 New Shows
220 Longer and More Thoughtful Chapters
221 New Projects
221 Becoming a Music Producer
222 Setting Up the Ideal Studio
223 Two Businesses in One
223 Learning Never Ends
225 Conclusion

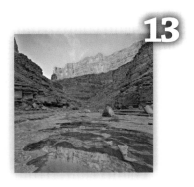

226 How You Can Do it Too

227 Introduction to How You Can Do It

227 Do What You Love

228 Take Control of Your Own Destiny

228 Fame or Fortune? Make a Choice!

230 Confront your Fears

231 Seek Help from People Who Are Where You Want to Be

234 Opportunities Often Come Under the Guise of Hard Work

234 Press On Regardless

235 It's About You

235 Quality or Quantity? Make a Choice!

236 Do a Little Bit Every Day

238 Integrity

240 Best Sellers

241 Photographic Skills Enhancement Exercises

243 Conclusion

246 Conclusion

248 Index

Preface

*"The use of the term art medium is, to say the least, misleading,
for it is the artist that creates a work of art not the medium.
It is the artist in photography that gives form to content by a distillation
of ideas, thought, experience, insight and understanding."*

EDWARD STEICHEN

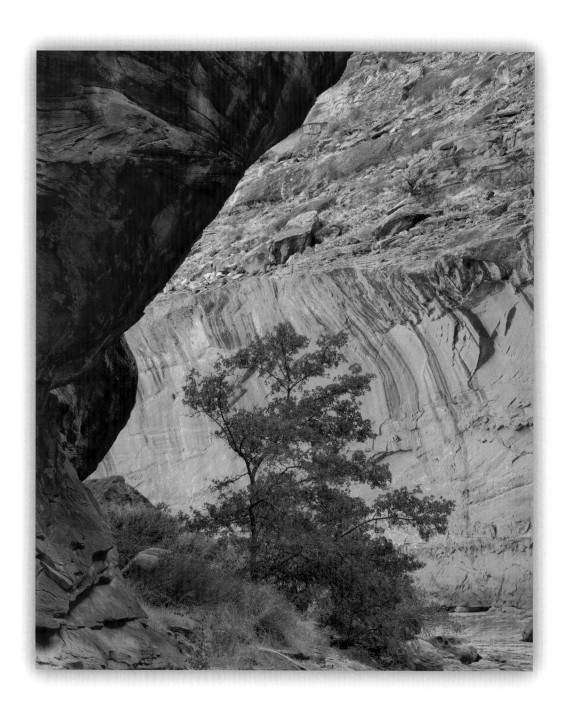

How does one learn how to master landscape photography? And, more importantly, how does one become a master landscape photographer? Those questions were on my mind when I decided to study photography in 1980. At that time, I found that the answers I was looking for were hard to find. In searching for these answers I discovered a world in which the practitioners kept many aspects of their work "secret", or at least, let's say, hidden away.

Certainly, technical information was prominently available. And, of course, things have changed in the 26 years since I started my photographic journey. But, the information that was available then mostly covered equipment: cameras, lenses, and darkroom gear. It did not cover the other aspects of the art of photography, such as light, composition, or how to create a portfolio.

It took me a long time to get answers to my questions, in large part because I had to figure out most of these answers for myself. In the process of doing so, I learned how to master the art of landscape photography, and I became a professional landscape photographer. How I got there and what I learned along the way is the subject of this book. In it I share the knowledge I acquired during all these years.

To offer a short summary of this book, "Mastering Landscape Photography" focuses on mastering three things: artistic skills, technical knowledge, and business sense. Photography itself is a combination of art and science; the result of artistic abilities combined with technical knowledge is required. To earn a living from photography a third set of knowledge: the business sense necessary to run a successful business.

This book covers all three areas: art, technique, and business. It starts with the technical aspects of photography that consist of learning how to see, compose, find the best light, and select the best lens for a specific photograph.

It continues by focusing on the artistic aspects of the medium with chapters on how to select the best photographs among the ones that were created, how to create a portfolio of one's best work, and how to become an artist.

Finally, it concludes with two chapters on being an artist in business, then looking at how „You Can Do it Too" in the final chapter.

This book encompasses the sum of all that I learned during the course of my journey in photography. My goal in sharing my knowledge is to save the reader time and to prevent the reader from having to experience the hardships I encountered. It is my hope that it will help make your own journey a resounding success.

Alain Briot

Introduction

Why is it so difficult to explain the things we do everyday; the things we do intuitively, almost unconsciously? I believe the reason is simple. It is difficult to explain because these things come naturally, almost easily, without having to purposefully think about them.

In my case, it is also difficult to put into words my personal photography *system* which has largely been developed through years of trial and error; years of learning what worked and what didn't work, until one day, I found myself looking at one of my images thinking, "I really like this one. How did I get there?" I got to where I am, I am tempted to say, due to *perseverance*; I never gave up, and I love photography so much that I somehow found both the motivation and the finances to continue in the face of less than satisfying results.

I am a visually oriented person. I have a long history, not only in photography, but as a visual artist working in several different media. When I began photography in 1980, I had already been trained as a fine artist in painting and drawing, and I practiced art under the guidance of my parents since my early childhood.

Furthermore, I am focused upon representing what I perceive as beautiful in the most aesthetic way I can conceive of. I practice aesthetics on a daily basis, yet I do not call it aesthetics. I don't actually have a name for it, but I create beautiful images of natural places. Quite simply, that is all.

I am looking for an effective way to teach what I do without making the subject unnecessarily complicated. After all, it would be easy to approach it from a theoretical perspective using lengthy and obscure terminology and creating a text which, although it may be of interest to academics, would provide no help whatsoever to photographers wanting to improve their photographs.

So how does one explain, in a manner as clearly and concisely as possible, something that is done unconsciously? One way is to explain how one proceeds step-by-step, by breaking the topic down into major areas. This is the approach I will follow, which has the advantage of being simple, of getting straight to the point, and of moving from one concept to another in a logical and organized fashion.

I have identified nine major areas related to aesthetics, which encompass what I focus on when I photograph. I have also identified three areas related to art and business:

Aesthetics

1 How to See Photographically
2 How to Compose a Photograph
3 How to Choose the Best Lens for a Specific Composition
4 How to Find the Best Light for a Specific Photograph
5 How to Choose the Best "Film" for a Specific Image
6 How to Determine the Best Exposure for a Specific Scene
7 How to Decide Which Photographs are "Keepers" and Which are Not
8 How to Create a Portfolio of Your Work
9 How to Establish a Personal Photographic Style

Art and Business
10 How to Be an Artist
11 How to Be an Artist in Business, Part 1
12 How to Be an Artist in Business, Part 2
13 How You Can Do it Too

In the first nine chapters I will cover the topics related to aesthetics by explaining my personal approach, and by describing the tools I use (those tools are not only cameras, as you will see). My photographs will be used throughout the book as examples. I chose images which relate to the topic being covered, and I describe how and why specific images were created.

Finally, the organization of these chapters follow the steps I take when creating photographs, as well as the steps I recommend the reader to take for the time being: find want to photograph, compose a photograph, choose the desired focal length, determine if the light is right, decide which film to use, calculate the proper exposure, decide which photographs are best and, ultimately, assemble a body of work and develop a photographic style.

How to See Photographically

Vision is the art of seeing things invisible.
JONATHAN SWIFT

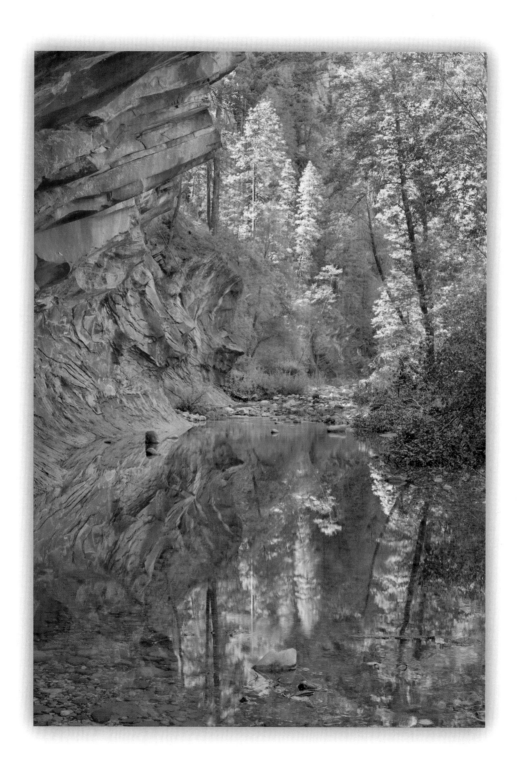

Seeing Photographically

When I refer to *seeing*, I am talking about *seeing photographically,* or *seeing like a camera.* Learning to see like a camera is the purpose of this chapter.

I firmly believe that I cannot take a photograph of something I have not seen photographically. In other words, I must first see something, then see a photographic opportunity, and finally, *see a photograph*, before I can set up my camera and compose an image. This may sound obvious, but it is not. I have met many photographers who "shoot away", so to speak, hoping that when they return home they will find a "good shot" somewhere in the mass of originals they brought back. Unfortunately, this approach often results in disappointment.

This is not to say that taking a lot of photographs is bad practice. Many professional photographers shoot large quantities of photographs and get excellent results. However, they know how to see photographically and are not just shooting in the hopes that something will turn out. My viewpoint is not based on the number of photographs one takes: rather, it is based on why and how one photographs, and on the premise that what one sees directly influences what one photographs.

Creating photographs is all about seeing, and in this sense it is no different from other two-dimensional arts such as painting and drawing. Creating photographs is really about studying and practicing "the art of seeing".

Making Abstract All Sensory Input Except for Visual Input

Imagine I am walking through the landscape in the spring, surrounded by the chatter of birds and the smell of fresh flowers. A breeze is softly blowing, swaying the leaves and the trees ever so gently. I feel both relaxed and energized by the warm weather, the new growth, and the overall rejuvenation of spring.

If I am to compose a photograph that expresses how I feel, I must remember that none of the pleasant fragrances, none of the gentle breeze, none of the feelings of respite I experience will be represented in the photograph. None of this will be present in the final print *unless*, through my personal knowledge of photography, I can manage to translate these non-visual feelings into visual information. This is because in a photograph *only* visual information is present. What is captured from the original scene is what was visual in this scene. What our other senses told us – scent, touch, sound, emotions – all those things are gone.

Is it possible to translate these other feelings into visual elements? Yes, I believe it is possible, and the purpose of this book is to explain how to do so. However, only with study, practice, and exercises aimed at sharpening visual skills will one be guaranteed success. Translating feelings into images is actually one of the most challenging aspects of photography, and one that separates the master from the apprentice, so to speak. As Ansel Adams put it, "Photograph not only what you see but also what you feel." This is certainly a tall order, but not an impossible one.

Focusing on the Visual Aspects of the Scene

As was just mentioned, it is easy to be fooled by one's senses into thinking that what feels good, sounds good, and smells good will also *look* good. It is now known that this is not necessarily the case. What captures one's attention when all the senses are at work may or may not be the visual aspect of a scene.

Therefore, in order to create successful photographs, at this point the following questions must be addressed:

1. Is there something visually interesting in the scene I am looking at?
2. If yes, then what is the most important point of visual interest of this scene?
3. Providing that I have decided to photograph this scene, how can my photograph visually convey the feelings I now have?

To answer these questions we must first learn to see the way a camera sees.

Learning to See in Two Dimensions

How does one learn to see *photographically,* the way a camera sees? Let's start with this important concept.

A camera sees differently from the way we see. One of the main differences is that a camera has only one lens and one eye, while we have two. We have binocular vision while cameras (except for stereo cameras) have monocular vision.

What does this mean in terms of seeing? It means that if we do not learn to see with only one eye, either by closing one eye or looking through a viewfinder while composing a photograph, we will end up with mishaps, such as the proverbial tree sticking out of someone's

head. In this instance, when looking at the scene with both eyes, the tree does not appear to come out of that person's head because binocular vision allows us to *measure the distance* between the person and the tree. Monocular vision removes all sense of distance – all sense of *depth* – leaving us with only a sense of height and width, thus placing the person's head and the tree on the same plane of vision.

A photographic print has only two dimensions as well; width and height (8x10, 16x20, etc.). Because depth, the third dimension, does not exist physically, a photographic print has no physical depth. Yet depth is part of our world, thus it is necessary for us to make sense of a photograph depicting this world. In order for a photograph to be realistic and pleasing to our eyes, depth must be simulated. If we were sculptors we wouldn't have to worry about any of this; we would have width, height, and depth as part of our medium. But, as artists working in a flat medium, we must learn how to recreate the appearance of depth.

Recreating Depth, the 3rd Dimension, in a 2-Dimensional Medium

How does one simulate or recreate depth? The appearance of depth can be created with the help of perspective. Well then, how does one use perspective to recreate depth? By implementing the following simple techniques:

1 – Converging Lines
We have all seen photographs of roads going from near to far until the road finally disappears into the distance. Such photographs create a very strong sense of depth because the roads act as lines leading our eyes into the distance. The photographic print, or digital

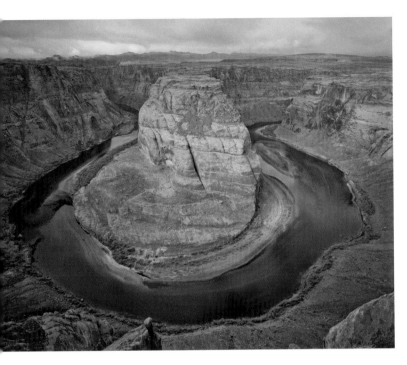

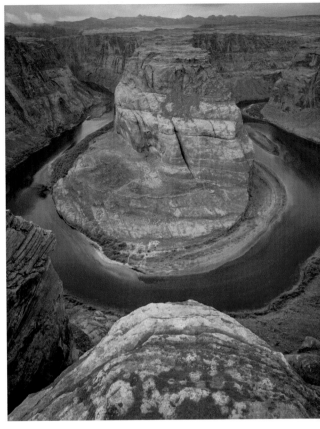

▲ Horseshoe Bend
Horizontal and vertical compositions.
Glen Canyon NRA, Arizona.
Linhof Master Technika 4x5,
Schneider Super Angulon 75 mm,
Fuji Provia. (both photographs)

▲ These two images were created in March 2003 during my most recent visit to this great location. I first created what I consider to be the "classic" view of the Horseshoe Bend, the horizontal image at left. I then realized that I had never seen a vertical composition of this scene. Knowing there was an opportunity to create a fresh image of an often-photographed location, as well as a foreground-background relationship (a horizontal foreground-background composition of the Horseshoe Bend is difficult to capture since nearly all the space in the image is taken up by the Bend itself). I "walked the scene" looking for a foreground element .

After searching for a few minutes, I found a rock formation with a shape that echoed the shape of the butte at the center of the Bend. In my opinion, this vertical composition offers a much stronger sense of depth and distance than the horizontal composition. It almost makes me feel dizzy when I look at this image.

image on a monitor, is absolutely flat, but to the eye, it appears as if we are looking into a scene many miles deep.

2 – Foreground Background Relationships (large and small objects).

We know that we perceive nearby objects as appearing larger than faraway objects. For example, a Ponderosa Pine tree appears gigantic when we stand right in front of it, but the tree appears to shrink to the size of a match-stick when viewed from several miles away. Placing such a tree in the foreground of a photograph, or even just showing a part of the tree, and then placing another similar tree in the background, will definitely give the viewer a clear indication of distance. Comparing the relative size of the two trees in the image allows the viewer to actually gauge the distance relatively accurately if he is personally familiar with natural settings and with Ponderosa Pines. Of course, any other plant or object can be used to the same end with the same result. Wide-angle lenses are often used for this purpose. However, any lens can be used, as it is the intent that matters rather than the equipment. I have personally captured near-far relationships with wide-angle lenses, as well as telephoto lenses.

3 – Overlapping

This third technique relies on one simple rule. We know that objects that are in front of other objects are closer to us physically. Using this rule, we can purposefully compose a photograph so that certain objects overlap other objects, thereby giving a strong sense of depth to the image.

4 – Haze

Atmospheric haze offers another way to recreate the appearance of depth in a photograph. We know intuitively and from experience that haze (and fog) gets thicker as the viewing distance increases. Distant objects, in hazy or foggy conditions, are thus harder to see than nearby objects. Atmospheric haze, usually despised because it makes distant objects difficult to see in the summer (the Grand Canyon is a case in point), actually makes it easier to tell that the North Rim (for example) is quite a distance from the South Rim (16 miles precisely at Grand Canyon Village). Therefore, haze can help us recreate the appearance of depth in an otherwise flat medium.

5 – Combining Several of the Above Techniques

These depth-creating techniques are often used in combination with one another. For example, I have created images of overlapping mountains or mesas in hazy conditions (again, the Grand Canyon for example). In this instance, these two techniques reinforce each other, resulting in a photograph that is visually stronger and more powerful than if a single technique had been used.

Similarly, overlapping objects are often used jointly with foreground/background relationships. For example, a plant in the foreground which is emphasized through the use of a wide-angle lens, can be purposefully positioned in the composition so that it partially hides a mountain in the background. Or, this same mountain can be seen through the branches of a tree, as in this photograph of Zion National Park.

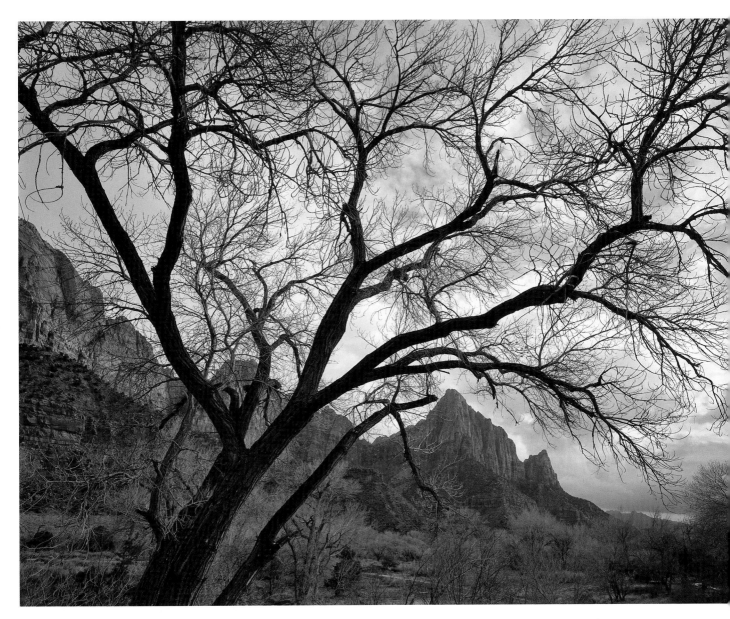

▲ In this instance, I did not think that the rock formations (the Watchman) were enough to create a successful image. The sky was nice because it wasn't completely blue or overcast, but again something else was needed. By walking the scene I found this tree through which I could frame the scene since it was winter and the tree had no leaves. The tree also leaned slightly to the right following the line of cliffs which drop towards the right of the frame as well. It is a bold composition which does not emphasize just the tree or just the cliffs but instead balances visual interest.

▲ **The Watchman seen through a Cottonwood tree, Zion NP, Utah.**
Linhof Master Technika 4x5,
Schneider Super Angulon 75mm,
Fuji Provia

How to Compose a Photograph

*For me, photography is the exploration in reality of the rhythm of surfaces, lines, or values;
the eye carves out its subject, and the camera has only to do its work.*

HENRI CARTIER-BRESSON

Introduction to Composition

In chapter 1 we learned how cameras see the world and how this differs from the way we see with our own eyes. Now, we will turn this knowledge into practice and create actual photographs. But before we can do this we need to learn how to compose a photograph.

Composing a good photograph is not easy. Teaching others how to create interesting compositions is even harder. In fact, composition is one of the most difficult areas of photography, or of any visual art for that matter, so much so that my teacher, Scott McLeay, refused to teach composition. McLeay's only "guidance" in this matter was brief and succinct. He would simply explain that, in regard to composing a photograph, "each part of the image is equally important."

If the reader is expecting rules that can be followed to quickly compose better photographs, the previous statement is certainly not going to help much (I will provide some rules at the end of this chapter). However, this quote carries within it, although in a cryptic manner, the roots from which excellent compositions can be created.

One of the mistakes commonly made when composing a photograph is to follow one of the tips that Kodak offered on the countless "How to Take Better Photographs" brochures they distributed a few years ago. Kodak's tip addressing composition, recommends that the subject be placed in the center of the frame and to be careful not to accidentally cut off part of the subject. Since this tip essentially addresses photographing people, it says to place the subject in the middle of the frame, have the person look straight at the camera, and press the shutter. This is certainly the perfect recipe for creating one of the most soporific photographs that may be taken. The subject will be completely within the frame, yet nobody will ever care about the image except members of the subject's immediate family, and then only because they are courteous.

Kodak's rule is in direct contradiction to Scott McLeay's statement. If, as McLeay states, each part of an image is equally important, then placing the subject in the center of the frame is only one of several possible options, and is arguably the weakest composition since only the center of the frame is used. In other words, what about the borders of the image? What about the corners of the image? And what about placing the subject off center to make the composition more interesting?

By thinking the way Scott McLeay proposes, we are moving towards a less superficial understanding of composition. Already we have understood a number of fundamental aspects of composition. Let's recapitulate:

1. Composing a photograph does not necessarily mean placing the most important subject in the center of the image.
2. Decentering: Placing the subject off center can result in a more interesting composition.
3. Both the edges and the corners of the image can and should be used. These areas of the image are not just "there" because there is no way to do away with them. They are there because they are important and can be used both effectively and creatively.

Kodak's rule – to place the main subject in the center of the frame – was designed for one essential reason: to enable photographers whose main purpose is to take family photographs in which the subject is completely shown. We have to keep in mind that several years back, when this rule was first established, most amateur cameras were rangefinder cameras that did not have a high-precision viewfinder. In

other words, the viewfinder was not accurate enough to show exactly what was and was not going to be captured in the photo. The borders of the image were uncertain, and thus, objects placed close to the edges of what was seen through the viewfinder may or may not have been visible in the final print. Worse, they may have been cut off, partly or completely, showing only half of a person's body because this person was placed too close to the edge of the photograph. Placing the main subject in the center of the image, safely away from the uncertain location of the photograph's borders, solved all of these problems. The resulting photograph may not have been contest-winning material, but it certainly kept customers from complaining about Kodak's products. No one created masterpieces, but no one complained either.

Things are very different today. Modern SLRs, which show 98% to 99% of the image in the viewfinder, have eliminated the risk of inadvertently cutting off important parts of the image. The use of tripods enables us to not only compose each image precisely, but insures that the composition stays exactly the same until we move the tripod to a different location. The use of transparency film, as opposed to color print film, means that what we see on the light table is the exact image we saw in the viewfinder. By comparison, most family photographs (for which Kodak's rule was established) are taken with negative film, developed at the local drugstore, and arbitrarily cropped by a one-hour photo operator. Finally, the fact that many of us scan and print our own work (or print it in our own darkroom) means that we have complete control over cropping our images. When shooting digitally, it is no longer necessary to wait to view the photographs; the actual image can be viewed on the LCD screen while in the field, as the photograph is taken.

Today, we can precisely control what will be visible in the image and what will be left out of the image. We can do this by firstly, paying very close attention to the elements we include in our photographs; and secondly, controlling the exact location of these elements within the viewfinder.

The Strongest Way of Seeing

Let's look at another photographer's take on composition: Edward Weston. When asked for his definition of composition Weston answered, "Composition is the strongest way of seeing."

Weston's definition contains two very important words about composition; seeing and strong.

We know from reading the first chapter in this book, that photography is largely about seeing. We now are learning that composition is about strength – visual strength.

If composition is the strongest way of seeing, and seeing is the strongest way of photographing, then composition is the strongest way of photographing. If this sounds like Aristotelian logic, that's because it is. Is it accurate? Let's see.

There is More Than One Way to Compose a Scene

In placing such high importance on composition, Weston implies that there is more than one way to compose a scene. Indeed, to the experienced and trained eye, the same scene can be seen and composed in a number of ways.

This fact was a revelation to me when I first discovered it. I had been struggling for years with trying to re-create photographs previously taken by other photographers. These photographs amazed me, and I literally sought to stand in the footprints of those who created them. The problem was that when I stood in the locations where those great images had been created, I could see only one composition; the one that another photographer had created. I could not see or compose for myself. I was a slave to the way other photographers saw the world.

One day I managed to free myself from this enslavement (how I did this is the topic of another chapter). That was the day I began to see the world for myself. I realized that there wasn't only one possible image in a given location, but a multitude of possible images. My mind had somehow opened up. That day my goal changed completely as I sought to capture on film, not the images I had seen before, but the images I could now see in my mind's eye. I was composing my own images.

One Composition Among Many

After I began composing my own images a new problem surfaced; I could capture only a few of the many images which now presented themselves to me. I had to make a choice because I had a limited amount of time to work while the light was at its best. It was then that I went back to Weston's definition, "Composition is the strongest way of seeing", and this definition allowed me to separate the wheat from the chaff, so to speak. What I was looking for wasn't simply nice or new compositions. What I was looking for was "the strongest way of seeing". To implement

▲ **The Linhof Multifocal Viewfinder**

Weston's approach, I started walking around the scene I wanted to photograph, looking for the composition which stood out above all the others; the composition which would enable me to represent the scene in front of me in the strongest possible manner.

Walking the Scene

After this long explanation about what composition is, I am sure the reader will want to know how this can be accomplished; how better photographs can be composed. The following is the approach I use. I encourage trying it, even just once, to see if it works for you.

Those who have seen the Luminous Landscape Video Journal, (if you haven't, you

should because each issue is really worth your time, www.luminous-landscape.com – Video Journal No. 1), may have noticed that whenever I photograph I spend a lot of time walking around and not photographing. I refer to this as "walking the scene". While walking the scene I carry a Linhof Multifocus Viewfinder (LMFV). This is one of my most trusted photographic tools. Basically, it is a portable viewfinder that allows me to see the exact composition I can get with lenses from 75 mm to 400 mm. These are 4x5 lenses, my primary format, and they roughly equal 24 mm to 135 mm in 35 mm format. Of course I could do this with a 35 mm camera and a zoom lens but the LMFV is much lighter and more compact than any camera. It also has the benefit of not showing any technical data in the viewfinder, such as shutter speed, f-stop, etc., thereby allowing me to focus my attention 100% on composition.

With the LMFV I can compose hundreds of 4x5 photographs each day without ever actually setting up my 4x5 view camera. As I compose photograph after photograph, I evaluate the respective strength of each image (remember, I am looking for the strongest way of seeing a specific scene). Many of these potential photographs are very casual and looking through the LMFV lets me know right away whether the composition is strong enough to make a good photograph. When I find a worthy subject, I investigate it further and look at the scene from different angles with the LMFV. Finally, when I find a composition I want to photograph, I set up the camera, already knowing precisely what I plan to do. Because setting up a 4x5 is time consuming, this approach is very efficient.

The beauty of the Linhof Multifocus Viewfinder lies in its portability and excellent opti-

cal design. I can precisely visualize 4x5 images all day without having to set up my camera. Of course, shooting 4x5 requires a different approach than 35 mm or medium format because it is so cumbersome to carry and so time consuming to set up. The point I want to make here is that what I am doing most of the time when I photograph is not actually photographing but rather looking for the best photographic opportunities. I spend much more time searching for a photograph than actually photographing. In other words, I must first find a composition before I can create a photograph.

Using a "Cutout" Finder

The LMFV is a great tool but, unfortunately, it is expensive. A low-cost alternative is to create a homemade viewfinder using a 4"x5" sheet of black cardboard, or black plastic, and cutting out an opening in it with an x-acto knife. Make sure the opening has the same proportions as the camera format (i.e. 24x36, 6x6, 6x7, etc.). Also, make sure to leave roughly a 1" border around the opening.

This simple cardboard viewfinder will allow us to frame the scene and isolate elements without having to carry a camera around and without being distracted by the information in the camera viewfinder. I used such a viewfinder for years before purchasing the LMFV. I carried several such viewfinders, each with a different opening size to match the different film formats I was using at the time.

Finally, certain rangefinder cameras come with detachable viewfinders. For example the Fuji 617 panoramic camera has a detachable finder for each lens. When I photograph with this camera I simply put the viewfinder in my

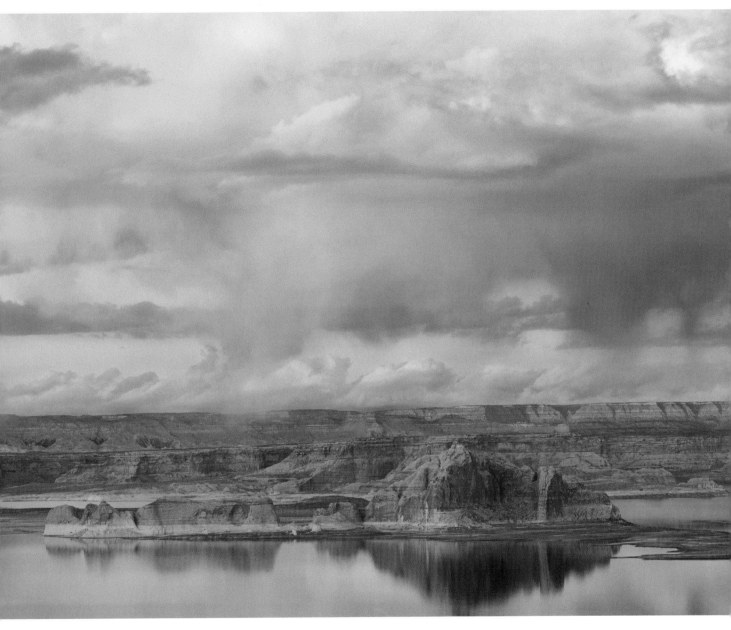

▲ **Lake Powell Sunset**

pocket, leave my camera in my bag, and look at the scene through the finder. The finder shows me exactly what the camera will see and is much easier to carry and use by itself. After I find a composition I like, I set up the camera and take the photograph.

Rules of Composition

I know this chapter will not be considered complete unless I discuss some of the rules of composition. Following are some of the most important rules:

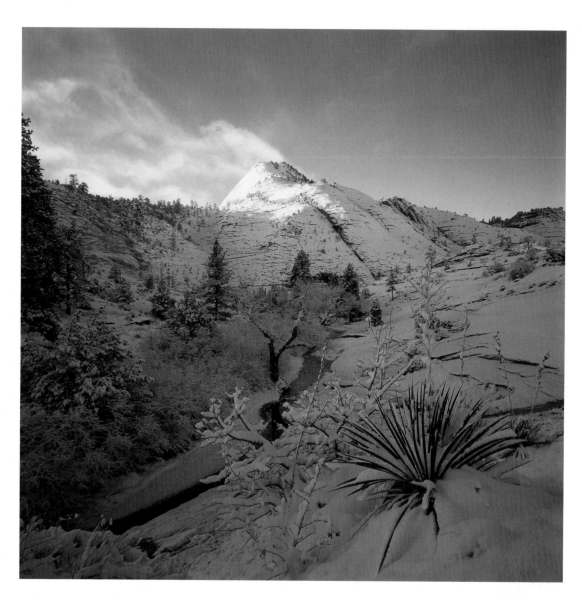

Zion
Winter Sunrise ▶

Rule 1 – The Rule of Thirds

This rule calls for the image to be divided into three equal parts, and to compose the image in thirds. This applies to both vertical and horizontal directions and vertical and horizontal compositions. The dominant subject matter in the photograph is placed one third up or down the image or one third from the left or right side of the image. In "Lake Powell Sunset," for example, the lake and the rock formations take only one third of the available vertical image space while the sky and the cloudscape take up the remaining two thirds.

Rule 2 – The Golden Rule

The Golden Rule came to prominence during the Renaissance when it was rediscovered by the Masters. It was, however, introduced in

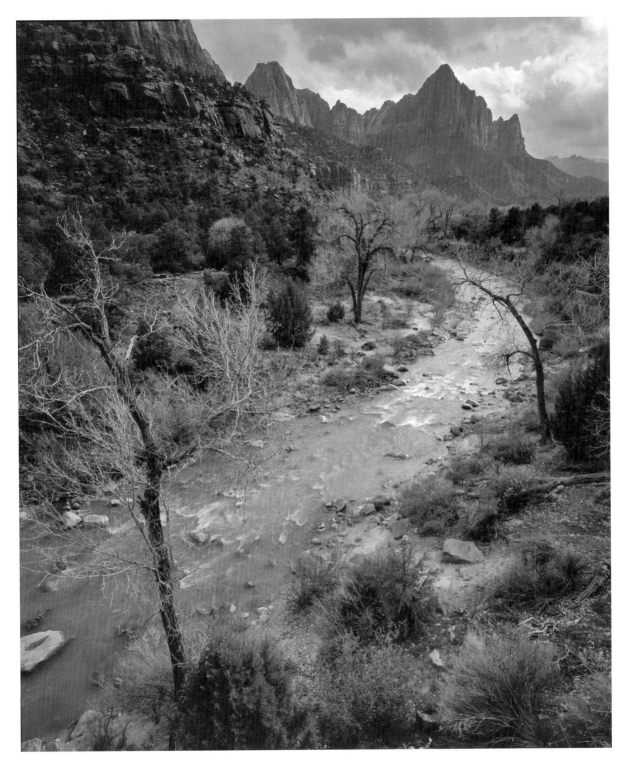

▲ **The Virgin River and the Watchman at Sunset**

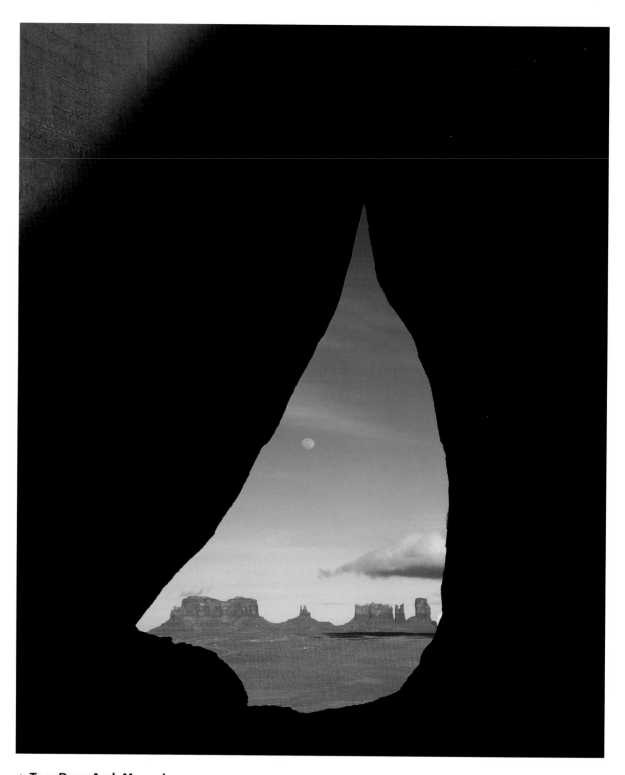

▲ **Tear Drop Arch Moonrise**

ancient Greece. The Golden Rule states that the most important area of an image is located near the bottom right corner of the image, roughly one fourth of the image height up and one forth of the image width to the left. "Zion Winter Sunrise" was composed according to the golden rule. The yucca, the most prominent foreground element, is located in the right bottom corner roughly at equal distance of the bottom and the right side of the image.

Why the bottom right corner? Essentially because theoretically we "read" images the same way we read a written text: from left to right and from top to bottom. Since our reading ends at the bottom right corner of the page this is the area that will hold our attention for the longest time as we either stop or pause before turning to the next page (or the next photograph). In line with this theory Japanese and Chinese readers look at images very differently.

Rule 3 – Leading Lines

Lines leading the eye into the composition, and thus into the image, are another classical way to compose a photograph. The typical example is a road, or a pair of railroad tracks, leading the eye toward the horizon.

In landscape photography we do not have roads or railroad tracks unless we decide to include man-made elements. Fortunately, we have other elements which can work just as effectively. One example is a river, as shown in "The Virgin River and the Watchman at Sunset". In this instance the Virgin River draws our eye deep into the image. The sweeping shape of the river adds a pleasing sense of movement and helps to make the image even more interesting.

Rule 4 – Perspective

Perspective is a strong compositional tool. In the example above, as the Virgin River moves into the distance, its width is progressively reduced. This reduction is caused by perspective, which dictates that the size of an object is proportionally reduced as the object becomes increasingly distant from the viewer. Perspective is one of the most effective ways of adding depth and a sense of distance to an image

Rule 5 – Framing the Photograph

Here, the main view, typically the background, is framed by another element of the scene, typically a foreground element. In the example shown below, I used Tear Drop Arch to frame a distant view of Monument Valley. Without the arch this view of Monument Valley would be far less interesting and dramatic.

Conclusion

Understanding the basic rules of composition is key to creating images that are both expressive and personal; images that represent a structured approach to the landscape. Elliott Porter described this process as "making order out of chaos". Nature, in this view, is chaos. Our role, as artists and photographers, is to organize this chaos to create aesthetically pleasing images. Composition is the process we follow to organize the natural work, to create order from chaos.

In chapter 3 we will study "How to Choose the Best Lens for a Specific Composition". This crucial aspect of photography will take us further along the path leading to the creation of fine images.

How to Choose the Best Lens for a Specific Composition

Look and think before opening the shutter.
The heart and mind are the true lens of the camera.

YOUSUF KARSH

The Importance of the Lens

Lenses are as important (perhaps more important than the camera itself). Choosing the right lens for a specific photograph is an important decision. This decision follows upon our previous decisions about how to compose the scene, and composition follows what we saw in this scene, what we want to photograph in the first place. In short, each step involved in taking a photograph, from seeing to composing is related.

With lens choice we now start thinking about *how* we can photograph the scene in front of us. We move from visualization to creation in a sense, and, for the first time we are actually going to use a camera. We are almost to the point where we will finally take a photograph!

What can be simpler than choosing the right lens for the job? If we want to photograph a large landscape, we use a wide-angle lens. If we want to photograph a distant detail, we use a telephoto lens. If we want to photograph something in between the two, we use a normal lens. What more is there to the subject? One could answer, "Nothing, case closed. Let's move on", but this most certainly is not true.

What is there to know about lens choice that we do not already know? For one, and this is a big "one", the lens that is used should be based on how we want to depict the scene in front of us. In other words, (and to go back to chapter 1, "How to See Photographically") the lens we use should be chosen so that it firstly follows our vision, and secondly, suits the composition we want to create.

In this chapter we will look very carefully at why learning to choose the best lens for a specific composition is one of the most challenging decisions we will make on our way to creating top-quality images.

Human Eyes and Camera Eyes

Our eyes have a fixed focal length, which is equivalent of a normal camera lens (a 50 mm on a 35 mm camera and a 150 mm lens on a 4x5). Cameras don't have fixed lenses (except some point and shoot cameras). Instead, they have interchangeable or zoom lenses. Human beings always see the same angular distance, the same field of view. While we can focus our attention to a narrow section of our field of view, this field of view remains fixed. When looking at the world through a camera we can vary the field of view by changing the lens. How much a camera sees depends on the focal length of the lens that is attached to it.

When we look through a camera equipped with a telephoto lens, in a sense, we turn our eyes into telephoto lenses (we do the same when we look through a pair of binoculars). When we look through a camera equipped with a wide-angle lens, we widen our field of view beyond what the human eye can normally see. The Linhof Multifocus Viewfinder, which I described in chapter 2, allows me to do this using the most compact package I know of.

Hence a camera, and a set of wide-angle, normal, and telephoto lenses (or zoom lenses), allows us to expand what our eyes can see beyond our human limits. With the use of lenses we can see wider than we normally can, or we can see further than we normally can. Our field of view becomes adjustable. Our ability to see is both enhanced and expanded. A new field of endeavor opens up to us, allow-

ing us to see the world in ways the human eye alone cannot see it.

In terms of aesthetics this means that photography opens up unique possibilities of representing the world. Certainly, once this new aesthetic has been discovered, it is possible to create it with a medium other than photography. For example, it is possible to paint a scene as viewed through a wide-angle lens. But I would argue that someone first had to see a scene through a lens (or in a ball-shaped mirror which closely duplicates a wide-angle effect) before such a painting was made.

One Landscape:
Three Main Lens Choices

What are the ways in which we can see the world differently with photography? To simplify the matter, I divided the possibilities into three main types of views using the three basic lens categories; wide, normal, and telephoto.

As we move from a wide-angle lens, to a normal lens, and then to a telephoto lens, less and less of the landscape is included in our photograph. In effect, we go from capturing as much of the landscape as possible with a wide-angle lens, to capturing what our eyes normally see with a normal lens, to capturing only a fraction of what we see with a telephoto lens. With these three lens options, we are focusing the attention of the viewer to an increasingly smaller field of vision.

The names I use for these three categories are Large Landscapes when we photograph everything there is in front of us, Medium Landscapes when we photograph part of what is in front of us, and finally Small Landscapes when we photograph only a fraction of what is in front of us.

In this process the photographer calls the shots. It is our decision whether we will photograph the entire landscape, a section of the landscape, or a fraction of the landscape. Although, certain subjects may naturally lend themselves to one of these three main categories, it is important to remember that any subject can be photographed in these three ways.

Let's look at these three main ways of interpreting the landscape in greater detail:

Choice 1 – The Large Landscape

Wide-angle lenses create the most dynamic compositions. As we move from wide-angle to normal to telephoto lenses, the composition becomes more and more static as we will see. Wide-angles introduce "movement" in the image by allowing us to show what is close as well as what is distant, at the same time, and/or by allowing us to show a huge amount of the scene in front of us. To see as much with our eyes as a wide-angle lens sees, we would have to move our head up and down and right to left. It is not possible for us to see with the human eye an entire wide-angle lens scene without looking through a camera (or through a Linhof Multifocus Viewfinder).

The dynamism introduced by wide-angle lenses comes from the fact we are looking at a scene which can only be seen with a camera. Wide-angle scenes exceed what we can humanly see with our eyes alone. They exceed our physical capabilities, blow open our boundaries, and reveal to us a world that is both attractive and foreign, a world we long to explore for ourselves.

Of course, the part that we all love is the near-far effect achieved with a 4x5 and a super wide-angle lens such as a 75 mm. The combination of wide coverage and sharpness throughout the image, ranging from a few

inches away to infinity (thanks to the combination of small f-stops and camera movements), makes this type of image both a visual delight and a photographic tour de force.

In such an image all the elements must work together in order for the complete image to be successful. Since we have at least 3 essential planes in the image – the foreground, the middle ground and the background – all three planes must be interesting for the whole image to fascinate our audience. We must have a stunning foreground, showing a subject that is not only visually attractive, but uncommon. We must have a pleasing middle ground, because it is this middle ground which effectively makes the transition from foreground to background. And of course we must have a great background, because the viewer's eye will repeatedly travel from foreground to background. Too many foreground-background images fail because what is primarily interesting is only the foreground. To avoid this pitfall think in terms of foreground, middle ground, and background and make sure each is equally interesting.

When I plan to photograph the Grand Canyon at sunset, for example, I look for a great foreground during the day (such as an uncommon tree or rock) and plan my composition. When I return to this chosen location at sunset I hope to be blessed with beautiful clouds over the Canyon. A tree may be my foreground, the Grand Canyon my middle and background, and the clouds my second background. It is hard not to create a wonderful photograph when we understand exactly what to do to successfully combine all of these elements!

A near-far composition is most easily achieved with wide-angle lenses. Notice that it is also possible to achieve this composition with the two other types of lenses; normal and telephoto. Near-far compositions are not lens-specific, although they are most often created with a wide-angle lens. However, with a normal or telephoto lens, a near-far composition will not be as dynamic. To achieve a near-far effect with a normal or telephoto lens, and still maintain sharpness throughout the image, we would have to use a distant foreground subject. Instead of a foreground subject just at our feet, we would have to choose an element 5 to 30 feet away, depending on the focal length of our normal or telephoto lens. This will result in an apparent compression of the image elements, which in turn will make the image more static, less dynamic. Notice that longer lenses do not cause this compression effect. Rather, this compression effect is caused by narrowing our field of view to a small fraction of what we normally see. One of the exercises I suggest at the end of this chapter is aimed at helping us to verify this fact.

Wide-angle lenses can also be used to photograph an inordinate amount of sky. In this case the near far relationship may not be achievable since only a small part of the landscape may be shown. Wide-angles can also be used to photograph wide vistas which otherwise could not be captured in a single photograph. Wide-angles are excellent for depicting circular shapes, such as a kiva or the curve of a canyon, since their natural curvature of field, which comes from their wide coverage, lends itself to depicting curved shapes.

Wide-angles can be used in various ways in landscape photography. But, in whichever way they are used, their dynamic quality often results in giving a feeling of exaggeration to the photograph. Since wide-angle images show us more than can be seen with our own eyes, they offer the viewer an element of surprise. As we

▲ **Sunset over Squaw Creek Ruin, Arizona.**
Linhof 4x5, 75 mm lens

◄ In this example, "Squaw Creek Ruin vertical", a serene and somewhat nondescript scene is energized by the use of a 75 mm wide-angle lens on my Linhof 4x5. This is a quiet scene, without any dominating elements. In fact, when I was visualizing this image, I couldn't help but think of the jumbled nature of this subject. My choice of a wide-angle lens allowed me to bring dynamism to a scene. This scene would have been far too static had I used a normal lens. The wide-angle lens allowed me to exaggerate the size of the foreground elements, enabled me to use an inverted Y shape (the low rock wall) to lead the viewer's eyes into the image, left me plenty of space to center the mountain on the other side of the canyon, and finally, allowed me to top it all off with a soft purple sky partly filled with purple evening clouds.

The extremely wide field of view means that the size of nearby objects is emphasized while the size of distant objects is reduced. This effect exaggerates the sense of perspective in the photograph and helps organize an apparently "jumbled" scene into near (foreground), medium (middle ground), and distant (background) planes. In a wide-angle photograph, elements that, in the actual scene seem to be "stacked up" on top of each other, tend to appear more separated, more "spread out".

will see later, telephoto lenses also surprise us due to the exaggerated view of distant objects which they create.

I nearly always show the sky in my wide-angle photographs, even if it is just a thin strip at the top of the photograph. If I want to crop out the sky in an image, I usually turn to a normal or a telephoto lens.

Choice 2 – The Medium Landscape

A normal lens is a lens with a focal length that is equal to the field of view of human beings. In other words, when looking through a normal lens we see as much of the scene in front of us as can be seen with the naked eye. The normal focal length for any film size is equal to the diagonal distance between two opposite corners of the film, or image sensor, in millimeters. We can easily find the normal focal length for any film format or image sensor, by using a metric ruler to measure the diagonal distance between two opposite corners of the film or image sensor. For 35 mm film a 50 mm lens is a normal lens. For a 2 1/4 system a normal lens is an 80 mm lens. For 4x5 a normal lens is a 150 mm lens.

Many photographers often consider a normal lens to be "boring." After all, why show the world the way we see it? Let's use a wide-angle or a super telephoto lens. Now that's exiting! I agree, to some extent, and I must say that my normal lens is not the one I use most frequently. But, I am not saying I never use it either! After all, what's wrong with showing the world as we see it with our eyes? If we only see boring things with our eyes, how can we pretend not to take boring photographs? It would be a mistake to think we can create exciting photographs only through the use of wide-angle and telephoto lenses. If this were the case, then it would be the lenses that

bring this excitement to our photographs; it is the lenses that make our photographs look interesting. If this were so then we know that this novelty will soon wear out, provided there ever was novelty there.

A proficient photographer must be able to create good photographs --interesting images-- with a variety of special lenses. Similarly, a proficient photographer must be able to create good photographs with a normal lens. Seeing, composition, light, and personal style (as we will see in the following chapters) are independent of the exact focal length of the lens we have in our hands. While we may not completely control the equipment at our disposal, we must have the ability to control the vision we want to express in our images.

More important to this discussion is the fact that a normal lens allows us to create what I call Medium Landscapes. These are images that are half way between wide-angle and telephoto images.

Wide-angles allow us to best photograph the Grand Landscape. They allow us to "take it all in", so to speak. We don't have to think about what we will leave out because the lens coverage is so huge that it allows us to capture almost as much of the scene as we want. Wide-angles are best for the large landscape; for views which stretch from just in front of our feet, to the distant mountains at the horizon, and to the sky above them.

But such a wide field of view is not always appropriate. Sometimes, a more subdued, less dynamic, and less exaggerated perspective is more desirable. For example, while wide-angles are great at showing "everything", they often downplay details of the scene. By "zooming" into the scene a little bit, and reducing our field of view, we can now emphasize relationships between elements. Rather

Canyon de Chelly at Sunrise ▶
Linhof 4x5, 75 mm lens

The two photographs, taken seconds apart as the sun was rising over Canyon de Chelly, clearly show the difference in view between a wide-angle lens and a normal lens. The wide-angle photograph shows the dramatic setting of Canyon de Chelly and emphasizes the turn the canyon makes along the gigantic sandstone walls. The normal lens photograph shows a more intimate and quiet landscape, and focuses our attention to part of the scene only. Although the sky is visible in the normal image, the space it occupies in the image has been dramatically reduced. ▶

Canyon de Chelly at Sunrise ▶
Linhof 4x5, 150 mm lens

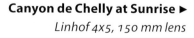

▲ Capitol Gorge Boulders and Desert Varnish
Capitol Reef National Park, Utah
Linhof 4x5, 150 mm lens

◄ The medium landscape may or may not show the sky. In the previous examples of "Canyon de Chelly at Sunrise" I used a minimum amount of sky. In this next example "Capitol Gorge Boulders and Desert Varnish" I included no sky at all. This is an intimate landscape created with a normal lens, and the sky just isn't needed. It wouldn't add anything to the image and, in fact, the brightness of the sky would exceed the range of the film and bring in an unnecessary, and distracting white or nearly white area.

This is a perfect example of a medium landscape. Not too large, yet not too tight. The normal lens gave me the freedom to stay a certain distance away from the boulders and still show them at a pleasing size. A wide-angle lens would have required me to step much closer to the boulders, and thus have them tower over me . This would have resulted in showing less of the top of the boulders (since I would have been partially below them) and thus would have shown less of the overall scene. The *quieter* framing of the normal lens added balance to the scene. The dynamism of a wide-angle lens would have been counterproductive to the quiet scene I wanted to depict.

than focusing on the whole, we now focus on parts of the whole.

Normal lenses excel at creating a sense of balance in a scene. They help create images that we accept for "real" at face value. We do not question images created with a normal lens, because we are intimately familiar with the angle of view covered by a normal lens. After all, it is our natural field of view; the field of view we live with and experience the world through everyday.

For this reason, whenever we want to depict a scene without creating a sense of exaggeration, without focusing the viewer's attention towards *how* the image was created, or without drawing attention to the particular lens which was used, a normal lens is appropriate. Such a lens will give a natural appearance to our image because the field of view covered by the image is the one we experience with our own eyes. This field of view will appear normal to our audience, and as a result, our audience will focus on the content of the image rather than on how the image was created. The lack of difference between how much we see and how much the camera sees means we more readily accept the reality created by the lens.

Choice 3 – The Small Landscape

The third category is the one I call Small Landscapes. These are, by definition, isolated elements of the landscape; elements that we may miss (and often do miss) while looking at the general scene, because we tend to see the whole rather than the parts.

Wide-angle views surprise us because they show so much more than we can see with our own eyes. Telephoto views surprise us because they show so many more details than we can see with our naked eyes. Details of faraway objects that we cannot see with our own eyes are revealed in absolute clarity by the lens. Telephoto photographs allow us to admire what we could only guess existed. We look into the small landscape as one looks inside a treasure box, wondering what is hidden inside, what else we missed, what else may be revealed to us.

The small landscape rarely shows the sky. The small landscape is an introspective view, rather than an overall view (as with the large landscape) or a focused view (as with the medium landscape). Not including the sky in a photograph means removing one of the most powerful elements the viewer has to define how big, how tall, or how deep a natural feature is. If we take the sky out of a Grand Canyon photograph, the viewer has no means of judging exactly how deep the Grand Canyon is, because the location of the rim of the canyon can no longer be seen. Removing the sky also means removing the one element we depend on to define not only where the horizon is, but whether a photograph is level or not. Without a skyline we will need some other element to act as a visual balancer in the image; an element that will metaphorically replace the horizon line. In the example below, "Paria Riffle, Colorado River, Lees Ferry, Arizona", the far edge of the river and the line separating the river from the cliff, act as a visual "horizon". This line acts as a metaphorical level line and helps give a sense of balance to the image. Also see "O'Neil Butte Telephoto" on page 45 for a second example of a small landscape.

Because telephoto lenses show details that cannot be seen with the naked eye, what we see in small landscape photographs often feels greatly out of context. We are now looking at the parts rather than the whole. This lack of context helps us to become detached from everyday reality. In our daily reality the sky is

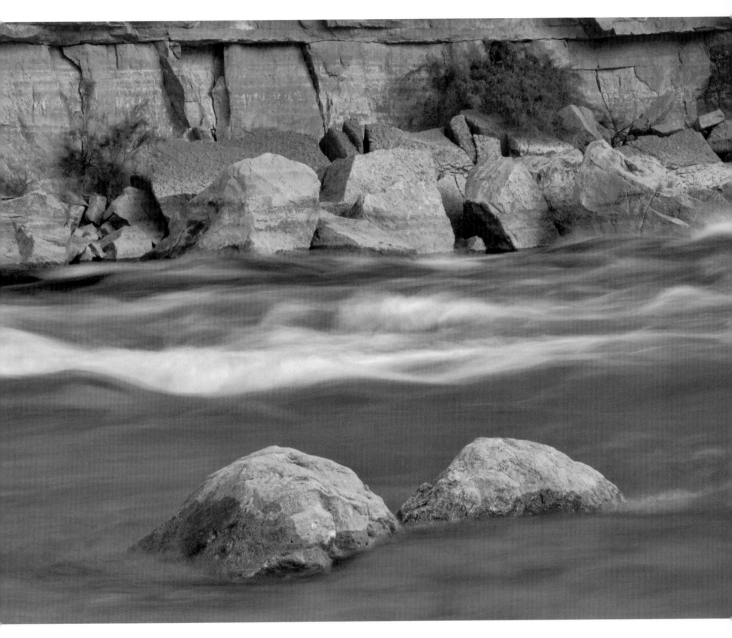

▲ **Paria Riffle, Colorado River, Lees Ferry, Arizona**
Linhof 4x5, 400 mm lens

always present; in daily reality, we cannot see minute details of far away objects. The fact that the sky is not shown, combined with the fact that infinitely small details in relatively distant objects can be clearly seen, creates a feeling of "otherness" in the viewer; a feeling that the photograph we are looking at is greatly out of the ordinary.

Which Lens Should I Take?

One of the most frequently asked questions I receive from workshop participants is "which lenses should I take?" This is a crucial question when we take into account both how heavy and how bulky lenses are. Besides hiking with these large, heavy lenses, we must also carry them on a plane if we are flying, or carry them in our car when we are driving from location to location.

No matter how we approach it, landscape photography involves a certain amount of exercise. We know we will have to walk around with our equipment at some point. Carrying more lenses than we need makes walking both more tiring and less enjoyable. I currently have 6 lenses for my 4x5: 47 mm, 75 mm, 90 mm, 150 mm, 210 mm, and 300 mm. With these lenses I can pretty much cover all my needs. (With 35 mm this lens selection would be roughly equal to 18 mm, 24 mm, 35 mm, 50 mm, 75 mm, and 135 mm.) Long telephotos are neither widely available nor practical for 4x5. The longest 4x5 telephotos are around 500 or 600 mm, and at those focal lengths both stability and weight become serious challenges. If I worked with 35 mm, I would either add one or two longer lenses or a 200 to 400 zoom. With 4x5 I could add a 500 mm lens if

I wanted to increase my maximum telephoto range.

Sometimes I need to pare down the equipment I carry. This may be because I am going on a long hike or because I am flying (or both). In this case I only take 3 lenses: 75, 150, and 210. Because the 150 fits in the Linhof when it is closed, it always comes with me. If I can take only one lens the 210 will stay at home. I must have a wide-angle!

Keep in mind that the quality of the photographs brought back with us is not directly related to the number of lenses carried. Certainly, a wide-angle view cannot be taken with a telephoto lens. But, if we are proficient photographers (and if we are not, this book is aimed at helping to achieve proficiency), we know how to create a quality photograph with the tools at our disposal. If the reader needs to sharpen their skills, the exercises provided below are here to help.

Photographic Skills Enhancement Exercises

A tourist visiting New York asks a New Yorker, "How do I get to Carnegie Hall?" The answer he receives is one of the most important lessons in an artist's life. "Practice, practice, practice."

Here are three practice exercises which will allow us to get where we want to go. These exercises are designed to help develop knowledge of lenses and to familiarize us with what each lens can do:

Exercise 1
Photograph the same scene without moving the tripod, using all the lenses in your "photographic arsenal." I realize that some of these

photographs may not be very good or interesting, because the subject may only lend itself to a particular type of lens. Nevertheless, this is a worthwhile exercise. Film is cheap and if we are shooting digitally it won't cost anything. Later, compare the photographs, looking for new possibilities for compositions. For example, it may be discovered that had this exercise not been done, the thought of using a particular lens in this location may have been missed.

Exercise 2

Go out on a serious photography shoot to a favorite location and carry only one lens: not two, not three, just one. Any preferred lens may be chosen, but there may be only one lens. A favorite lens may be selected because we know we enjoy photographing with it; or a lens may be chosen that we have not worked with much, so that we can investigate the possibilities offered by this lens. Don't take a zoom lens, since this will go against the purpose of this exercise. If only a zoom lens is available, or if the focal length we want to use is only available on a zoom lens, do what it takes to change the zoom into a fixed lens. For example, tape the zoom control ring so the focal length cannot be changed.

John Sexton used only one lens -a 210 mm on his 4x5 – for several years when he started photography. There is no doubt that when he purchased a second lens he was intimately familiar with all that a 210 mm could do. The same approach can be used with every focal length.

Exercise 3

Take two photographs of the same scene without moving the camera or tripod with both a wide-angle lens and a telephoto lens. When back in the studio, crop and enlarge the photograph taken with the wide-angle lens so that it results in the same composition as the image taken with the telephoto lens.

Compare the two "telephoto" images: the one created with a telephoto lens and the one created by cropping the wide-angle view. No difference will be noticed as far as composition and "compression" of the scene are concerned.

Telephoto lenses do not compress distant scenery any more than wide-angle lenses distort scenery (except for fish-eye lenses). The perspective created by a telephoto lens is the same as that of a wide-angle lens, except that only a fraction of the wide-angle photograph is visible in a telephoto view. Distant objects are naturally "compressed" because as objects recede in the distance (get further away from us) they appear to be closer and closer together. This effect is caused by perspective, not by lenses.

Either going from a wide-angle lens to a telephoto lens, or cropping a photo, each have the same effect. Theoretically, if it were possible to take photographs with limitless resolution, a wide-angle lens could always be used, then after returning to the studio the photographs could be cropped. All the desired variations of cropping and composition could be created from a single image, and each of these various images would appear as if they had been created with different lenses. In practice, due the finite resolution of film and image sensors, this is not feasible.

Conclusion

Photographing natural landscapes is exciting: here we are in a beautiful natural location, trying to express our feelings towards the scene in front of us. We go to beautiful

Sunset from Yavapai Point ▶
Linhof 4x5, 75 mm lens

Example ▶
This is what I have done in the three photographs below which all show the Grand Canyon at Sunset from Yavapai Point on the South rim. "Sunset from Yavapai Point" was created with a 75 mm lens. "O'Neil Butte Cropped" is a cropping of "Sunset from Yavapai Point "showing only O'Neil Butte. "O'Neil Butte Telephoto" was created with a 300 mm lens on my Linhof 4x5, the equivalent of a 135 mm lens on a 35 mm camera. As you can see, "O'Neil Butte Cropped" and "O'Neil Butte Telephoto" are identical as far as composition, and compression, are concerned. The grain and the resolution are better on "O'Neil Butte Telephoto because I didn't have to enlarge it. The rocks are redder on the telephoto photograph because it was taken later than the wide-angle photograph. As we will see later in chapter 4 on light, at sunset and sunrise dramatic changes happen within a few minutes.

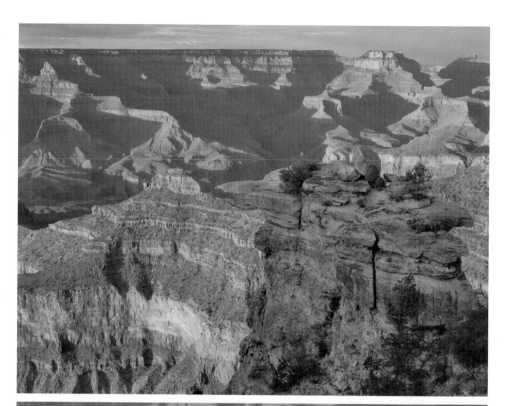

O'Neil Butte Cropped ▶
Linhof 4x5, 75 mm lens
(crop of the original image)

◄ O'Neil Butte Telephoto
Linhof 4x5, 400 mm lens

natural places, we discover and explore these places with an artist's eye, and we work toward creating images that convey what we saw and felt while we were there. What an exciting endeavor. And how wonderful the prospect of sharing with others the fruit of our creative endeavors!

Primeval landscapes, such as the Southwest's canyon country, evoke powerful, almost instinctive, reactions. Pastoral scenes, such as in France and Italy, evoke subdued reactions and are best rendered in a more poetic fashion. But how is all of this achieved when the only equipment used is a camera and film, neither of which have the flexibility of the written word or the infinite variations of tone, shape, and texture afforded by painting or drawing? One of the most powerful ways of expressing what is seen and felt is by a judicious lens choice.

Wide-angle lenses allow for the creation of dynamic, all encompassing images that are both surprising and enticing. Normal lenses allow for the creation of balanced images that will feel natural because the field of view they depict closely approximates the field of view of the human eye. Finally, telephoto lenses allow for the creation of images that reveal more details than can be seen with the naked eye, images which will surprise and delight our audience.

For maximum diversity in one's work, and to vary the type of images that will eventually be selected for one's personal portfolio, I recommend striving to create top-quality images with all three lens families. This, combined with the different compositions I discussed in chapter 2, will do wonders towards creating a stunning and diversified collection of landscape photographs.

How to Find the Best Light for a Specific Photograph

How glorious a greeting the sun gives the mountains!

<div align="right">JOHN MUIR</div>

And God said, Let there be light: and there was light (Genesis 1:3)

Light, from the earliest time recorded in history, has played a role of great importance in human culture and existence. In Genesis, God creates light. In ancient Egypt, the Pharaoh was responsible for bringing the sun back every morning. What a responsibility! The Incas worshipped the sun, and a solar eclipse was believed to be a foreshadowing of the apocalypse. The Incas could not comprehend that the sun could be hidden from sight in full daylight. The Anasazi, and most contemporary Pueblo Indians, developed a sophisticated understanding of the sun's movements in the sky. They used this knowledge for agriculture and for religious ceremonies. Louis XIV, King of France, was called Le Roi Soleil, the Sun King, in reference to the all-encompassing light which he supposedly shed on everyone and everything in his kingdom. Throughout history, various secret societies have been called luminaries, and social revolutions have brought about what is referred to as enlightenment.

Time and again, light has been part of the most important aspects of our lives, and has always played a major role in our existence. Even today, our lives are ruled by light and darkness, as most of us rise at dawn and go to bed after dark. We work during the day and we rest during the night.

As landscape photographers, we abide by the same schedule. We follow the sun in its migration while the earth rotates upon itself and circles around the sun according to, respectively, a one-day and a one-year path in the sky. Our days are organized around the 24 hours the earth takes to make a complete rotation upon its axis. Our yearly calendar is based on the one-year journey that the earth makes around the sun. The sun, and more importantly the light it sheds upon the earth, controls our lives.

Drawing with Light

Photography is all about light. The name itself implies it. Composed of two Greek words: photos, meaning light, and graphos meaning drawing or writing. The word photography literally means "writing (or drawing) with light." When photography was first invented it was called heliography, taken from the Greek word helios meaning the sun. Heliography meant "writing (or drawing) with the sun." It was believed that only sunlight could be used to create photographs because at that time films were not sensitive enough to be exposed with artificial light sources. When more sensitive films were invented, artificial light sources were used to create photographs, and magnesium started to be used as "flash" light, the term heliography became inaccurate. It was then replaced by "photography" to encompass the different light sources that could be used to create photographs.

Scott McLeay, my first photography teacher, often said that if we were to walk into a closet, close the door behind us, set up our camera on a tripod and proceed to take a time exposure, we would not get a photograph regardless of how long the exposure time is. We can expose for hours, days or months and get nothing on film or on our digital file.

The fact is that light is required to create a photographic image. We may not need much light, but we need some light. In a dark closet, even with a multi-hour exposure, we will not get a photograph because there is no light

whatsoever. The first thing a photographer needs, besides a camera, film, and a lens, is light. Photographs are images made with light. Without light there can be no photographs.

Three Governing Rules Regarding Light

Three main rules govern both the appearance and the behavior of light for photographic purposes. Understanding these rules is essential for photographers. Later in this chapter, we will see how these rules translate to the actual creation of landscape photographs.

Rule 1 – Quality of Light

The larger the light source – the softer the light. For the quality of the light to change, the surface of the light source must change first, either in terms of size, color, reflectance, or a combination of 2 or 3 of these elements.

In practice, and for landscape photography, this means that direct light from the sun alone will be much harsher than light coming from the entire sky on an overcast day. This is because the sun, although a giant star, is actually a very small light source when seen from the earth. On an overcast day, the cloud-filled sky becomes a giant light reflector the size of the entire sky above us.

A small light source, such as the sun, produces a very harsh light with bright highlights and deep shadows. A large light source, such as the entire sky on a cloudy day, produces a very soft and even light with little or no shadows.

Rule 2 – Reflected Light

If the light is reflected, the light will take on the color of the reflective surface on which it bounces. This is best exemplified by the lighting situation in the canyon country of the southwestern United States. In a canyon, the light reflected off one side of the canyon bounces onto the other side -the opposite wall- of the same canyon. While direct light is basically colorless, the light bouncing from one canyon wall to the other takes on the color of the canyon wall off which it bounces. This bounced light may be tinted red or orange and in turn, adds this reflected color to the other canyon wall. The result is that the wall lit by this bounced light appears much warmer in color -much redder to the eye and much redder on film- than if the wall had been lit by direct sunlight alone.

Rule 3 – Intensity of Light

The intensity of the light on any given surface decreases in a manner inversely proportional to the square of the distance between the light source and the subject. Doubling the distance between the light source and the subject is equivalent to reducing the quantity of light reaching the subject to 1/4th the original illumination. This rule is very important in a studio situation where artificial lights can be moved at will closer or further to the subject being photographed. In an outdoor, natural light situation, it is mostly academic since we cannot move the sun, the clouds, or the canyon walls. However, knowing this rule is important and this is why I am including it in this chapter.

How to Find the Best Light

How do we find the best light for landscape photographs? What we need for a photograph is not only light, but we need quality light.

Scott McLeay often spoke not of light, but of the quality of light. Light alone is not enough. Quality light is what we seek. But which quality of light do we need as landscape photographers?

Ansel Adams said, "God created light and he divided it into ten zones." Adams' tongue-in-cheek statement shows that it isn't just light that we need. It is light of such nature as to fit our needs as photographers. We need light with an artistic quality: light that we can, if not control, then at least learn to work with so that it is controllable through photographic means.

The quality of light chosen by each of us depends on what we want to photograph and what we are looking for. Traditionally, the best light is found at sunrise and at sunset, especially when photographing large vistas or the grand landscape. To take advantage of this light we must be at the location before sunrise and before sunset. The extra time is necessary to select a location, set up the equipment, and prepare to photograph. At sunrise a headlamp is a must to be able to see in the pre-dawn darkness.

Additionally, when photographing at sunrise at a given location for the first time, I recommend visiting the this location the day before so a suitable composition may be found ahead of time. It will be very difficult to find a composition in the dark, and the best light may be wasted while trying to find a composition as the sun rises. Clearly, it is much better to know what we want to use as a foreground, for example, by scouting the location the day before during daytime.

When photographing at sunset I recommend exploring the location during the afternoon, finding a good composition, and then either waiting for the sunset, or return-ing later to the location for the sunset. Again, being there approximately an hour before sunset will maximize the chances of getting a good photograph, as it will be possible to see and photograph the landscape as the light is progressively changing and the sun is getting lower in the sky. At both sunset and sunrise it can be very challenging to decide when is the best time to photograph since the light changes constantly during the hour after sunrise and the hour before sunset. It is best to be there early and photograph continuously without being overly critical of our efforts and without trying to find out when the light is at its peak. Once back in the studio, the results can be studied and decisions can be made on which image(s) is best. Equipped with this knowledge, we will be in a much better position to gauge the quality of light when next photographing at sunrise or at sunset.

Do not overlook the possibilities offered by pre-dawn and past-dusk light. About 30 minutes before sunrise, and about 30 minutes past sunset, the landscape basks in soft colorful light which is extremely propitious to photography, both in black and white and in color. At those times shadows are nonexistent, greatly simplifying contrast problems, and the colors are vividly saturated. The naked eye may not notice these colors, but film certainly will, especially when using a high contrast, high color-saturation film such as Fuji Velvia. There is no need to worry about excess contrast except for the sky, which will most likely be the brightest part of the scene at those times. If the brightness of the sky needs to be lowered, simply use a graduated neutral density filter to lower its brightness by one or two stops, as needed.

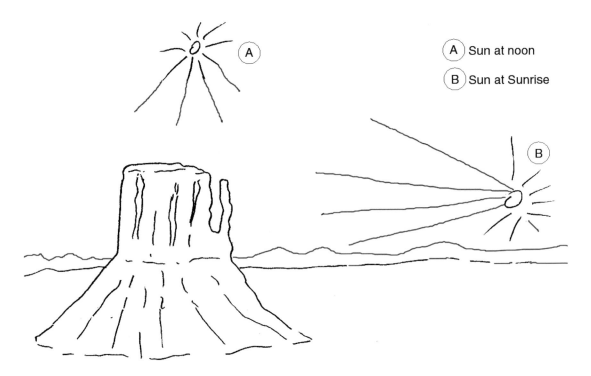

▲ Sunlight at Noon and at Sunrise

This drawing of Monument Valley shows the position of the sun both at
noon and at sunrise. At noon the sun shines right above the monument,
projects vertical rays of light, and casts short shadows below the monu-
ment (shadows are not drawn to avoid confusion as there would be
two different sets of shadows). At Sunrise the sun is at the horizon level,
casts horizontal rays of light and projects long shadows on the side of
the monument. At sunrise the sun lights the monument from the side. At
noon it lights the monument from above

Sunrise and Sunset – The Best Light

Why is sunset and sunrise light the best light
for the grand landscape? To put it simply,
sunset and sunrise light is the best because at
those times the light is horizontal. Horizontal
light is light that is parallel to the horizon,
grazing the subject and giving it a strong
three-dimensional quality.

Because the sun is low in the sky at sunrise
and at sunset, just above the horizon, sunlight
has to go through all the layers of dust, atmo-
spheric haze, and pollution before it reaches
the scene. During this process, the intensity
of the sunlight is greatly diminished and
softened, because the layers of dust and haze
filter the light of the sun. This filtering also
removes both the green and blue parts of the

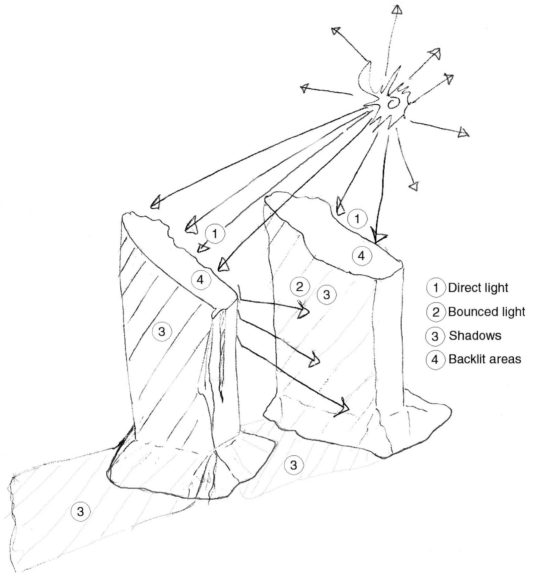

1 Direct light
2 Bounced light
3 Shadows
4 Backlit areas

▲ Reflected Light

This drawing depicts a typical reflected light situation in a canyon setting. The sunlight hits the left-side rock formation and is reflected onto the right-side formation. Other types of light are present in such a scene making it complex as far as light is concerned. We have shadows cast by the rock formations, directly lit areas, and backlit areas. The possibilities for different types of images in such a situation are numerous and worth investigating.

visible spectrum leaving, mostly the red part visible. As a result, sunrise and sunset light is warm, tinted either pink, red, or orange, depending on the particular conditions on a specific day. The combination of diffused light and the warm glow of sunrise and sunset creates a light which is excellent for photography. Furthermore, light that is both soft and warm is extremely pleasing to the eye.

In addition, human beings perceive light shining on the side of the subject (sidelight) as more aesthetically pleasing than light shining from above the subject (vertical light). This may have a lot to do with portraiture. When photographing (or painting) people, light coming from above the subject casts deep, unsightly shadows under the nose and eyes of the subject. When the face is lit from the side, one side is in the shade while the other side is in the light. This creates a pleasing three-dimensional effect. The same remarks apply to landscape photography with equally pleasing results. As a general rule horizontal light (sidelight) is much more aesthetically pleasing than overhead or vertical light, such as light coming from above the subject.

Other Light Choices

Are there other types of light propitious to landscape photography besides the horizontal light of sunrise and sunset? Rest assured; there are! While sunrise and sunset are great, there are other opportunities to create pleasing photographs during the rest of the day. In the following section, I take a look at the different types of light encountered outdoors. For each type of light I describe the light, its quality, color, contrast, and shadows. I also make film and digital correction recommenda-

tions. Learning all we can learn about these different qualities of light can only further our photographic skills and our ability to create superior photographs.

The Various Types of Natural Light

Natural Light Type 1 – Reflected Light
Description: Also called bounced or diffused light, reflected light is created by having direct sunlight hit a surface and then be reflect onto an adjacent surface. For example, in the Canyon Country of the Southwestern United States, a north to south running canyon will be directly lit by the sun on one side, while the other side will be lit by the reflected light. This reflected light bounces off the first side of the canyon onto the other side. Reflected light reduces contrast by bouncing light into the shadowed areas on the opposite side of the canyon. Reflected light will take on the color of the object from which it is reflected. In a canyon the light will take the red color of the canyon wall from which it is reflected, and will give this color to the shadowed areas on the opposite side of the canyon. As a result the shadows will have a warm, red glow to them. The narrower the canyon, the more prominent the effect. It reaches maximum intensity in the narrow confines of slot canyons where the light bounces from one side to the other multiple times. The further the light bounces in a slot canyon the redder the light becomes.
Quality: Soft and even. Canyon walls reduce contrast by bouncing light into the shadowed areas on the opposite side of the canyon.

◄ **Antelope Wall of Light**
Linhof Master Technika, Rodenstock 150 mm, Provia

▲ The photograph of Antelope Canyon in Arizona is all about light and form. Light makes the image in this instance. Notice there is no direct light in the photograph despite the presence of a highlighted area at the top left corner. The different light levels, from bright to dark, are created solely by diffused light reaching deeper and deeper into the canyon. As the light descends into the canyon it gets both weaker and more colorful. until at the very bottom it turns into a deep reddish glow.

**Gillepsie Dam
Petroglyphs ▶**
*Linhof Master Technika,
Schneider 75 mm,
Provia*

▲ In the photograph shown above, open shade differs from overcast light in that the sun is out, but is not shining onto the objects. Open shade light is warmer than overcast light because bounced light is often reflected into the scene. It is soft and shadowless; one of the best lights for photography.

Color: Tinted light. Intense colors tinted by the color of the surface from which the light is reflected. The naked eye may not see the exact colors, but the film will.

Shadows: No shadows.

Contrast: Low contrast.

Natural Light Type 2 – Overcast Light

Description: Found on cloudy days, this light is both soft and bluish in color. It comes from the entire sky which acts as a diffuser for the sunlight.

Quality: Soft, diffused light. The whole landscape is enveloped in shadows. Shadows, which are by nature bluish, are responsible for the blue cast found in overcast conditions. This cast is often unnoticeable to our eyes but clearly present on color film.

Colors: Tinted light (bluish cast)

Shadows: Soft to nonexistent

Contrast: Low

Recommended film or contrast adjustment: This is the perfect opportunity to use a high contrast and high color saturation film such as Velvia. If shooting digitally, add a contrast-enhancement curve (S-curve) to the file to compensate for the naturally low contrast of digital sensors.

Natural Light Type 3 – Open Shade

Description: Soft, diffused light with very low contrast.

Quality: Soft, diffused light

Colors: Intensely tinted light with a tendency toward blue cast.

Shadows: No shadows

Contrast: Low contrast

Recommended film or contrast adjustment: This is another great opportunity to use a high contrast and high color saturation film such as Velvia. If shooting digitally, add a contrast-enhancement curve to the file to compensate for the naturally low contrast of digital sensors.

Natural Light Type 4 – Backlight

Description: Light coming from behind the object being photographed. Often dramatic and creating a high contrast situation. Watch for lens-flare caused by direct light striking the lens. When direct light cannot be avoided, use a small lens opening (f16 to f22 for 35 mm) to create a star-like effect in the photograph.

Quality: Rim of light around the edges of the subject. Sun star if the sun is in the photograph and the aperture is closed to a small opening such as f16 on a 35 mm camera.

Colors: The light is not tinted. Colors are weak since the direct sun shining through the scene, as well as the high contrast ratio, combines to wash out the color.

Shadows: Shadows are present. They will be oriented towards the camera and will look as if they are moving towards the viewer.

Contrast: High contrast

Recommended film or contrast adjustment: Moderate contrast film such as Fuji Provia or color negative film. If shooting digitally, avoid adding a contrast-enhancement curve to the file. The contrast created by the digital sensor should be high enough.

Natural Light Type 5 – Direct Light

Description: Direct sunlight, from approximately one hour after sunrise and before sunset. Unfiltered by clouds and un-diffused by anything. This is light which is both intense and direct, unforgiving in many ways, revealing the most intricate aspects of the landscape, and casting strong shadows. Usually best avoided in color

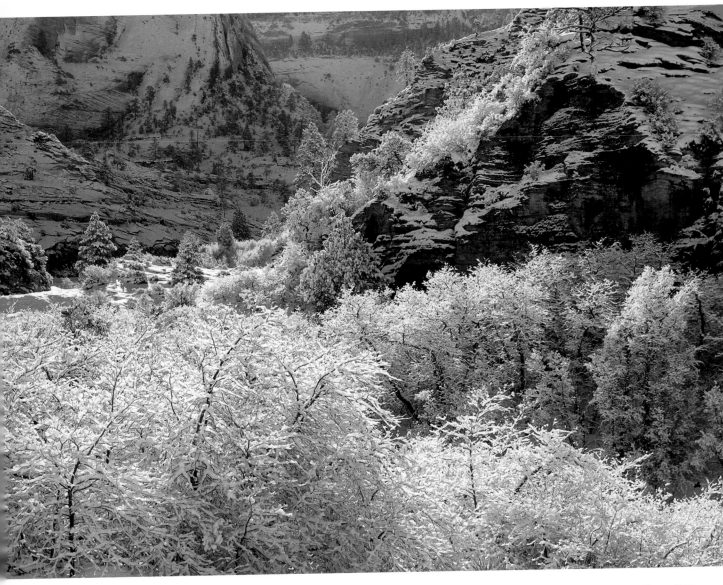

▲ Backlight creates a rim of light around nearby objects in the scene shown above. In this instance, the light partly shines through the semi-transparent snow creating a glowing effect. Taken a few minutes after sunrise, the warm glow of backlight in this photograph mixes with the bluish colors of the shadowed areas to create a complimentary mix of light and shade. Notice the near absence of color in the scene, except for the blue color of the shaded snow areas. Compare the color in this backlit photograph with the color in the side-lit photograph in the next example.

▲ **Zion Snow, Sun, & Trees**
Hasselblad 503SW, Sonnar 150, Provia

photography, it can lead to some interesting results in black and white where color is not a concern and strong contrast is acceptable. Nevertheless, do not discount it completely in color photography as there are instances where it can work great.

Quality: Direct light is both harsh and intense. Glancing light. A polarizing filter is often necessary when shooting at about a 90 degree angle to the sun.

Colors: The colors are not tinted. Direct sunlight washes out the colors in the scene. Expect low color saturation and washed out colors in the final print.

Shadows: Shadows are present. Strong cast-shadows- the darkest shadow, caused by the object's blocking of light from the source.

Contrast: High contrast

Recommended film or contrast adjustment: Low contrast film such as Fuji Provia or Color negative film. If shooting digitally avoid adding a contrast-enhancement curve to the file. The contrast created by the digital sensor should be high enough.

Natural Light Type 6 – Morning and Evening Horizontal Light

Description: The soft, warm, horizontal light of sunrise and sunset. Horizontal because in the morning and in the evening the sun is just above the horizon, casting rays of light that are parallel to the horizon. This is excellent light for photography; especially color photography, due to the combination of low contrast, warm tones, and enveloping quality, causing a strong three-dimensional appearance to the objects in the scene. Objects lit directly by this light seem to glow, as if illuminated from within. Learn to use sunset and sunrise light

for amazing images that can be created at the beginning and the end of the day.

Quality: Soft, enveloping light that is pleasing to the eye. Able to reveal many details of the landscape while retaining some of the mystery in the scene in front of us. A transitional light, at the verge of dusk and dawn, it marks the transition between night and day. Because it changes very rapidly, I recommend shooting continuously, perhaps exposing images every 5 to 10 minutes or so, eliminating the need to second-guess oneself about when the light is at its peak. The images can later be edited in the studio.

Colors: Tinted light with a warm overtone to it. The light at sunrise and sunset is tinted red, orange, pink, or other warm colors.

Shadows: Shadows are present. Shadows are mild at the break of dawn or just before the sun dips below the horizon at sunset; they grow progressively stronger and deeper as the sun rises in the sky or sinks below the horizon.

Contrast: Low contrast when the sun is just above the horizon, but increases as the sun moves higher in the sky.

Recommended film or contrast adjustment: High contrast and high color saturation film such as Fuji Velvia. If shooting digitally it may be desirable to add a contrast-enhancement curve to the file depending on the contrast of each photograph.

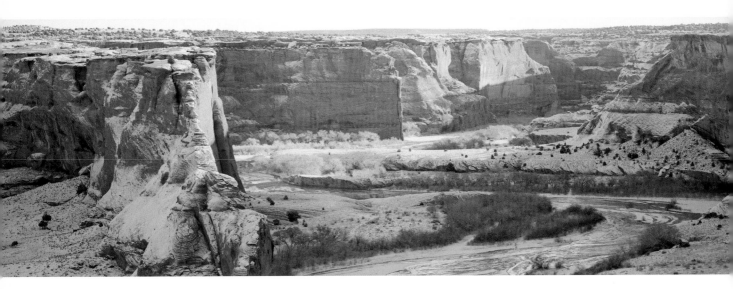

▲ Created at daybreak on the morning after a snowstorm, the photograph shown above exhibits various types of light: sunrise light, direct light, reflected light, and shadow areas. Notice that the snow in the shadowed areas appears blue, while snow in direct sunlight is pure white. Also notice that canyon walls in direct light glow with a warm orange tone, which is quite a different effect from the backlit scene of my previous example in Zion National Park. Light reflected off the canyon walls bounces across the canyon, opening up the shadows and reducing the overall contrast of the scene. Finally, the snow also acts as a reflector, further brightening this scene. Scenes with complex lighting situations such as this one are common when photographing the grand landscape.

▲ **Canyon de Chelly Snow Sunrise**
Fuji 617, Fujinon 300 mm, Velvia

Photographic Skills Enhancement Exercises

Exercise 1
Take photographs using the six different types of light described in this chapter.
Different subjects may be used for this exercise since it may be very difficult to capture the same subject in all six different light qualities. However, if possible, try to photograph the same subject in several different types of light. For example, find a subject that is partly lit directly by sunlight and partly in the shade. Photograph both areas and then compare the two photographs to see how colors, contrast, and shadows differ.

The most important part of this exercise is to bring back photographs showing all the different types of light. Once back in the studio, it will be possible to compare and contrast these six different images. Study them carefully and describe the characteristics of each

light (even write it down). What do we like or dislike about each light? Which light looks best? Which one is our "favorite", or do we have a favorite? Which light would we prefer to work with if we were to create a new series of images with only one type of light? Which light do we like the least and would prefer not to work with again?

Exercise 2
Photograph the same scene from before sunrise to after sunset.

Go to a location of your choice, frame a specific composition, and photograph this same exact composition from before sunrise to after sunset. Ideally, do not move the tripod or the camera. However, if it must be moved (so it doesn't get stolen or to take a break for example) mark the tripod holes (literally) and memorize the framing, so that the tripod can later be placed back in the exact same location. The goal of this exercise is to see how the same scene, and the same exact composition, changes and is transformed by the light throughout the day.

Exercise 3
Construct and use a nigrometer.

What is a Nigrometer? A nigrometer is a tool designed to allow us to see the actual color of objects in front of us. Basically, it is a dark tube with a very small opening at each end through which to look at specific areas of the landscape. Because we are looking at small, selected areas, we are able to isolate them from surrounding areas. This allows us to see the actual color of these areas much more accurately than when we are looking at the whole scene.

How do we build a nigrometer? Simply take a cardboard tube, one and a half to two inches in diameter, and ten to twenty inches long,

such as a poster tube or the core from a roll of kitchen paper towels. A sturdy tube is best as it will not crumple during use. Cut two additional circular pieces of cardboard, the same diameter as the tube, or use the plastic end caps of a poster tube. Punch a small hole, a quarter of an inch in diameter or so, in the center of each end cap. Install these end caps at both ends of the tube by either pushing the plastic caps into place or gluing the cardboard caps onto the tube. Now, the nigrometer is ready to use. If we want to be really fancy, both the interior of the tube and the end caps may be painted black so they do not reflect light.

How do I use it? Hold the nigrometer in front of your eye and point it toward the subject whose color you want to study. The best way to start is to find an area that is partly in the shade and partly in direct light. Look at the shaded area and at the lit area alternately with the nigrometer. It will be noticable that colors in the shaded area are both deep and rich, while colors in the directly lit area are weak and washed out. Follow the same process for other areas for which you want to determine their exact color.

The advantage of using a nigrometer is that it allows us to isolate a specific area from its surroundings and to look only at the color of this area. Since we are looking at a small section of the scene, our eyes are not "mixing up" colors so to speak, and are therefore able to perceive the actual color of a given object. Spend time studying various scenes with the nigrometer. Much can be learned about the actual color of objects in front of us as well as how their color changes depending on different lighting conditions.

When in a rush, we can instantaneously create a nigrometer by closing our fist until only

a small opening remains between our closed fingers, then look at objects through our hand. This approach is very handy once we have gained knowledge of colors and light with an actual nigrometer and we only want to check the color of a specific object in the field.

It may be assumed that the actual color of objects is fairly obvious. It can be obvious if you have acquired the knowledge that a nigrometer will give you. If you haven't, I strongly urge you check the world out through a dark tube with a small opening at each end. You will be surprised at what you will see!

Exercise 4
Read Light and Color in the Outdoors by M.G.J. Minnaert.

In his book, "Light and Color in the Outdoors", M.G.J. Minnaert explains many naturally occurring visual phenomena and how and why they occur. He describes phenomena involving light, including the color of the sky, clouds, mirages, halos, rainbows, the effects of ice in the atmosphere, and much more. This book encourages personal exploration of these phenomena. It teaches how to identify natural lighting phenomena, where and when to look for them, what causes these phenomena, and why some are common while others are extremely rare.

▲ **Light and Color in the Outdoors,** M.G.J. Minnaert

Conclusion

Our success as landscape photographers, regarding our ability to choose the best possible light for individual photographs, greatly depends on our experience. Nature is the best teacher, and there is no alternative to studying and experimenting to develop and refine the experience needed to make the correct lighting choices. In many ways, becoming a master photographer starts with becoming a master of light. In landscape photography this means becoming not only intimately familiar with the different types of natural light, but also being able to predict when and where we can expect to find specific types of light. It also means building experience in working with each type of light so that, when conditions are optimal and time is minimal, we can intuitively work toward a successful image without consciously thinking about the light. Such experience is the result of years and years of practice and one must realize that there are few shortcuts to acquiring this experience. Similarly, there are few tools besides our own eyes to help us in this task. While it is certainly important to carry a spotmeter in order to analyze the contrast of the scene in front of us (more on this in chapter 6, "How to Determine the Best Exposure for a Specific Photograph"), nothing replaces our innate ability to see the scene in terms of quality of light, diffused or direct light, shadows and highlights, colors, and so on. In the end, we are left with what nature gave us along with the knowledge and experience we gathered along the way on the path to creating ever better and ever more exciting images.

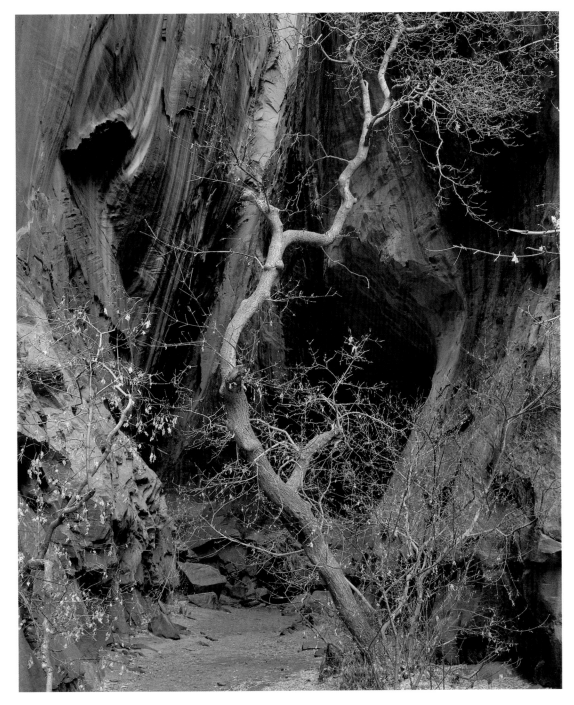

◄ Long Canyon Tree, Escalante Area, Utah
Linhof Master Technika, Schneider 75 mm, Provia

▲ Photographed in overcast light conditions, this image exhibits no shadows and a soft contrast level. A magenta color correction filter was used to remove the bluish cast typically present in such lighting conditions. In direct sunlight, the contrast of this scene would have been too high to reveal details in the background.

How to Select the Best "Film" for a Specific Photograph

A film is never really good unless the camera is an eye in the head of a poet.

ORSON WELLES

All the photographs featured in this chapter are of Spiderock in Canyon de Chelly National Monument, Arizona. I wanted to simplify the comparison of the images I used as examples. While the films and image files are different, the subject remains the same throughout this chapter. Although unrelated to film choice, this approach demonstrates that endless variations of the same subject can be achieved. These photographs were created over the seven and a half year period I lived in Chinle, at the mouth of Canyon de Chelly.

Introduction to Film Choice

Film choice. The subject seems quaint and outdated. "Besides the point", one might say. After all, most of us have done away with film altogether and those who haven't know it is only a matter of time until we do so. While I insist on using film, I do so solely due to the cost and the impracticability of 4x5 digital backs.

I was reminded of how quickly film was fading away from our collective unconscious when I was asked by a teenage photographer, "How did photographers record their photographs before digital capture was invented?" Well, before we shot digitally we used film. And before film we used light-sensitive devices called glass plates and daguerreotypes and, even worse, paper coated with light-sensitive emulsions of various types.

A Look at Photography in History

The ever-increasing portability of camera equipment has redefined what being a landscape photographer means. Today, we go into the field with cameras that are light-weight, have instant capture, are rugged, and are reliable. Of course, we still have to carry equipment, and the weight of this equipment depends on the format we use and on how much gear we choose to take along. However, no matter how we look at it, our job today is a lot easier than it was less than a hundred years ago.

For the earliest American landscape photographers, people such as Timothy O'Sullivan, William Henry Jackson, and Carleton E. Watkins, carrying their equipment in the field meant using a beast of burden rather than a camera backpack. Donkeys and horses were just as important as cameras and lenses. Taking a photograph meant first setting up a tent-darkroom so the glass plates could be coated with the proper emulsion; an emulsion that first had to be mixed, meaning photographing near a water source was primordial. A dry camp meant no photographs. A river or a lake was paramount to a productive and creative opportunity. After exposure, the glass plate had to be developed right away, which meant going back under the tent and doing whatever was required to get an image to appear on the plate. After that, it was either stay at that location for the night, or take down the tent, pack up the equipment, and move on to the next photographic location. We often cover great distances for what many of us do today; driving from one photographic opportunity to the next, shooting digitally without a care in the world, and downloading our images while we drive on.

Another option for early landscape photographers was the daguerreotype. While mostly used for portraits, some daguerreotypes of landscapes were created. Again, the use of a tent-darkroom was necessary, as was the use

of mercury to develop. Typically, a daguerreo-typist (the name given to photographers who used the process invented by Daguerre) developed his daguerreotypes with a cloth over his head, watching the image emerge on a metal plate, while breathing in mercury fumes by the lung-full. Many of these daguerreotypists ended up in mental hospitals, their brains and nervous systems hopelessly damaged by mercury fumes. Interestingly, hatters also used mercury as part of the hat-making process. This practice had equally damaging results to the mental health of the hatter, resulting in the metaphor made famous by Lewis Carroll in *Alice in Wonderland*; the Mad Hatter. Mad Daguereotypist would be just as accurate, but for some reason the term never gained favor. Perhaps if Lewis Carroll had included a photographer in his cast of characters this dangerous aspect of photography would have gained a more widespread reputation.

At any rate here we are: film is dying, digital capture is taking over, and I am writing this chapter about film choice. Have I breathed mercury fumes myself?

Well, rest assured; I am no more (or no less depending on how one looks at it) mentally challenged than I have been in the past. In fact, this chapter is arguably more relevant today than it has ever been. Now that we have digital photography, the choices in regard to "film", i.e. color or black and white, saturation or lack of it, etc., are more important – and more numerous – than they have ever been. Why? Because when we shoot in raw mode with a digital camera we are, technically, responsible for the "development" of our image. We are also responsible for deciding whether we want this image in color or in black and white, and for deciding how much saturation and contrast we desire. In short, we are the lab operator. Let's see what this new digital film reality implies.

Film and Seeing

The first thing to keep in mind about film choice (or raw converter choices as we will soon see) is that these choices start with seeing. Photography is about seeing, as I explained in the first chapter in this book. All the chapters are not only related to each other but they are related to seeing as well.

What we see before we take a photograph influences all the decisions we will later make regarding this photograph. In regard to film choice we need to ask ourselves:
- Do I see this scene in color or in black and white?
- If I see this scene in color, do I see it with low saturation or high saturation?
- If I see this scene in black and white, do I see it with high contrast or low contrast?
- If I see this scene in black and white, do I see it as straight black and white or as a sepia (or other tone) print?

One accessory that will help us to see, in regards to film choice, are viewing filters. The most popular viewing filter is the Kodak Wratten #90. This filter removes all colors from the scene, allowing us to see in black and white. In practice, the filter gives a faint yellowish tone to the scene, but after using it for a while one's mind gets used to it and we see in black and white. We no longer see color, we see only contrast ratios and shades of grey, white, and black. Because black and white is an abstraction – the natural world is in color – seeing in black and white is not necessarily easy. Using a Kodak #90 filter is therefore very helpful. Calumet photographic sells black and white

viewing filters which were originally manufactured by Zone VI studios. Peak also manufactures a black and white viewing filter, as do other manufacturers.

There are also viewing filters for color films. These filters attempt to duplicate the contrast of specific color films. However, with today's digital workflow, contrast is not as much an issue as it used to be. Plus, a filter is an inaccurate way to estimate the contrast level of a scene. A spot meter is more efficient for that. I personally prefer to use my sunglasses to see how a scene will look in color. I wear polarizing glasses so that I can see how the scene will look polarized without having to get my polarizing filter out of my bag.

Of course, if we are shooting digitally, we do not need a color-viewing filter. A look at the LCD screen is enough to tell us exactly how the camera sees the scene in front of us. This is one of the huge advantages offered by digital cameras.

The Importance of Raw Conversion

As we know, if we are shooting digitally our raw file is our latent image and our raw converter is our "film" development. In this respect, raw conversion is more than film development; it is also film choice. It is during the raw conversion process that we decide whether we want our image to be color or black and white. It is also during raw conversion that we decide how much color saturation we want in our images, in effect making choices similar to using a more or less saturated color film in our camera.

Traditionally, photographers have selected color films based on their desire to achieve specific colors in the final print. For example,

Fuji Velvia has been a popular choice among landscape photographers because of its high color saturation and contrast. While the high contrast limits the range of values that can be recorded by Velvia, the highly saturated colors and the faithfulness of these colors offer a trade-off that many photographers consider to be favorable. Kodachrome was favored for its warm colors and its ability to reproduce red tones. Ektachrome was favored when a cooler color quality was desired because of its slight bluish cast.

Other film choices are available. For example, I personally like to use Fuji Provia, a lower-contrast and lower color-saturation film than Velvia, and then I can bump-up the contrast and saturation in Photoshop if I want to. In practice, I rarely do, since I usually favor low contrast and soft saturation images at this time.

Another choice among many, available to film-based photographers, is negative film. Long shunned by publication editors due to the need for prints along with color negatives in order to actually see the "real" colors, negative film is now comparable to transparencies after it has been scanned. When looking at a digital photograph it no longer matters whether an image was created on color positive or color negative film since all digital images are positives. Scanning eliminated one of the challenges of using negative film. The main advantage of color negative films is that, for the most part, they offer a wider range of contrast than positive films. This allows one to capture a much greater range of values and thus photograph in higher-contrast situations. Color negative films also have a lower color saturation, something which can be a plus if we are looking for soft, subtle colors.

Color or COLOR

Now that saturation is no longer a factor of
film alone, or a factor of the digital camera
that is used, the question of how much satura-
tion is desired in an image becomes a matter
of personal taste. "How saturated is saturated
enough?" is a question we each have to answer
for ourselves. Furthermore, it is a question
we can answer in countless ways since we can
endlessly fine-tune the color saturation of a
photograph in Photoshop.

This endless choice means we must rely on
our personal judgment and good taste rather
than on the characteristics set by film manu-
facturers. It also means that if our choices are
not pleasing to our audience (and we do have
an audience, as we will see later) we can no
longer blame the film manufacturers for exces-
sive color saturation or contrast. Instead, we
must take the blame (if there is blame) and the
responsibility for making these choices.

As I said earlier, I personally favor soft,
lower color saturation images. This has not
always been the case. I have had my "Velvia
moments" as I like to say, and I jumped on
the Velvia-Cibachrome bandwagon for a while.
But that is all in the past now. Over the last
few years I have grown increasingly tired of
in-your-face, super-saturated, super-contrasty
images created with a film type that has such
a limited contrast range that it dictates which
light we must photograph with. That doesn't
mean I will never print a highly saturated im-
age. Rather, it means that my current work is
aimed at exploring the possibilities offered
by today's technology, as well as discovering
what can be achieved through subtle and lower
color saturation images.

Let's Use Film (or digital capture); Let's Not Let Film Use Us!

Color transparency films, such as Velvia, in-
crease contrast and color saturation. When us-
ing such a film, a scene that appears dull and
"colorless" to the eye, turns out to have fully
saturated colors when we see the same scene
captured on the resulting transparency.

This characteristic of Velvia, which has been
explored by countless photographers, has in
turn, influenced the choice of light conditions
in which Velvia has been used. Because Velvia
increases both the color saturation and the
contrast of the original scene, it is important
to select scenes that have a low contrast range
and low color saturation. In turn, this means
certain specific natural situations must be
avoided, which, if photographed with Velvia,
will result in blown highlights and overly exag-
gerated colors.

A typical Velvia scene is one of low con-
trast and soft light. The favorite light of many
Velvia photographers is either open shade or
overcast conditions. It also works well in can-
yons where and slot canyons, the tendency is
to avoid including areas of direct light – other-
wise known as hot spots – in the photograph.
Sunsets and sunrises are also favored because
the light is both soft and colorful in the morn-
ing and in the evening, although these shots
are more technically challenging due to their
still-high contrast. A graduated density filter
is often used to compensate for the high con-
trast ratio between sky and land.

The characteristics of Velvia can be used to
our advantage: simply select a scene that ap-
pears flat to the eye, knowing that the film will
significantly bump-up the contrast and the
saturation. If we select a scene that is already
high in contrast, the resulting transparency

will most likely be too contrasty, and may be unpleasant to the eye because the contrast range of the scene is too much for the film to handle.

You may be shaking your head at this point, thinking that what I just wrote pretty much describes the approach most landscape photographers follow, regardless of whether they shoot film (any type of film) or use digital capture. In a sense, you are right. Open shade, overcast conditions, sunrise, and sunsets are ideal condition for landscape photography no matter what equipment is used to record our photographs. But, the problem is that with certain high contrast and high color saturation films, such as Velvia, these are pretty much the only lighting situations in which a photograph can be shot without either blocking the shadows or blowing the highlights.

If we love these types of light, we might be just fine. But if we want to explore other types of light – such as direct light either past sunrise or before sunset – or if we want to include directly-lit areas in canyon and slot canyon scenes, then Velvia will severely limit our endeavors.

What I am trying to express is that we have had, and still have, an entire generation of photographers whose style has been shaped by the use of films such as Fuji Velvia. There is nothing wrong with that. The work of many of these photographers is magnificent and worthy of both attention and praise. But, let us not forget that there is life after Velvia, and that there are other possibilities besides what Velvia excels at. It is these other possibilities that I am currently engaged in exploring, and it is these other possibilities that I want to make the reader aware of. This is not a criticism of "Velvianism", as we may someday come to know this trend, but rather a state-

ment to remind us that these are not the only type of color photographs we can create.

Color or Black and White?

Just as we have to make choices regarding color, we also have to make choices regarding black and white.

Prior to digital photography, this choice had to be made in the camera and at the time of exposure. We needed to use color film for color images, and black and white film for black and white images. It was possible in the darkroom to use a paper manufactured by Kodak called Panalure which allowed us to print color negatives in black and white. However, although the results were at times pleasing, I was never able to match the quality of a fine black and white print (which today has come to be known as a Silver Gelatin Print) made from a properly developed black and white negative.

Today the choice of color or black and white can be postponed, and in effect often is postponed, until the image is in the computer. With film, I wait until after scanning the image to turn it into a black and white file, if I so decide. With digital, this choice is done during the raw conversion process. With both Photoshop Raw and Capture One it is possible to see thumbnails in black and white allowing us to have a 100% black and white workflow. With Photoshop Raw we simply set the sliders to the black and white settings which yields a pleasing result. With Capture One we do the same, then we save these settings as a profile and then select this profile as default.

Whichever methodology we follow in order to create a black and white file, we eventually face the decision of whether or not we want to have a black and white image instead of a

▲ The original color photograph is at left. The black and white version on the right was created in Photoshop. I thought I would like it better since there is so little color in the original. However, I never printed the black and white version. It turns out that the little bit of color is an essential part of the image; remove the color and the image loses its unique quality.

▲ **Spiderock in Snowstorm,**
Color and Black & White Versions

color image. Color can be so compelling and color reproduction so accurate, that removing color is not only difficult, but is often not even considered. However, black and white is a serious option for photographers, an option that allows us to do what color cannot do.

I have often noticed that good color images are also good black and white images. To see

this for ourselves, we can simply look at a color photograph with a Kodak #90 filter. My explanation for this fact – that good color photographs are also good black and white photographs – is that good photographs have good composition. Composition is, in a sense, the "backbone" of a photograph – the supporting framework. Because composition relies on the

placement of objects in the scene, on leading lines, and on perspective, it is by nature not linked to color per se. Rather, composition is to photography what drawing is to painting. While paintings are done in color, drawings are done in black and white or sepia. Many painters draw sketches before they begin painting. Their drawings are aimed at defining a compositional arrangement. Composition is a line-based, element-organization process, and by nature, a black and white process. What is vital to good composition is not color, but shapes, forms, lines, and objects arranged in a pleasing and depth-creating fashion.

Of course, a composition may be created based on color; a composition where color is not just "an" element of the scene but is "the" element of the scene. However, I will be so bold as to say that color-based compositions are the exception rather than the rule in landscape photography. In my experience, color-based compositions define a personal style rather than an established approach that anyone can follow. Why? Because of the fact that color-based compositions in nature are quite difficult to find. With man-made objects, color can be the main element. A wall painted in bright colors, a set of dishes each of a different color, and multicolored garments pinned on clotheslines, are just a few of the examples that come to mind. In nature, color is rarely the main element. Instead, color is often one of the accompanying elements. The main element or the backbone of the drawing of a natural scene is usually something other than color. It is the trees, the rocks, the mountains, the canyons, and a myriad of other natural objects.

I am sure that this point can be further debated and not everyone will agree with me.

Whether you agree, disagree, or do not have a definite opinion on the matter, I do encourage looking at color photographs through a Kodak #90 filter. There is something to be learned from doing so.

Duotones, Tritones and Quadritones

I encourage exploration of the alternatives to pure black and white images that are offered by Photoshop – namely duotones, tritones and quadritones. These are images in which more than one tone of ink is used to create a subtle hint of color. In pure black and white, and when printing with ink, only black ink is used (either pure black or various shades of lighter and darker blacks) In duotones, tritones and quadritones, medium gray may be replaced with magenta, and white may be replaced with yellow, resulting in a sepia tone image. In a duotone, two colors of ink are used. In tritones, a third color is added, and in quadritones a fourth color is added. The combinations of colors are endless, and open a wide field of experimentation for creative endeavors. This is certainly an area worth exploring if one is so inclined. A set of predefined duotone, tritone and quadritone curves is provided with Photoshop. Each of these curves can be altered to one's liking to create a customized set of curves. Sepia is only one of many possibilities.

Here are the settings I used to create the sepia images that appear in Practice Exercises #2 later in this chapter. ▶

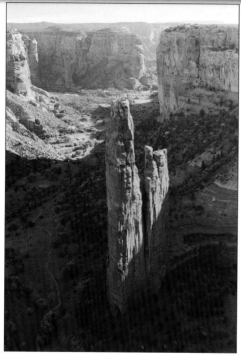

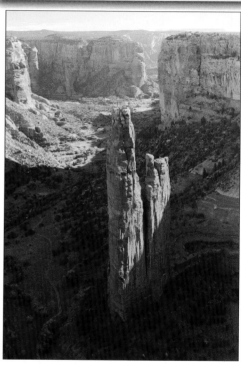

Film Speed

Film speed is rarely an issue in landscape photography and this is why I have waited until now to discuss it. In my case, and in the case of most landscape photographers, I use either the lowest, or one of the lowest, film speeds available. Currently, I use Fuji Provia which is an ISO 100 film. Velvia is an ISO 50 film, however the grain difference between these two films is minor. An ISO 100 version of Velvia is also available, with hardly any additional film grain when compared to the original ISO 50 Velvia. As a rule, in landscape photography the slower the film, and/or the less noticeable the film grain, the better.

Another rule that I personally follow is to use the same ISO for all my films, if I use different film types. For example, if I use both color and black and white film, I will use an ISO 100 black and white film, such as Kodak T-Max 100, in conjunction with Fuji Provia.

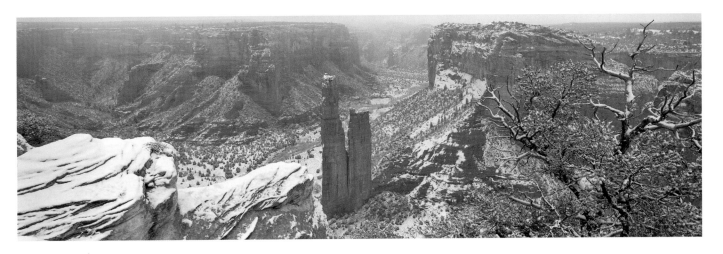

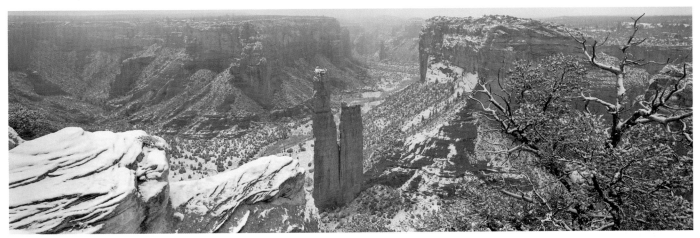

▲ Here, the original image is a color transparency. I created the black and white version solely for the purpose of using it here as an example. While the color image is displayed in my home as a 5 foot long panorama, I have no intention of printing the black and white version. The comparison of these two images is worthwhile nevertheless.

▲ **Spiderock Snowstorm Panorama**

Or, if I use both color negative and color positive films, I will use an ISO 100 color negative film and an ISO 100 color positive film. The reason for this choice is to avoid getting confused when calculating the exposure for either film. Having the same ISO means I can set my meter to that particular ISO once and for all. In my case, I hardly ever move the ISO setting on my light meter. Having several film types with different ISO numbers means there is a chance of forgetting to make the necessary adjustment and either overexposing or underexposing at least one of the two films. Of course, if only one camera or camera back is used, or if the camera has DX coding abilities, this is

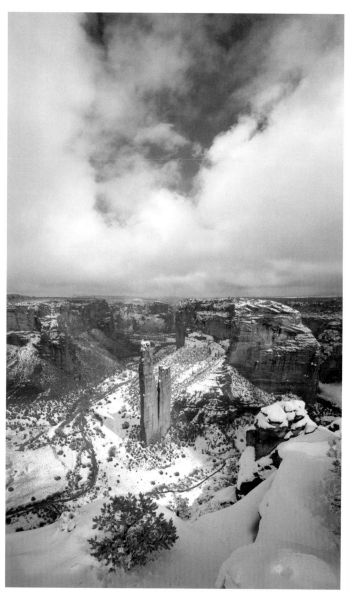 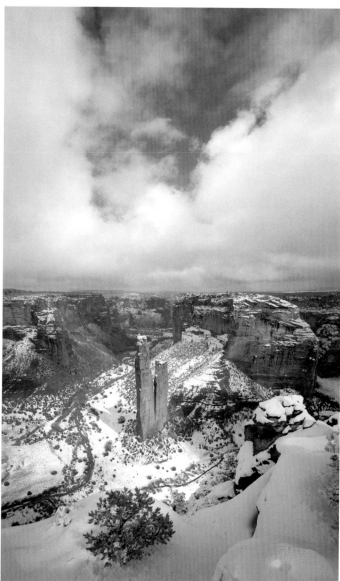

▲ The original image is a color transparency. I transformed it into a grayscale file in Photoshop. Although I photographed in black and white for years, I have more and more difficulty finding as much visual enjoyment in black and white than I do in color. In this case, I have never printed the black and white version.

▲ **Clearing Winter Storm over Spiderock**

not an issue. But, if a handheld light meter is used, like I do with 4x5, it is a definite concern.

With digital capture the issue of film speed is very different since the film speed can be changed "on the fly" and in "mid-card" while shooting. At the push of a button and a twist of a dial, there we are: ISO 1600 instead of 100, while the light level is going down and we need to photograph hand-held. Also, the best digital cameras have little loss of quality between ISO 100 and 400 (and sometimes higher).

However, unless there is a need for higher shutter speeds, it is a good idea to continue using ISO 100 as the standard setting. We do get, even if marginal, a small quality gain. And, for landscape work, unless we are photographing hand held, we normally use a tripod, which means that shutter speed is not an issue. If a tripod is not being used, start using one! Doing so will definitely improve image quality.

Photographic Skills Enhancement Exercises

Conducting the following exercises will help build knowledge in regard to "film choice". These exercises will help in the visualization of what film, or RAW conversion software, can do in terms of transforming (literally) a specific photograph into an entirely different photograph.

Exercise 1
Take the same photograph, with the exact same composition, in both color and black and white. Use a Kodak #90 filter to preview the scene in black and white prior to photographing it. Look for a scene that looks good in both color and black and white. Make sure to take

the two photographs one right after the other so that the light and the clouds are the same in both images.

With film, switch films (or use 2 camera bodies or backs). With digital, transform the RAW file to black and white in the raw converter software. Compare the two photographs to see how the same scene looks in color and in black and white. Decide which one you like best.

Exercise 2
Starting with one specific photograph, create as many color, black and white, and sepia variations as possible. With film, scan the color original, then turn it into a black and white image and a sepia image first. If black and white film was used, bypass the conversion to black and white. Create different sepia variations by adding more or less of a brown tone to the print. Explore the possibilities offered by duotone and tritone and quadritone conversion. The exact process of converting to a duotone, tritone or quadritone is beyond the scope of this book, but the Photoshop manual offers good information on this subject. Finally, going back to the color file, create variations using different levels of color saturation. Try a very saturated image and see how far it can be pushed without making the image overly saturated. Also try a desaturated version and again see how far it can go without making the image black and white. Save each version, print them all in roughly a 5x7 size, and compare the prints. Find out which one you like best and which one you like least. There is no limit to the number of variations that can be created. Also, notice how some variations may be so close to each other that there is no significant difference.

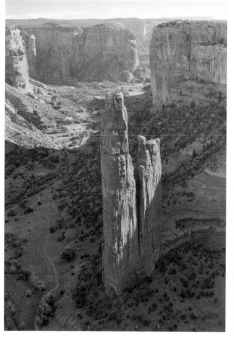

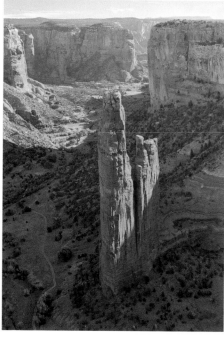

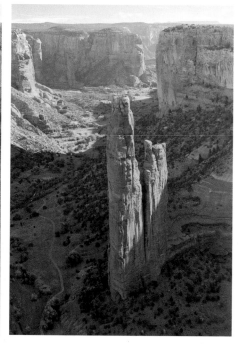

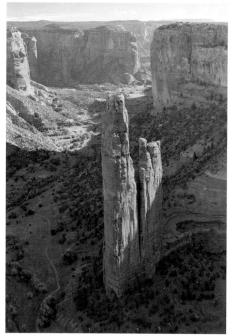

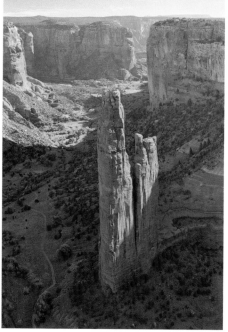

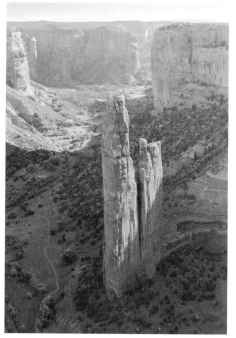

▲ **Spiderock in the Spring at Sunrise**

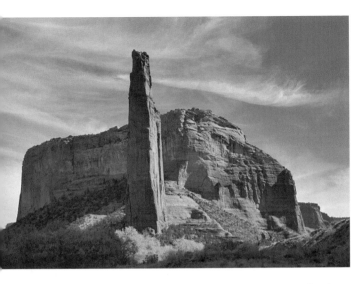

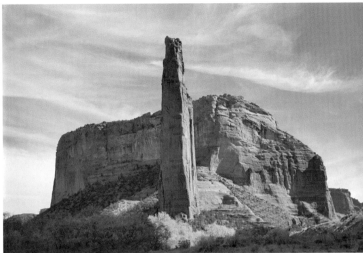

▲ I created a black and white version of the original color transparency. While I love color, sometimes black and white is just as pleasing. However, deciding which one I like best can be difficult.

▲ **Spiderock from the floor of Canyon de Chelly**

◄ Six variations from one original color transparency. The original image is at the top left of this series. The other 5 images are variations created in Photoshop by either increasing or decreasing color saturation, creating a grayscale image, and creating two sepia tritone images. An endless number of alternate variations are possible.

Conclusion

Which "film" to use is as relevant today as it was when film was the only choice. This is because film meant, and still means, which kind of photographic images we want to create. We make choices regarding "film" unconsciously, whether we know it or not. These choices are made when we convert an image from Raw to Photoshop, when we adjust scanner settings, and when we fine-tune an image for printing. Knowing why we make these choices, and how to make the appropriate choices to achieve a specific result, will no doubt result in better images. It will also result in images whose final appearance is under our control rather than under the control of the film, the camera, or the software being used.

How to Determine the Best Exposure for a Specific Photograph

My true program is summed up in one word: life.
I expect to photograph anything suggested by that word which appeals to me.

EDWARD WESTON

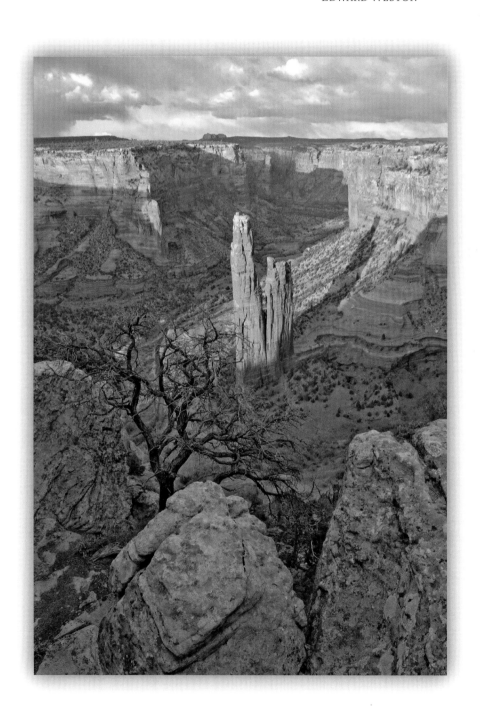

Introduction to Exposure

Exposure. The word contains a certain notion of risk and a certain amount of irremediable commitment. Once the exposure has been set on a camera and the subsequent photograph taken, there is no way to physically change this exposure. We are done, set, and must live with the consequences. Hopefully the exposure is "right on" and the photograph holds detail everywhere.

What if the photograph does not hold detail everywhere? What if the calculated exposure is not absolutely, 100% correct? What if the calculations were off? What if a mistake was made? Then what? Is there a way out, a way back to a great image despite the fact that it could have been done better in the field exposure-wise?

More importantly, in order to avoid post-photographic-exposure stress, how can one calculate, with absolute accuracy, the perfect exposure each and every time in the field?

So many questions and, I am afraid, so few answers. Exposure isn't the most widely discussed subject in photography. Articles on exposure are rare and many photographers skirt the issue. This should not come as a surprise. Exposure isn't rocket science. There is a certain amount of leeway, adjustment, and artistic interpretation involved.

Let's take a closer look at this aspect of photography that is rarely examined. And let's try to relax and have fun in the process. After all, poorly exposed photographs are not dangerous. They are just annoying and disappointing. The good news is, we can expose other photographs, and hopefully improve our skills after reading this chapter.

The Importance of Proper Exposure

Exposing each photograph properly is of utmost importance in order to get the best print possible from a single image. This is because, whether film or digital capture is used, the original film or digital image contains all the available information one will ever get of the scene that was photographed.

Ansel Adams was originally trained as a professional pianist. He often made comparisons between photography and music. In regard to exposure, he compared the negative to the score, and the print to the performance. Today, we can extend this score to transparencies and RAW files. The performance (the print) has not changed; neither has the overall idea behind Adams' comparison. The better the score, the better the performance will be.

In order to get the best possible "score", the maximum amount of information from the scene being photographed must be recorded on film, or on the RAW file. Ideally, it is desirable to have detail everywhere in the image. Since the two most important areas of the scene are the shadow and highlight areas, we want to make sure there are details in both.

The problem is that getting detail in both shadow and highlight areas is difficult. This difficulty stems from the contrast range that can be captured by the specific film, or digital sensor, being used. This contrast range, which is measured in f-stops, varies from film type to film type and from one digital sensor to another. From this statement, we can already deduce one of the most important tenets of exposure: in order to properly expose film, or a digital file, the contrast range must be known.

Gray Cards, Overexposure, and Underexposure

Before proceeding any further it is necessary to explain some of the terms commonly used when discussing exposure.

Gray Cards

A gray card is a card painted a medium shade of gray. These cards are available from Kodak. Gray cards have precisely an 18% reflectivity, meaning they reflect 18% of the light that falls on them.

This is important to know since light meters all over the world, regardless of the manufacturer, are calibrated to give an 18% gray reading. This means that reading a uniform surface and photographing it without adjusting the exposure given by the meter will turn any surface into an 18% reflectivity gray surface. Even when a photograph is taken of a solid black or white surface, it will become 18% gray in the photograph.

In other words, a light meter is simply a machine designed to render the world 18% gray and calculate each exposure accordingly. To get a lighter or darker photograph based on the reading from a light meter, the exposure must be adjusted accordingly and either be overexposed or underexposed. Relying on what the meter tells us will result in an 18% gray photograph of every surface photographed!

Photographing in black and white will actually get a medium, 18% shade of gray. When photographing in color, the resulting image will have a color equivalent to an 18% reflectivity; it will not be gray, but it will have the same reflectivity as an 18% gray card.

Many cameras today calculate the exposure and then compare the scene in front of them to a database of thousands of photographs pre-recorded in the camera's digital memory. Such cameras do not blindly follow what their light meter tells them. Instead, they compare the exposure provided by the meter to correct exposures for similar scenes pre-calculated and recorded in the camera's built-in database. They then adjust the final exposure accordingly. These cameras will deliver a much higher percentage of correct exposures. However, in extreme exposure situations, it may still be necessary to make exposure corrections manually.

Overexposure

Overexposure is the process of exposing a photograph more than what is advised by the light meter (either in-camera or hand-held). In other words, we do not follow what our camera tells us. Instead, we are making a decision and saying "I don't think the exposure my light meter tells me to use will result in a properly exposed photograph, hence I will change it and expose more than what the meter is telling me."

Overexposure results in a brighter image.

Underexposure

Underexposure is the process of exposing a photograph less than what the light meter advises. Again, we are not following what the meter is telling us. This time we are making a decision to expose less than what the meter is saying.

Underexposure results in a darker image.

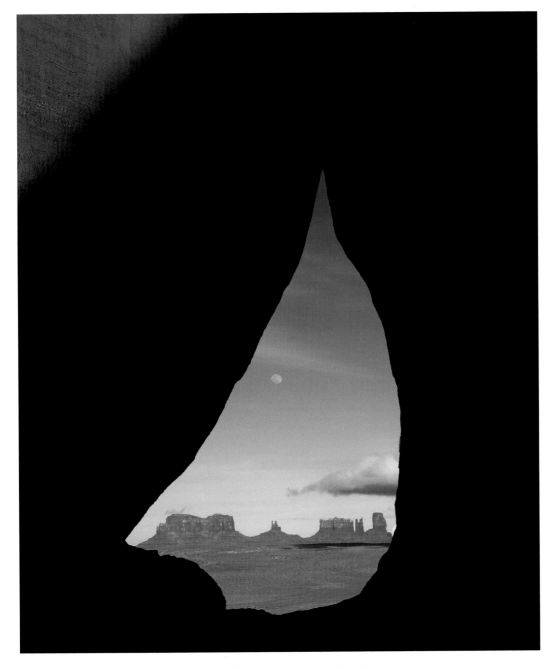

◄ Tear Drop Arch Moonrise, Monument Valley, Utah

Linhof Master Technika 4x5, Rodenstock 210 mm, Fuji Provia F

▲ This photograph could have easily been overexposed had I used an average meter reading of the scene. To hold detail in the moon and clouds I had to considerably underexpose the arch.

There is actually some detail on the arch but I decided to print it pure black, except for the triangle of directly-lit rock at the top left corner, to emphasize the stark quality of this scene.

How to Determine the Contrast Range that the Film or Digital Camera Can Capture

This brings us to our first exercise in this chapter: determining the contrast range of the film(s) and/or digital cameras we are using. Here is how to conduct this test with either film or digital capture:

- Find a uniformly lit and colored textured surface. A wall that has a texture to it and is in open shade may be used. Choose a wall that isn't painted in a dark shade. Ideally, this wall should be a medium gray or as close to medium gray as possible.
- Get as close to the chosen surface as possible so that only this surface can be seen in the viewfinder. Nothing else should be in the photograph.
- Take a photograph at the reading given by the camera. That is the exposure setting the camera, or the light meter (if a hand-held meter is used), says is "correct".
- Take a photograph underexposed by one stop, two stops, three stops, four stops and five stops. For those who are not familiar with how to do this, instructions can be found in the camera manual .
- Take a photograph overexposed by one stop, two stops, three stops, four stops and five stops. Again, for those who are not familiar with how to do this, consult the camera manual.
- If film was used, have the film developed normally by the lab. Do not ask for any compensation of any kind during film development. Do not scan the film.
- If digital capture was used, import the RAW files in the RAW converter and do not adjust the exposure compensation whatsoever.

Make no adjustments in the RAW converter. Simply convert the images and open them in the image editing software.

- Look at the film (transparencies or negatives) on a light table and look at the RAW-converted files on a closely calibrated monitor. There should be 11 images to examine. One exposed "correctly", five overexposed, and five underexposed.
- Look for images that are either so light or so dark that they do not show any detail (any texture) on the film or on the monitor.
- Once the images that have detail in them have been determined, count them. Count only those that are underexposed or overexposed. Do not count the one that shows the exposure given by the meter.
- If there are 6 images showing detail (not counting the "correctly exposed" image) it means the film or digital sensor is able to record a 6-stops range. If there are 5 images with detail, a 5-stops range can be recorded, and so on. The results will vary from film to film and sensor to sensor, as was previously mentioned.

For example, I use almost exclusively Fuji Provia 100F. I know, from conducting the test I just described, that I can safely record a range of 5 stops: 3 under and 2 over. Your own tests will show the exact contrast range that your film or digital camera can record. Knowing this allows us to get a lot closer to finding the optimal exposure for a specific scene.

To calculate the optimal exposure, do the following:

- First, measure, either with the camera or a hand-held meter, the darkest and lightest areas of the scene being photographed.

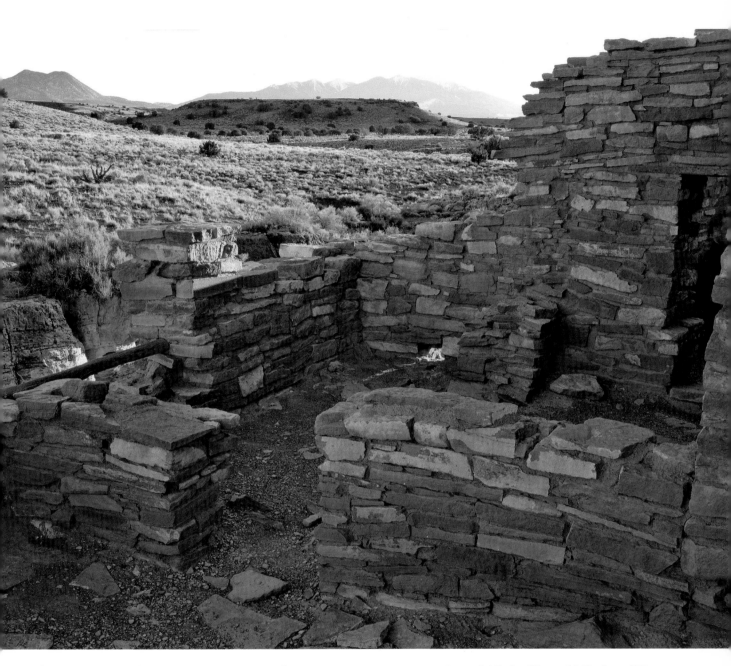

▲ This photograph shows an extreme range of contrast from the shaded part of the ruin to the mountains and the sky. I had to almost overexpose the mountains to get detail in the ruin. I could not have calculated the exposure correctly had I not known precisely the contrast range of the film I was using.

▲ **Lomaki Ruin, Wupatki National Monument**
Linhof Master Technika 4x5, Rodenstock 150 mm, Fuji Provia 100F

Using a spot meter will make this process much easier.

- Second, calculate how many stops are between the darkest and lightest area of the scene. For example, if the shadows measure at f2.8 at 1/60th of a second, and the highlights measure at f.16 at 1/60th of a second, there is a 5-stop contrast range in the scene being photographed. Keeping either the f-stop or the film speed constant will make this calculation a lot easier. In this example I kept the speed constant, using 1/60th of a second, and changed the f-stops.
- The f-stop and shutter speed scales will need to be memorized. Here they are:

f-stops:
f1 – f1.4 – f2 – f2.8 – f4 – f5.6 – f8 – f11 – f16 – f22 – f32 – f45 – f64

shutter speeds:
1/500th – 1/250th – 1/125th – 1/60th – 1/30th – 1/15th – 1/8th – 1/4th –1/2 – 1 sec – 2 sec – 4 sec – 8 sec– 16 sec – etc.

Each of the settings on either scale are one stop apart. Going up or down from one setting to the next means either overexposing or underexposing by one stop.

On the f-stop scale, changing to a higher number means underexposing, and changing to a smaller number means overexposing (provided the shutter speed is not changed).

On the shutter speed scale, a smaller number means overexposing, and a larger number means underexposing (provided the f-stop is not changed).

The Power of the Histogram

Digital capture introduced a new tool in the quest for the perfect exposure: the histogram. With a histogram available on the camera we have much more than just the proper exposure settings. We also have the result of setting the camera at a specific exposure. What the histogram shows and tells us is:

- What will happen to the range of contrast when the scene is recorded digitally
- Where the different exposure value areas will fall
- If all the elements of the photograph will be recorded with detail

In this respect, the histogram is the best thing to happen to photographers since the invention of the light meter. A histogram does not replace a light meter, as we still need a meter to calculate the exposure. But the histogram gives us what could previously be seen only in the darkroom, or after scanning, and that is a map of where each area falls.

Histograms come in two styles: monochrome and tri-color. Monochrome histograms show where the brightness values are located on the photograph. Tri-color histograms show how the brightness values of the three primary colors – red, green, and blue – are recorded. Tri-color histograms allow the photographer one additional level of control, since the red, green, and blue channels of a digital image are visible, and thus each of the three channels can be monitored prior to shooting the photograph. Since the light level of red, green, and blue objects is often different, this control is very important.

Exposure for Digital Captures

Digital capture, either from a 35 mm digital camera, medium format back, or large format scanning back, revolutionized the way in which we calculate and expose photographs. In regard to calculating the exposure, digital capture made things much simpler, although knowing the basic tenets of exposure, as I explain in this chapter, is still very important.

In short, with a digital camera, a light meter is not needed, unless one is wanted for personal reasons. The light meter is now the histogram, so to speak. Furthermore, there is no need to wait for the film to come back from the lab to see how well (or poorly) exposed a photograph is. All that is needed is to look at the preview image on the LCD screen and the results of one's artistic endeavors can be seen right there, seconds after capturing the image.

Personally, when I use a digital camera, I set the expose mode to aperture control and start by taking an exposure at the speed recommended by the camera. Since I nearly always use a tripod, and since my concern is with depth of field and getting everything in focus, it makes sense that I want to choose the aperture and let the camera decide on the shutter speed.

After this first capture is completed, I look at the results on the LCD screen, paying close attention to the histogram. My goal is that the histogram captures all the range of values in the scene, from the shadows to the highlights. With this goal in mind we may encounter the following four situations:

1 – The complete range of values is captured on the first attempt.

It is rare to capture the complete range of values on the first attempt, but it can happen. If it does happen, great – our job is done. We simply make sure that the histogram does not show values clipped either to the right or to the left side. In the examples shown on page 85, you will find screen shots of histograms that have captured all the values in a scene.

2 – The histogram is clipped on the left side, meaning that the camera did not record some of the shadows.

This may be ok if we don't need shadow detail. For example, we don't need detail if we want shadows to be completely black. However, if we want detail in the shadows, we need to overexpose the image. e must be careful not to overexpose too much, otherwise the histogram will get clipped on the right side and detail in the highlights will be lost.

3 – The histogram is clipped on the right side, meaning that the camera did not record some of the highlights.

This is rarely acceptable, except in instances where an extremely bright light source or specular reflection is included in the photograph. Otherwise, it is desirable to have detail in the highlights. To achieve this, the photograph needs to be underexposed. However, be careful not to underexpose too much, otherwise the histogram will be clipped on the left side and detail in the shadows will be lost.

4 – The histogram is either clipped on both right and left sides, or just touches one side and is clipped on the opposite side.
In this instance, there is no way to record the full dynamic (brightness) range of the scene in one capture. The only solution is to take two photographs, one exposed for the highlights, and one exposed for the shadows. Later both images may be merged into a single image in Photoshop. (This method is expanded upon in the section below on "High Contrast Remedies".)

The Importance of Shooting RAW

One thing must be said in regard to digital capture for fine art photography, and that is the importance of capturing the digital image in RAW format. A digital camera can capture either RAW files or JPEGs. JPEGs are compressed images, with a reduced contrast range. JPEGs are essentially used to reduce storage space and file size. Essentially, they are favored by sports photographers and by other photographers for whom shooting fast and keeping the file size small are very important.

For the landscape photographer, shooting fast and keeping the file size small are of secondary importance. Our primary concern is getting the finest image quality possible, and for this RAW is the answer. Firstly, a RAW file in uncompressed, meaning no information is lost due to compression. Secondly, the dynamic range of a RAW file is far greater than that of a JPEG, meaning we can record more detail in highlights and shadows. Thirdly, and most importantly, we do the conversion from RAW to a tiff or Photoshop file, meaning we have control over each and every aspect of this conversion, including brightness, color, hue,

saturation, shadow detail, etc. The RAW file can be saved and made into a different conversion in the future, when new and better RAW conversion software is introduced.

With JPEGs, this conversion is done within the camera, using parameters chosen by the camera. In other words, when shooting JPEGs, creative control is given to the camera instead of allowing the photographer to enjoy the creative control.

Exposing to the Right

Digital cameras also changed the way exposure is approached. With transparency film, the concern was to protect the highlight, and therefore the solution was usually to underexpose slightly. This is because there is very little that can be done to recover overexposed highlights with transparency film.

With digital capture the situation is very different because we are dealing with levels of information in a RAW file, rather than with grains of silver exposed to light. Digital capture basically records information on a 0 to 256 scale for an 8-bit file. Zero represents a pure black shadow, while 256 represents a pure white highlight.

Two very important things have to be explained at this point. Firstly, the higher the number of the level, the more data is being captured. Secondly the information is captured on the 0 to 256 scale is not permanently fixed because this information can be moved to a higher or lower level at will. What cannot be done, is to later increase the amount of data that was captured at the time of exposure.

How does this translate into properly exposed digital captures? Simple. The goal is to capture as much data as possible, because

Some Examples of Common Histograms

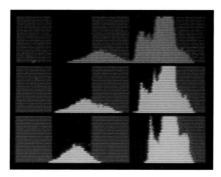

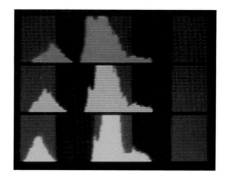

▲ A single-channel histogram from the Canon 300D. A single-channel histogram is an average of the three color channels (red, green, and blue). While the histogram shows no clipping in the highlights (right side) there could be clipping in one of the three-channels. The only way to know for sure is to have a three-channel histogram, which is a much more reliable way to tell if the image is clipped or not.

▲ A tri-channel histogram from the Canon 1DsMk2. This histogram shows a properly exposed photograph, with detail both in the shadows and highlights. Furthermore, this photograph was exposed to the right, as demonstrated by the shadows having been moved away from the left side. The tri-color histogram clearly shows that not all three-channels have received the same amount of exposure. The blue channel extends way further to the left than the red channel, for example. If we had a single-channel histogram to evaluate this image, we would basically be looking at the equivalent of the green channel because it is in between the red and blue channels in exposure and therefore is very close to being the average of all three-channels. In that case, and if we placed the green channel all the way to the left, we would be clipping the shadows in the blue channel.

▲ This histogram, while capturing detail in both shadows and highlights, was not exposed to the right, thereby lowering the quality of the data in the shadows. There is no doubt here that shadows in this photograph will have a lot of noise in them. Since there is room to the right, it would be better to "expose to the right" in order to capture more data.

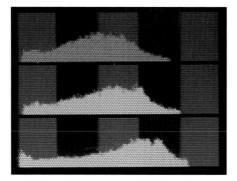

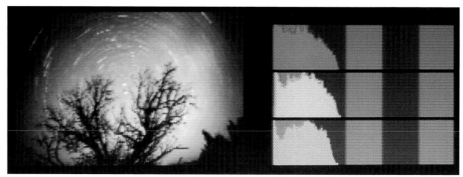

▲ This histogram shows definite clipping of the shadows. This photograph will not have any detail in the shadows. Here too, since space is available on the right side of the histogram, exposing to the right would have given detail in the shadows.

▲ This photograph shows an even more dramatic shadow-clipping situation. However, because this is a star trail photograph, we expect shadows to be completely black. After all, it is night! Therefore, in this instance this is not a problem. In fact, because the exposure is done on bulb mode and for a very long period of time, there is virtually no way to expose to the right.

▲ Here is the histogram of a photograph that was clipped both in the shadows and highlights. This is a sunset scene looking straight west towards the sun, an extremely high contrast situation. In this situation, the only way to get detail in both highlights and shadows is to take two photographs, one exposed for the shadows (overexposed) and one exposed for the highlights (underexposed), and then merge them into a single image in Photoshop.

▲ Here is the histogram of a perfectly exposed photograph. The shadows have been adequately moved to the right by overexposing slightly, yet the highlights are not clipped, in fact there is additional space available between the highlights and the right side of the histogram. The photograph is brighter than it should be, and looks overexposed and desaturated, but this is not a problem, as it will be easily fixed during RAW conversion and/or in Photoshop. To see a photograph with proper brightness and saturation in the field, all that is needed is to take a "visualization" capture by underexposing by 1 or 2 stops. Just make sure not to use this visualization capture during RAW conversion! It may look better on the LCD screen, but the image quality will definitely be lower.

where no data is captured the camera fills the "empty" space with noise. In short, information captured low on the 0 to 256 scale, contains a lot of noise and digital artifacts. This may be acceptable if one plans to print these areas solid black, but if these areas are opened up they will reveal noise and artifacts instead of photographic detail.

The solution is to record the image as high on the 0 to 256 scale as is possible without clipping the highlights. In practice, this results in "exposing to the right", a term coined by Michael Reichmann describing the process of moving the data in the digital capture to the right side of the histogram, so that more data is captured.

How is that done? Simple: by overexposing the photograph until the data nearly touches the right side of the histogram. With a low contrast image, we may be able to overexpose substantially. With a high contrast image, we may be able to overexpose only slightly, or not at all. In this situation, if the goal is to avoid noise in shadow areas, a second, overexposed photograph may be shot to increase the amount of data captured in the image. Later these two photographs can be merged together in Photoshop.

While exposing to the right, keep in mind that where the information is recorded on the scale is not important. What is important is that all the desired information is recorded and that this information contains as much data as possible, which means that it is recorded as far to the right of the histogram as possible.

Of course, when doing so the photograph will appear too bright on the LCD screen. That

is because it was purposefully overexposed. Don't let that bother you. The photograph is fine! Later on, when converting the photograph and/or optimizing it in Photoshop, we will have the opportunity to lower the brightness of this photograph to make it appear the way you want it.

However, if we want to see a non-overexposed image in the field, we can simply take a "visualization" capture by underexposing the image. This visualization capture will have low quality data in the shadows, but will display properly on the LCD screen, allowing us to make a call about the color and composition of the photograph. Just be sure not to convert this image later on and not to use it to create a fine art print!

Bracket, Bracket, Bracket

For years, photographers have used a simple remedy for the difficulty of determining the perfect exposure: bracketing. Bracketing refers to the widely used practice of taking several photographs of the same scene, each with a slightly different exposure, in the near-certain hope that one of these exposures will turn out to be right on.

With film, bracketing carries a cost equal to that of the film, plus development, plus storage supplies (and possibly scanning if the photographs are digitized). With digital, bracketing is nearly free, the cost being only that of digital storage, effectively amounting to pennies per photograph. While a large amount of bracketing may be a concern with film, due to cost, it should not be a concern with digital capture. All that is needed are plenty of storage cards and the availability of a digital wallet (or a laptop) to download the cards when they are full.

Bracketing shows that empiricism is still a valid approach. It also shows that despite the continual improvements in equipment, technique, and methodology, a certain amount of guesswork remains.

Bracketing also offers a universal remedy to exposure difficulties. All that is required is to "get in the ballpark", to use one of the many baseball metaphors found in the American language.

Personally, I bracket with both film and digital capture. With film, the cost of the extra film is worth the peace of mind I get. With digital, cost is no longer an issue and bracketing becomes second nature in situations where finding the correct exposure is either challenging or overly time-consuming.

In practice, I normally bracket one stop over and one stop under my calculated exposure. I may bracket in full stops or in half stops. For example, if my calculated exposure is f.22 at 1/4th of a second, I will make an exposure at this setting, one exposure at f.22 and 1/2th and one exposure at f.22 and 1/8h. This way I have a two stops bracketing the range which, in nearly all situations, assures me I will have at least one properly exposed image.

With digital capture it is recommended to "expose to the right", as Michael Reichmann says. This approach stems from digital cameras being able to record more information in the high values than in the low values. Exposing to the right means overexposing the image. How much? As much as it takes to place the highest value all the way to the right of the histogram without going exceeding it. It also means bringing the exposure level down in the RAW conversion software which will bring the image back to a normal exposure. The gain

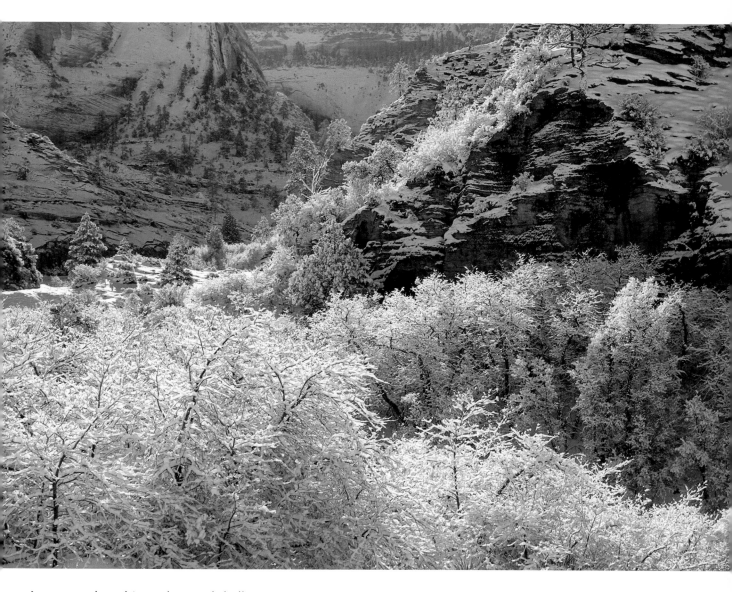

▲ A scene such as this can be a real challenge to meter properly. I actually took only one exposure and got it right because I knew that I wanted the shaded snow area medium gray. Therefore, I took a spot meter reading of the shaded snow area at the top left of the photograph. As a result, the cliff in the top right of the image is darker and the snow covered trees in direct sunlight are nearly white, just the way I wanted it. This scene is a perfect candidate for bracketing if one is not 100% sure what the proper exposure may be. It is better to be safe than sorry.

▲ **Winter Sunrise,**
Zion National Park, Utah
Hasselblad 503CW, Zeiss 150 mm, Fuji Provia 100F

is better image quality, especially in the mid-tones and shadows, where additional information was recorded through overexposure.

When exposing to the right it is important to keep in mind that each image is composed of three channels (red, green, and blue) and that brightness levels are different in each individual channel. If the camera has only a single-channel histogram, extra care must be taken when exposing to the right since one or two of the individual channels may be accidentally overexposed. Ideally we want to use a camera which has a three-channel histogram, since only a three-channels histogram will show what is happening in each of the red, green, and blue channels.

When I expose to the right with a single-channel histogram camera, I also take another photograph underexposed by one stop, and sometimes, a third photograph underexposed by two stops. Why? Firstly, because this assures me that I will not accidentally clip one of the individual channels and that I will have an image in which all the information is recorded; secondly, because there is no extra cost; thirdly, because it takes hardly any additional time to do so; and fourthly, because this allows me to see a properly exposed image on the camera's LCD screen instead of an overexposed image. Seeing this image is important to me in terms of estimating how each color and brightness value will look on the final print.

Study the Scene Being Photographed

Whether we shoot film or digital, not all photographic subjects are created equal. Therefore, not all photographic subjects can be exposed in the same manner. It is important to carefully study the scene being photo-graphed. Following are three basic situations to watch out for:

1 – Very bright objects

Very bright objects will nearly always "throw the meter off" and will result in underexposed photographs. The reason for this is that the meter wants to turn all objects in the scene into an 18% medium gray value. If the object is white, and we want it white on film, we will have to overexpose in order to counter balance the meter's desire to make all objects gray.

A typical, yet challenging situation in landscape photography is photographing snow. Snow is by definition white, highly reflective, and the cause of many underexposed photographs. With most light meters, either hand held or built in, it is necessary to overexpose snow by one to two stops. Of course, whether the snow is in the sunlight or in the shade must be taken into account. Snow in the shade does not need to be overexposed very much unless the goal is to show it brighter than it really is.

Shiny and reflective surfaces are another subject which may potentially result in underexposed photographs. The sun reflecting off a pool of water, a metallic object lit by direct sunlight, or even a very bright canyon wall may also need to be overexposed from what the light meter is saying by one stop or more. Again, the meter is reading the brightness of these objects correctly, but wants to render them 18% gray while they are actually much closer to pure white or actually are pure white.

2 – Very dark objects

Very dark objects will also confuse the meter, this time causing it to overexpose in order to turn a black or nearly black object into medium gray. A typical situation is a backlit

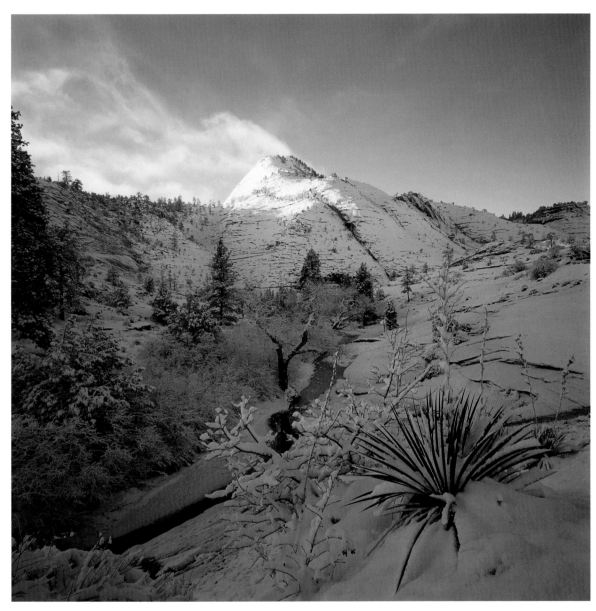

▲ This was another challenging scene exposure-wise. Firstly, the light level was changing very quickly as the sun was rising, requiring constant monitoring with my light meter. Secondly, the contrast was very high due to the presence of sunlit snow and relatively deep shadows. Thirdly, I had to make a decision about how dark I wanted the shaded snow to appear. I did not have time to bracket since the clouds disappeared shortly after I made this exposure. Fortunately, the image holds detail throughout. Shaded snow turns blue on film because shadows are lit mostly by blue light from the open sky.

▲ Zion Snow Sunrise, Zion National Park, Utah
Hasselblad SWCM-CF, dedicated Zeiss Biogon 38 mm, Fuji Provia 100F

scene at sunrise with the outline of cliffs, mountains, monuments or trees. It is best to let these elements be pure black on the final photograph, because getting detail in both the monuments and the sky is very difficult, if at all feasible. However, the meter will want to average the scene to 18% gray, resulting in grayish blacks, which in my opinion, are less than pleasing. In this situation we need to underexpose by one to two stops in order to get the proper exposure.

Similarly, other dark objects, such as a very dark tree, coal, black sand, etc. will end up being overexposed if an adjustment is not made to underexpose from the reading given by the meter.

3 – Rapidly changing light levels

I cannot stress enough the importance of constantly monitoring the light level of a scene at critical times such as sunrise, sunset, and active weather. For example constantly increasing light levels at sunrise, and constantly diminishing light levels at sunset, is very difficult to monitor with the naked eye. The presence of clouds, alternately hiding and revealing the sun, offer the same challenge. When the light is quickly changing, our eyes adapt accordingly and we may not see the change in brightness levels precisely.

In such situations, it is necessary to continually monitor the light level. This is particularly true when using a manual camera and a hand-held light meter, which is my situation when I work with 4x5. However, the need to monitor light levels also applies when using automatic cameras. What was a dark object at dawn may have become a very bright object after sunrise, and this bright object may be confusing the camera's built in meter. The same thing applies at dusk where the camera may be overexposing what it sees as a dark landscape.

High Contrast Remedies

What happens if we do not succeed in exposing a photograph properly in the field or if the range of values is too high to record detail both in the highlights and in the shadows?

Well, rest assured this is not a unique situation. This is a problem that has plagued photographers since the very beginning of photography. Fortunately, there are a number of solutions available. Following is a look at some of these solutions:

1 – Split Neutral Density Filters

A split neutral density filter is a filter that is divided in two parts: a clear area at the bottom and a neutral gray area at the top. The clear area of the filter is larger than the neutral density part, the ratio being usually 2 to 1, or 3 to 1. The transition between the clear and neutral gray area is graduated.

Split neutral density filters are available in either one-stop, two-stops, three-stops, or more. I personally recommend either a one-stop or two-stop split neutral density filter. More than that and the effect appears obvious and unnatural. I also recommend a soft transition between the graduated and the clear areas of the filter so that this transition is not visible on film.

Using a split neutral density filter is easy. The filter is placed in a holder in front of the lens and moved up and down until the transition is in the correct location. A typical use for this filter is to compensate for the brightness of the sky at sunrise or sunset. In this case place the neutral density area over the sky and the transition along the horizon. Other uses are possible, the limit being one's own imagination.

▲ These 3 photographs show a perfect example of digital sandwiching. I took a single photograph of this scene in Paris. When I converted the image from RAW I realized I could not get detail in both highlights and shadows on a single converted image. I therefore decided to do two RAW conversions, one for highlights and one for shadows. I then combined these two files in Photoshop. This technique takes only a few minutes and works extremely well. Furthermore, it is virtually invisible since the brush size can be adjusted and the areas removed at will. The third photograph, on the far right, shows the final result.

▲ **Paris Bistro**
Canon 300D with dedicated 18-55 lens

2 – RAW Conversion for Highlights and for Shadows

There isn't much more that can be done in the field besides optimizing the exposure and compensating for a large contrast range with split neutral density filters. One can certainly look for scenes in which the contrast range does not exceed that of the film or digital sensor, but doing so will severely limit what can be photographed.

If a scene is captured in which the contrast range exceeds that of the film's or digital camera's capability, the next step is to compensate for this excessive contrast range in the darkroom.

One very effective technique for digital images is to make a separate RAW conversion for highlights and for shadows. This technique is perfect when all the desired information already exists in the RAW file, but cannot

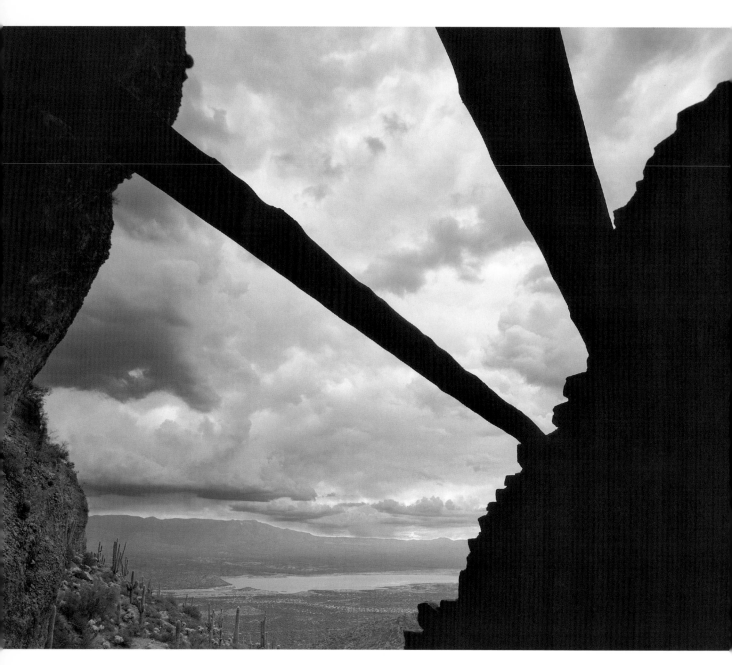

▲ This photograph combines two different scans from two differ-
ent transparencies. Aware of the extreme contrast range of this
scene I decided to make 2 exposures to capture detail in the sky
and in the cliffs. I combined the two scans in Photoshop with lay-
ers using a layer mask to erase areas of the image I did not want to
keep. The wall to the right had slight detail in it but, just like in Tear
Drop Arch Moonrise, I prefer it pure black than rather dark gray.

▲ **Lower Ruin,
Tonto National Monument, Arizona**
*Linhof Master Technika 4x5,
Schneider 75 mm, Fuji Provia 100F*

successfully display all this information in a single RAW conversion.

To apply this technique, start first with the highlights and adjust the exposure control in the RAW conversion software so that the highlighted areas appear on the monitor as desired. Typically, the exposure of the photograph will need to be lowered. Convert this image. Then, going back to the original RAW file, make adjustments to the shadows so they too appear on the monitor as desired. Typically, the exposure in the shadows will need to be increased. Make a second conversion for the same image.

Open both images in the image processing software and drag one of the images on top of the other in a separate channel, making sure they are in perfect registration. Add a layer mask to this channel and, using the eraser and a soft, wide brush, remove the parts of the top image which are not wanted. For example, the image with the proper highlights is placed on top, then erase the shadow part of this image to reveal the properly converted shadows on the layer underneath it.

3 – Scanning for Highlights and for Shadows

A similar technique can be used with film, this time by scanning the same transparency or negative two times; one time with the scan settings optimized for the highlights, and the second time with the scan settings optimized for the shadows. Import both images in the image processing software and proceed as described above. Make sure not to move the film in the scanner between the two scans otherwise the two images will not register perfectly.

The question may be asked, "why not scan or convert from RAW only once and then use image adjustments- such as curves, dodging and burning or the new highlight-shadow filter in Photoshop CS?" This approach may certainly be used for many images which require only a minor amount of contrast correction. But, for images which require significant contrast correction, better quality results will be achieved using the technique I just described. This is because the images will have all the information needed from the start, instead of images that have little or no data either in the highlight or shadow areas.

4 – Sandwiching

In some extreme situations the above technique will not work because nothing was recorded in the shadow or highlight areas on a single photograph, either film or digital. However, several photographs were taken, and one was exposed for the highlights and one was exposed for the shadows. Highlight details are present in the first photograph, and shadow details are present in the second photograph.

In this instance, the only resource is to sandwich the two images and use the areas with details from each of them. Doing this successfully takes more time than the previous technique. Furthermore, sandwiching works better with digital since digital images are always in perfect registration if the camera was placed on a tripod, if the camera wasn't moved between exposures, and if the same lens or zoom setting was used for both images. With film, things are more problematic since films are almost never exactly in the same place in the camera in successive frames, no matter what format is used.

At any rate, open both images and bring them together in one file on two different layers. Then use the same approach I described previously to erase the unwanted areas, and show the desired areas that will be kept. Use

◄ Gossen Luna Pro Analog Light Meter with Spot Attachment

I have used this meter since 1980. The spot attachment gives it a measurement angle of 7.5 or 14 degrees. I use the 7.5 degree angle setting nearly all the time. The needle gives the measurement value by zeroing it in the center of the top dial. Measuring a highlight area, placing it on "2" on the right side of the top dial, and then measuring shadow areas, immediately tells if the film can handle the contrast range in the scene +2 stops, being what most transparency films can handle without burning the highlights. The circular dial gives all the f-stop and speed combinations for the measurement as well as zone system placement.

◄ Gossen LunaStar Digital Light Meter

I consider this meter to be the digital version of the Luna Pro. It has the advantage of offering a one degree and 5 degree measuring angle, flash metering, ambient light metering, and more. Several areas of the scene can be measured and the meter will calculate the average exposure value. It is very accurate but, in my estimation, it does not offer the immediate visual comparative feedback that the analog meter offers. Digital light meters with similar functions are offered by several other manufacturers, such as Sekonic, Minolta, etc.

◀ Pentax 1-Degree Spot Meter

Introduced over 20 years ago and recently discontinued by Pentax, this meter has become the archetype for spot meters, as well as a favorite of many photographers. Its success is due to its reliability, accuracy, simplicity, and ease of use. This meter has a fixed one-degree angle of view and gives an EV value in the viewfinder for the measured area. This EV value is dialed on the front settings area (see photo at right) and the corresponding f-stop/speed combination are immediately available together with zone system placement if one adds a zone system strip to the meter, as shown in the photograph on the right. Providing accurate measurements is only

the first step in meter functionality. The second and very important step, is to allow easy contrast evaluation. A good meter allows one to easily calculate where the highlights and shadows will fall.

a very soft brush and a relatively wide transition zone. The opacity setting of the top layer may need adjusting, and may be set at lower than 100% to show part of both images in areas where the transition from one to the other may be noticeable.

As these techniques are practiced, or if their use is considered, keep in mind that just because images can be combined doesn't mean they should be. Nobody says that detail in both highlights and shadows are a must in each and every image that is created. In fact, with some photographs, having detail in both highlights and shadows does not result in the strongest image possible. Furthermore, in some instances, having detail everywhere seems unnatural or fake. Eventually, the final call belongs to the photographer, and the decision must be made, not on whether or not detail can be shown everywhere in the image but, rather, on whether or not we want to show detail everywhere in the image.

Given several originals and enough time, patience, and skill, we are likely to be successful in most instances in producing an image with detail throughout the scene. However, once this is done, we may decide it is not what we want. We are talking here more about personal style than technical skill, a subject we will revisit at length later on in this book.

Familiarize Yourself with Hand Held Light Meters

A hand held light meter, especially a spot meter, is a great asset when used to meter a scene carefully. Such a meter can be useful whether we use a camera with a built in meter or not. I use a hand held spot meter, actually two of them at this time, whenever I photograph a scene that is challenging exposure-wise. Below are several examples of hand held light meters and spot meters.

▲ **The Lens of the Sony Clie NZ90**

◄ **A Possible Future PDA-Spot Meter**
Shown is a composite image of what such a meter may look like. It would be the size of a PDA, hence much smaller than a digital camera such as the Canon 300D and not much bigger than currently available spot meters

Spot Meter Meets PDA

As I discussed earlier in this chapter, digital cameras not only have a built in light meter, they also have a built in histogram display. To my knowledge, this function is not available on any handheld meter, as of the writing of this book.

I understand that a histogram is calculated from all the values present in a scene and not from meter readings of specific areas of the scene. In other words, a histogram is created from a photograph, not from meter readings. To get a histogram one needs a photograph and to get a photograph one needs a lens. So far, light meters have not been designed to capture photographs.

Certainly one can say that all that is needed to get a histogram is to use a low-cost digital camera to meter the scene. I do this with the

Canon 300D, which I use regularly as a light meter that can also take photographs. But I also carry a light meter because I need the spot meter function and the comparative metering capabilities that are provided by a hand held meter, such as the different models described above.

A number of PDA's, such as the Sony Clie NZ 90, are equipped with a photographic lens and can capture low-resolution photographs. If such a PDA was able to display a histogram for the photographs they take, and was fitted with a one degree spot meter, we would have a measuring instrument the likes of which we have not seen before.

Merging a digital spot meter with a PDA fitted with a miniature zoom lens would produce a spot meter that can take a photograph, zoom in and out to give different compositions and croppings, meter the entire scene

just like a digital camera, take spot meter readings of specific areas of this scene, and display the resulting histogram on a PDA-like screen. The histogram displayed on this PDA-spot meter would be a tri-color histogram to provide reliable information about all three channels of the photograph. The display area would be about 2"x3", much larger than the LCD screen of any currently available digital camera. Spot meter readings of specific areas in the scene would be indicated on the display and would provide EV and f-stop/speed combinations for each area measured. Overexposed and underexposed areas would blink as they do on most digital cameras.

The processing and storage capabilities of a PDA would also make it possible to store photographs and their related histograms and spot measurements for later reference. This data could be opened in a separate "Histogram and Light Measurements" software, independent of the browsers, RAW converters, or image processing software we currently use. This program would also be able to output a print of the histogram and spot meter readings. We could even combine this with a GPS system and record the GPS coordinates of each photograph at the same time as their exposure information.

Photographic Skills Enhancement Exercises

None of the chapters in this book would be complete without specific Photographic Skills Enhancement Exercises targeted to help develop skills in the area covered in each chapter. I know that many readers conduct these exercises carefully, therefore I designed a set of exercises specifically for this chapter.

Exercise 1
Determine the overall contrast range of a specific scene.

This is a simple exercise in which a meter reading is taken of the brightest and the darkest areas of the scene.

The easiest way to do this is to use a spot meter. However, if a spot meter is unavailable this exercise may be conducted while using the built-in light meter in the camera or a hand-held light meter.

If the built-in meter in the camera is used, it will be necessary to get close to the area being measured to make sure that only this area is measured. A long lens may also be used in order to narrow the camera's field of view to just this area. Getting close will work for nearby objects, but not for distant ones or for the sky. For these areas a long lens must be used. Of course, if the camera has a built in spot meter function, make sure to use it.

After the highlight and shadow areas have been measured, count how many stops there are between these two areas. This is the contrast range of the scene in front of us.

Exercise 2
Measure the important values of a scene and write each exposure value on a sketch of this scene.

When I started working with my first view camera in 1983, I made sketches of each scene I photographed using tracing paper placed against the ground glass of the view camera. I made a drawing of each photograph by tracing the outlines of my composition. Then, using a Pentax 1-degree spot meter, I took readings of all the important value areas in the scene and wrote these values on each drawing. Comparing each print to the corresponding sketch taught me volumes about how light is cap-

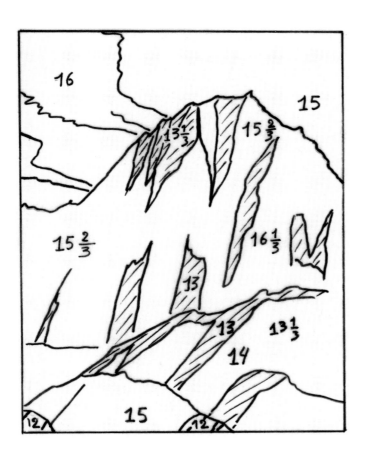

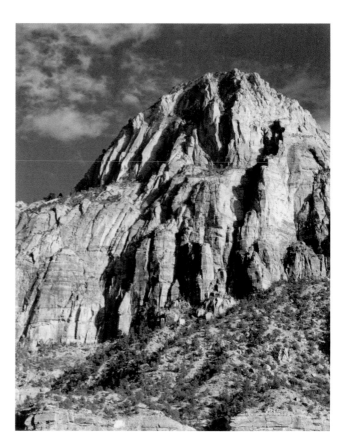

▲ This is one of the sketches I made in 1983 by using tracing paper pressed onto the ground glass of my Arca Swiss 4x5 monorail view camera. Next to it is the corresponding photograph. I drew the outlines of the main shapes in the photograph, took meter readings of the scene with my Pentax 1-degree spot meter, and wrote the corresponding EV values on the drawing. EV values are practical because only one number is needed to find the corresponding f-stop and speed ratio. Also, they take up less space on the drawing. I did similar drawings for over 100 4x5 photographs during my six-month journey throughout the southwest in 1983.

▲ **Bridge Mountain,
Zion National Park, Utah**
*Arca Swiss 4x5 monorail view camera,
Rodenstock 210 mm,
Polaroid Type 52 B&W film*

tured on film and how light is translated into light and dark values onto the final print.

This exercise is aimed at providing the same knowledge. If a 35 mm or a medium format camera is used, a hand-drawn sketch will need to be created, as it is not possible to sketch directly on the ground glass. However, the quality of the sketch is not important. What is important is that the sketch shows the rough outlines of the objects in the scene, and that the exposure information for each area is written on it.

Below is shown one of the sketches I made in 1983 next to the corresponding photograph. The photograph was taken on Polaroid 4x5 Black and White film type 52. The use of Polaroid film enabled me to visually compare the scene in front of me to the photograph of this scene in the field, and to see how my meter readings were translated into shades of black, white, and gray on the print.

The outlines of the shapes in the photograph were traced on the ground glass of my Arca Swiss 4x5 monorail view camera. The exposure values were recorded as EV values because these are the values provided by the Pentax 1-degree spot meter I was using at the time. EV values are not directly related to a specific speed and f-stop setting. Rather, they are absolute values that express a specific brightness. To use them however, a light meter is needed that can give the f-stop and shutter speed settings for a specific film speed. Some camera manufacturers use EV values. For example they are provided by Hasselblad light meters and are present on each Hasselblad lens.

It is not necessary to use EV values. Instead, the f-stop and shutter speed combination may be written on the drawing. Just make sure to keep either the f-stop or the shutter speed constant. Doing so will make it much easier to calculate the overall contrast range.

Exercise 3
Photograph a specific subject and bracket the exposure widely
- Bracket 5 stops under and 5 stops over the "normal" exposure
- The goal of this exercise is to create purposefully overexposed and underexposed photographs
- The result will be photographs that are much lighter and much darker than normal

Exercise 4
Memorize f-stop and shutter-speed scales
- This will help greatly when time is of the essence, such at sunrise and sunset
- Refer to the f-stop and speed scales provided in this chapter

Exercise 5
Find the available contrast range of the film(s) and/or digital camera
- See pages 80-82, under the heading, "How to Determine the Contrast Range that the Film or Digital Camera Can Capture"
- Follow my detailed description of this process
- This is a very useful and informational exercise which will enable us to know the exact contrast range of the film or digital sensor

Conclusion

The goal of learning how to expose goes beyond the ability to determine the "correct" exposure. Most cameras do this automatically, and in many instances we can trust what the camera tells us. Plus, with the histogram function we can visualize how the final image will be exposed. Finally the LCD monitor of digital cameras allows us to immediately view the photograph we just captured.

The goal of learning more about exposure is to gain control over how our photographs are exposed. Our goal is not only to find the proper exposure, but also to find the exposure that will give us the effect we are looking for.

For this we must first learn to calculate the range of contrast present in the scene in front of us. As of the writing of this book, no camera does this automatically. We also need to determine if objects will be rendered the way we want them to be rendered. As we have seen, very bright and very dark objects or scenes, will often result in incorrect exposures. Since these are ultimately artistic calls, we cannot depend on our cameras alone. Cameras are devices that, at best, can only capture the world the way they were programmed to capture it.

A properly exposed photograph is one that will eventually be considered for printing. In this sense such a photograph is what is often referred to as a "keeper". But, being properly exposed is not enough to make a photograph a keeper. Other things come into play when making this selection. What are those other things? This is what we will look at in the next chapter, where we will learn how to decide which photographs are keepers and which ones are not.

◄ **The Hoodoos at Sunset,
Lake Powell Area,
Arizona**
*Linhof 4x5 Master
Technika,
Rodenstock 150 mm,
Fuji Provia 100F*

◄ As with many land-scape photographs which show both skys and shadow areas, contrast was a challenge in this image. The original transparency holds detail everywhere but several contrast masks were needed in order to convey a sense of light and brilliance on the final print. I used multiple curve layers in Pho-toshop to both open the shadows on the hoodoos and reduce the brightness of the sky behind them. The final print con-veys how I felt when I photographed this scene.

Keepers or Non-Keepers?

The word 'art' is very slippery. It really has no importance in relation to one's work.
I work for the pleasure, for the pleasure of the work, and everything else is a matter for the critics.

Manuel Alvarez Bravo

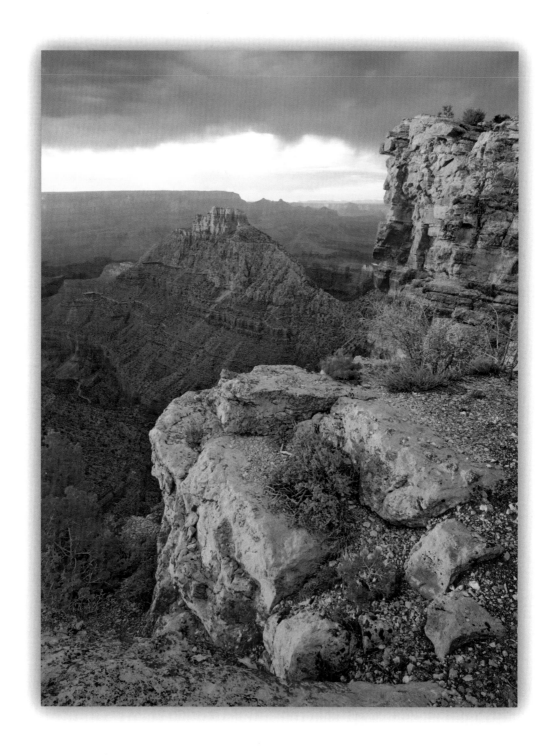

Keepers or Non-Keepers?

Keepers: A photographer's term for the photographs we like enough to keep in our permanent files and to print.

But how do we decide which photographs are good enough to be kept around or good enough to be shown to others, printed or exhibited? I receive numerous emails asking me this very question. It seems that many who ask this question believe there is some sort of infallible test which allows photographers in the know to somehow "weed out" the bad photographs and select the good ones, without faltering, without hesitating, knowing exactly how successful any given image will be with the public.

Well, let me start this chapter by saying that "it ain't so." I wish it was, but it is not that simple. Why? That is what this chapter not only aims to explain but also aims to help with. Read on!

Which Ones Are Good; Which Ones Are Bad?

"That is a very good question," was the answer given by some of my university professors when they didn't know the answer to a question. The fact is that what constitutes a good photograph and a bad photograph can be somewhat elusive. There are ways to narrow down the search and to remove the ones that are definitely not up to the task, but the process is neither clean nor linear. Selecting photographs isn't exactly like tallying up the score on a multiple answer test. It is eventually an aesthetic decision and aesthetics do not follow mathematical formulas.

I will walk through the process I follow as a way to get started on this topic:

1 – "Weeding"

When I receive a batch of film back from the lab, or when I download images from a digital camera into my RAW conversion software, the first thing I look for are images which suffer from irremediable ills: blank frames, totally blurred images, images shot accidentally, images way over or underexposed, etc. These are the first to be eliminated, i.e. they are either thrown in the trash or deleted from my hard disc. To me this process is similar to weeding out the yard: we want to get the inferior images out of the way immediately and without remorse. They are errors, mistakes, and gross negligence by-products of the creative process; unfortunate accidents, mishaps, or other miscalculations.

After this has been done I always feel slightly better. I do keep bracketed frames (film and digital) for several reasons. Firstly, I may want to create composite images of high contrast scenes in which case I will need bracketed exposures of the same scene. Secondly, certain exposures work well for scanning while others work better for printing and reproduction, hence the need to have bracketed exposures of the same image. Finally, future technology may be able to extract more data than we can extract today from overexposed or underexposed images making it worthwhile to use that extra bit of storage space to preserve this material.

2 – Filing

At this point I file my photographs. Developed films are stored in transparent filing pages and kept in Bestfile binders. Digital files are burned to DVD. Two copies of each DVD are

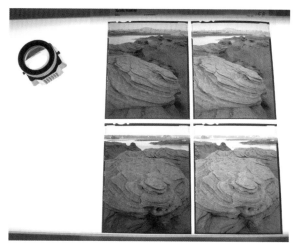

▲ Two Aspects of the Selection Process

▲ 4x5 transparencies on my light table with the indispensable 8x loupe ready to be used to check for sharpness and to take a close-up look at each image. These 4x5 photographs were created at Lake Powell.

▲ RAW Conversion software interface, in this instance Phase One C1 Pro 3.7 with 35 mm digital files. These 35 mm images were created in Eastern Arizona. Either way, the goals are the same: finding out which images are keepers.

made, each kept in a different physical location for maximum security.

I find it important to file film and digital files immediately for several reasons. Firstly, with films, dust is a huge concern. The sooner my films are in slide pages and in dust-proof binders, the sooner they are protected as much as possible from dust. With digital there is always the chance that a file may be accidentally deleted or overwritten, and there is always the potential for a hard drive crash. For these reasons making two back up copies as soon as possible, and keeping them in different physical locations, is the best insurance we can get.

Filing is an important process. For me filing serves two main purposes. First, it guarantees

that my originals are protected from damage, dust, and loss. I currently use Bestfile binders for film originals because they are sealed binders. Secondly, efficient filing makes finding any given image quick and easy. To reach this goal I use a database listing the film file page number, the location where the photograph was taken, the date each photograph was taken, and other pertinent information. I keep a digital version of this database on my computers and a printed version in each Bestfile binder. I also keep a digital catalog of all my digital images, using Extensis Portfolio cataloging software. Finally, I keep a virtual catalog of all my CDs and DVDs on each of my computers. Searching any of these databases or catalogs, based on what I am looking for,

▲ **Bestfile film binder opened** showing the 4x5 Print File filing pages stored inside. Each Bestfile binder can store 100 print filing pages

▲ **Locations database printout in Bestfile binder.** I keep a printed version of this database in each binder.

▲ **Bestfile Binders in my Office**

◄ **CD and DVD Wallets in my Office**

Each wallet holds 24 discs. The discs numbers are on each wallet and each disc is searchable via Disc Catalog software. I started by backing up all my digital files on CD's before upgrading to DVD's in 2003. Each disc has a number and each disc wallet carries a label with the numbers of the discs stored inside.

enables me to find any image within 5 minutes or so. Finding an image in a timely fashion is crucial to me since I receive orders for specific images daily, and I have to find these images amongst my collection that consists of over 50,000 images.

3 – Selecting

The third part is the most difficult. I now have to decide which images are my favorites, which ones I think are the best, and which ones I think are second rate. In other words, it is now up to me to decide what is good and what is not.

Let me start by saying that the fewer images I have to look, at the easier the process. This seems to be self-evident and in a sense it is. However, the number of images I have to review out of a single batch is directly related to the camera format I used. The quantity of images I shoot is inversely proportional to the film format I use. In other words, the larger the format, the smaller the quantity of images. This makes reviewing and selecting 4x5 images much easier and faster than 35 mm images. Why am I saying all this? Because, if the selection task is arduous, if not nearly impossible, moving up to a larger format should be considered.

My Personal Selection Criteria

So far I haven't answered the question of how I select images. That is because a selection can only be made according to a criteria, and we have not yet discussed what this criteria may be.

A criterion is a list of things to look for in an image, or a list of goals an image must reach. Without criteria, making a selection beyond technical excellence is not feasible. We need something to go by the image being technically good. Furthermore, as we have just seen, at this stage in the process only technically good photographs are left.

So what do we go by? Firstly, there has to be a purpose for taking photographs. If we have a purpose, the photographs that meet this purpose, and which are technically good, will be keepers.

I will review the various criteria I am currently using. Keep in mind that my criteria and my focus have changed over the years, and will continue to change in the future.

1 – Positive outlook

Since the beginning of my involvement with landscape photography, my overall criteria has been to focus on the positive aspects of the world. This is why I do not photograph poverty, misery, gloom, depressing scenes, etc. This focus is present in each of my landscape photographs. In terms of selection, I purposefully reject images that are gloomy or depressing and select images that are inspiring and up-lifting. Auguste Comte, father of Positivism, would be pleased.

2 – Fresh Images

I aim to create images that are different, not only from the images created by other pho-

tographers, but also from the images I created previously. For example, one of my current goals is to create a different photograph each time I return to a place I have previously visited. Therefore, in selecting which photographs are the keepers from a specific shoot at a location I have previously photographed, I purposefully reject images that are too similar to images I created in the past. The images I reject will most likely be technically good, however, they fail to meet my current aesthetic criteria.

3- Single Image from a Specific Location

One of my current goals is to cover a number of specific locations and assemble a collection of images, each one representative of how I perceive each location. I regularly visit specific locations for the sole purpose of bringing back a single image from this location. Of course, I will shoot many photographs during my photographic expedition. However, when looking at my film and digital files to decide which are keepers, I actually look for a single image.

4 – Capture Multiple Photographs of Same Scene with Same Exact Composition

In this situation the only changing variable is the light. An excellent example of this situation is my December 2001 Sunrise shoot at White Sands National Monument where I exposed about 40 double 4x5 film holders without changing the composition, camera position, or lens, except for the very last exposure. This shoot is described in my "Briot's View" article on the Luminous Landscape website at www.luminous-landscape.com, "Seeing the Light, Sunrise at White Sands", as well as on the Luminous Landscape Video Journal number 2. At the time I wrote the ar-

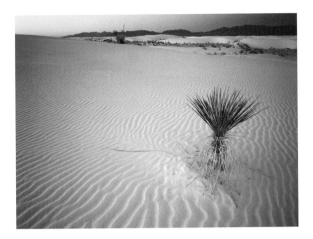

▲ **White Sands Sunrise #1**

▲ **White Sands Sunrise #2**

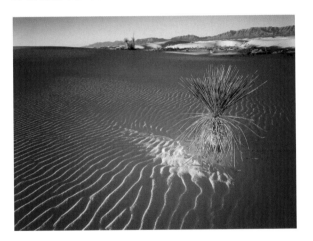

▲ **White Sands Sunrise #3**

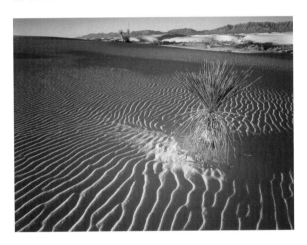

▲ **White Sands Sunrise #4**

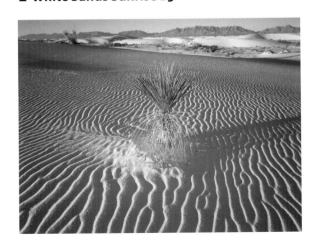

▲ **White Sands Sunrise #5**

All five images were created with a Linhof Master Technika 4x5, Schneider 75 mm lens, and Fuji Provia 100F film.

◄ These five photographs are the five original keepers from my White Sands Sunrise shoot in 2001. This selection was made out of the forty 4x5 originals I took that morning. About nine months later I narrowed my keeper selection down to "White Sands Sunrise #1". I went from 40 to 5 to 1. I still like the other four images and may add a second image to my selection because #5 is very attractive to me right now. Notice that I changed the camera position slightly for #5.

ticle I had narrowed the selection down to five keepers. Several months after the article was published I selected a single keeper from this shoot and added it to my Portfolio Collection.

5 – Print Size

I make my living selling fine art photographs in multiple sizes, with an emphasis on very large photographs, 40x50 and 40x120. These photographs are designed to decorate homes and offices where they will be displayed for many years. With this goal in mind, when selecting my keepers, I look for photographs that can sustain the viewers' interest for extended periods of time. I look for photographs that can withstand years of viewing without becoming boring, repetitive, or clichés. I am not necessarily looking for an image that will make an immediate impact, such as is the case with advertising images. Instead, I am looking for images that grow on the viewer; images that become more enjoyable as time passes and as the viewer becomes intimately familiar with them. I look for images that reveal themselves over time, rather than images that make a quick, short-lived impact.

Technical Excellence vs. Aesthetics

Technical excellence is not an end in itself; an aesthetic focus is needed to make a final selection.

To decide which of my photographs are keepers, and to move beyond technical considerations, the fundamental questions of all great photographers had to addressed. These questions were, and still are, "Why do I take photographs?", "What do I want to express in my photography?", "What is my main reason for creating the images I am now reviewing?",

and so on. Without such questions, and without answers to these questions, I would be unable to select my keepers on any basis other than technical quality alone.

Of course, my criteria are designed to help me reach my current goal, which is first and foremost to create images that I intend to display as art. If my goal were to shoot images for stock photography, for publication, or for commercial use, purposes on, my selection criteria would be different. Therefore, the criteria will most likely differ depending on the intended use of one's work.

The Selection Criteria

Selecting a criteria, a focus, an intended purpose, and use for one's work may be difficult, because we may not want our work used for commercial purposes. In this case, all commercial uses of our work may be removed from the list of possible criteria. This will definitely make the job easier since the list is shortened considerably.

For work that is not intended for commercial purposes, a different set of criteria is available. These criteria are essentially based on aesthetic considerations. A number of possibilities are listed below. Keep three things in mind while reading through this list:

Firstly, the list below is compatible with a list of commercial uses for one's work. In fact, these two lists can be merged to some extent. Secondly, the criteria will usually need to be selected *before* the next shoot. Only then will we be able to purposefully look for photographs that meet the goals set by this criteria. Thirdly, these are only guidelines. The actual criteria may include some of these suggestions or may be entirely different.

Here are some possibilities to help establish one's criteria:

- Create photographs that will be matted, framed, and displayed
- Create photographs that will be offered for sale
- Create a body of work covering a specific number of different locations, with one keeper per location
- Create a collection of sunset (or sunrise) photographs
- Create a collection focused on a specific theme such as the four seasons, water, movement, trees, etc.
- Create a series of black and white (or sepia, or color) photographs

Photographic Skills Enhancement Exercises

As in each chapter in this book I am including some Photography Skills Enhancement Exercises. For many, these exercises are the highlight of each chapter, and many readers conduct these exercises faithfully.

Exercise 1
Focus and Criteria

Set up a specific goal for the next shoot. Write this purpose down on paper as precisely as possible. Go as far as setting the specific number of photographs that should be brought back from this shoot. Think of it as an assignment from an editor, a stock agency, a gallery, a customer, etc. Set a specific time limit with a specific number of images in mind to complete this assignment. Go out and do it, then edit the photos carefully, choose the keepers, print them, and display them on your home or office walls. Lastly, go back to the written as-

signment description and see how closely the criteria were followed.

Exercise 2
Popularity Contest

Pull out all the photographs from your last significant shoot. Start by "weeding out" the ones that are technically poor. Then make prints of all the remaining photographs. It is not necessary to make very large prints, 8x10's will work.

Find four keepers among these prints. Make sure these are your favorite images. Using a red pen, put a check mark on the back of these keepers to identify them later on.

Then take all the prints, including the keepers, and show them to as many other people as possible. Show them to friends, co-workers, clients, acquaintances, and complete strangers who don't mind giving their opinions. Ask each person to select their four keepers. Place a check mark on the back of the four prints selected by each person that looked at them. This time, use a black pen so these checkmarks differ from the red checkmarks.

When you run out of people to show your work to, turn the prints over and count the checkmarks on the back of each print. Find the four prints that have the most checkmarks. Put these four prints aside and turn them face up again. Compare these four images to your four original keepers. Are they the same? Are any of your four original keepers in this final group? The results are likely to surprise you!

Exercise 3
Different Styles; Different Keepers

A photographer's work may be traditional at times and cutting edge at other times. Maybe the photographer has two or more differ-

ent styles that are evident at different times depending on the feeling and response to a specific subject at a specific time. If this is the case with you, this is a helpful exercise.

Looking at the work from your last shoot, or from several of your recent shoots, make two selections.

Firstly, make a selection of your best traditional images. These should be images that do not "go against the grain"; images that are done in a classical style, which do not break any rules and do not stretch anyone's sense of taste.

Secondly, make a selection of your best "radical" or cutting edge images. These are images that break the rules; images that are surprising, uncommon, new, or personal. Keep these two selections separate and show them to people as two separate groups. Pay close attention to the kind of response each group of photographs receives, as there is much to be learned from your audience.

Conclusion

The selection process is a gradual, multistage process. Keepers are the images that are remaining at the end of this process. By studying the process I use, and by looking at some of my photographs, I have shown that this process often takes place in stages. These stages are as follows:

- First, keep only technically excellent images.
- Second, narrow the selection down to the photographs that best express what was seen and felt.
- Third, further narrow this selection down to the one image that encapsulates the experience, the place, the feeling, etc. This one

image should be the best image of the entire group.
- Fourth, find the images that meet the goals set by your criteria.

This selection process is far from being linear and straight forward. I find that this process often makes sudden twists and turns as my perception of my work changes or is affected by the response from my audience.

It is important to remember the following four points:

1. Photography is art and art is subjective; therefore photography is subjective and so is the process of selecting the best work from any given photography shoot.

2. In order to remove some of this subjectivitiy other people can be involved in the selection process. Friends, relatives, coworkers, and other photographers may be asked for their opinions.

3. Eventually, we cannot be both artists and critics. As the saying goes: "Critique is easy while art is difficult." Therefore, our job is to do the difficult part and leave the final decision as to the value of our work to our audience. This means we need to know who our audience is and to trust our audience's choice.

4. Finally, we need to retain artistic license in our final selection. Knowing what others like and dislike, and knowing how our audience reacts to our work, does not mean giving up our personal artistic beliefs and taste. The final cut is ultimately up to us.

This forth and last point is what makes all the difference between selecting which images from a given shoot are keepers, and putting together a portfolio of what we consider our best work. How to assemble a portfolio is the subject of the next chapter in which I expand on the final four points above.

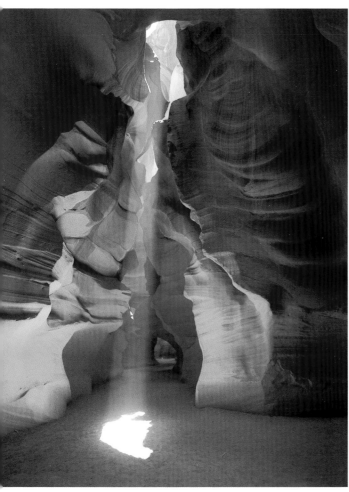 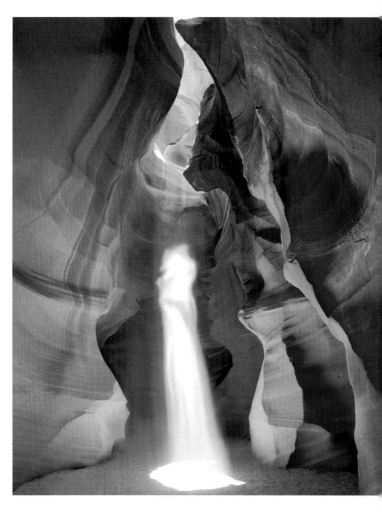

▲ Antelope Light Shaft
Linhof Master Technika 4x5, Schneider 75 mm, Fuji Provia

▲ Antelope Canyon Light Dance
Linhof Master Technika 4x5, Schneider 75 mm, Fuji Provia

▲ My original keeper from this shoot was "Antelope Light Shaft." However, while response from the public was good, it wasn't as overwhelming as I had hoped. In response to a suggestion, I printed a second image from this shoot: "Antelope Light Dance". The public's response to this second image was overwhelming and "Antelope Canyon Light Dance" has since become one of my all time bestsellers as well as one of my Portfolio Collection images.

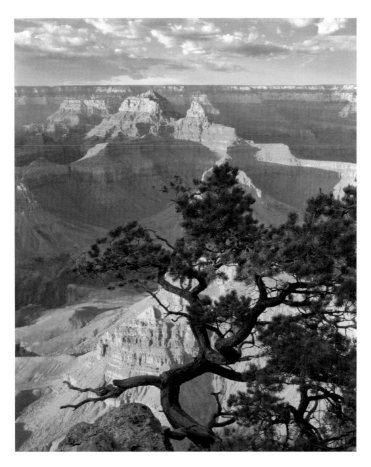

All three images were created with a Linhof Master Technika 4x5, Rodenstock 210 mm lens, and Fuji Provia 100F film.

◄ These three photographs were created on the same shoot and on the same day. The camera was only moved a few feet for each image, and the lens used was the same for all three photographs. These are the only three images I created on this particular day. While all three were taken from the same location, they are so different, both in composition and mood, that I selected all three as keepers.

▲ Pinon Pine and Clouds at Sunset, Yavapai Point, Grand Canyon National Park

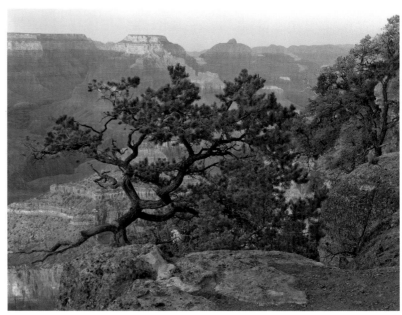

Pinon Pine at Sunset, Yavapai Point, Grand Canyon National Park ►

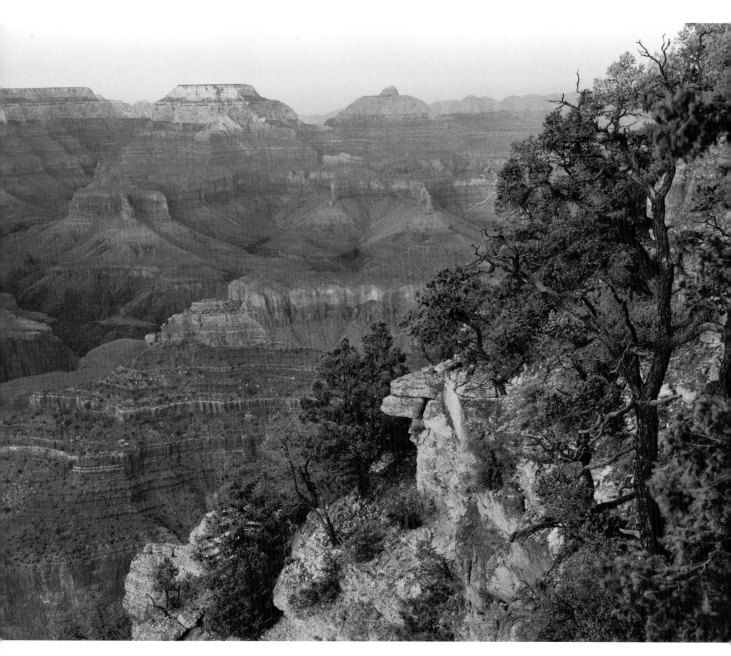

▲ **Sunset from Yavapai Point, Grand Canyon National Park**

How to Create a Portfolio of Your Work

*Of course, there will always be those who look only at technique,
who ask "how," while others of a more curious nature will ask "why."
Personally, I have always preferred inspiration to information.*

<div align="right">MAN RAY</div>

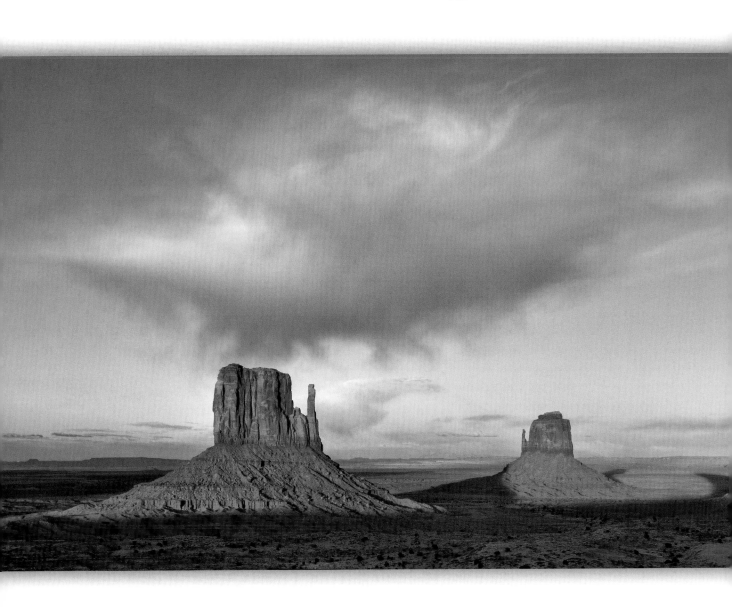

Introduction to Creating a Portfolio

Creating a portfolio of one's work is one of the most important things we can accomplish as a photographer. Unfortunately, relatively few photographers create portfolios because they find the process daunting or they think their work is not good enough to be included in a portfolio. Some squirm at the idea of having to review thousands of photographs taken over many years. Others do not know how to select photographs for a portfolio. Finally, there are those who believe that a portfolio cannot be created by themselves; that such an endeavor must be conducted under the control of a museum or a gallery, or must take place in the context of a retrospective of the artist's work.

While these concerns are valid, let me begin by saying that they are inaccurate. Assembling a portfolio is not the daunting and frightening task it is touted to be. Let's start by taking a close look at what a portfolio is, study why it is important to create portfolios of one's work, and learn how to create a portfolio of our own work. Throughout this chapter I will use portfolios I have created as examples.

What is a Portfolio?

Let's start by taking a look at what a portfolio really is. A portfolio is, literally, a *porte folio*, in French, meaning a page carrier. A *folio* is a large page roughly the size of a single newspaper page. *Porte* means to carry. A *porte folio*, shortened to *portfolio* in English, is basically a device designed to carry loose pages. The first goal of the *porte folio*, we might say, is to hold these loose pages together in a secure place so they do not get lost or damaged. For artists these loose pages are works of art on paper.

Although a folio is a large page, there is no implied size for the contents of a portfolio. Similarly there is no implied restriction on the nature of the works of art placed inside a portfolio. These can be drawings, paintings, architectural sketches, photographs, collages, etc. There is also no implied restriction on the type of container to be used. The device used to hold these works of art, the *porte* part of the *porte folio*, can be a folder, a box, or some other device chosen by the artist. Finally, there are no restrictions on who can create a portfolio. It is most often the artists themselves who create portfolios of their own work.

Portfolios and *Portfolios*

In today's digital age, and in theory, a portfolio no longer needs to be printed. It may be created solely through digital means, either from scanned or digital photographs that have been color corrected and optimized, then presented in PDF, JPEG or preferably, another platform-independent format.

Presenting a digital portfolio is a perfectly legitimate way to select images, submit images for publication, apply for acceptance in a gallery show, or for other similar purposes. However, in my view a portfolio is not a *portfolio* unless it consists of images printed on paper. Why? For the simple reason that, in my eyes, a final image is an image on paper, not an image on a computer monitor. There is a tremendous difference between looking at an image on screen and looking at an image on paper. For me, the end product of my efforts is a fine art print on paper, and for this reason a portfolio of my work must be a collection of fine art prints on paper. Of course my way is not the only way, and opinions may differ.

Example 1: ►
Black and white
portfolio Dune and
Cloud
Hasselblad 500CM,
Zeiss Distagon 60 mm,
Kodak TMax 100

▲ From 1980 to 1997 I printed my black and white work in my own darkroom. I sold all my darkroom equipment in 1998 and today all my printing is done digitally. However, when I created a portfolio of my Southwest Black and White images I decided to keep the uneven print borders that I created by using an oversize negative carrier on my Besseler enlarger. These borders were different for each print and were truly personal since I had personally hand-cut the negative carrier. I scanned each print at high resolution and created digital versions the size of the chemical prints. The portfolio included only black and white images, each printed with uneven borders. The photographs were printed on Somerset 300 gram paper, signed in pencil, and embossed with my personal embossing stamp. They were left unmatted to better show the quality and "organic" feel of the paper.

◄ **Example 2:**
Paris Canon 300D Portfolio
In December 2003 I purchased a
Canon 300D and used it exten-
sively while photographing in
Paris in December 2003 and Janu-
ary 2004 (see "A Rebel in Paris").
Upon my return to the United
States I decided to assemble a
portfolio showcasing a selection
of my favorite Paris 300D photo-
graphs. While I used both medium
format and 4x5 in Paris, I decided
to create a separate portfolio fea-
turing only photographs created
with the Canon 300D. I printed all
the images in this portfolio on the
Epson R800 Ultrachrome printer
using Epson Premium Photo
Glossy Paper. My goal was to
show that world-class images and
print quality could be achieved
with a relatively inexpensive cam-
era and printer combination. This
is a perfect example of a portfolio
focusing on a specific location,
a specific camera, and a specific
printer. The prints in this portfolio
are all 8x10 double matted to16
x20.

However, if one's work is not printed, one of the greatest rewards offered by photography is missing: looking at a fine art print which embodies not only the abilities of the photographer but also demonstrates one's abilities as a fine art printer.

Goal and Purpose

It is important to consider one's goal and purpose before creating a portfolio. Doing so will make the process much easier. Let me use my work as an example.

Each portfolio I create has a specific goal. Several examples of these goals are provided in the captions accompanying the illustrations featured in this chapter.

I photograph for a purpose. Currently this purpose is to show the beauty and the positive aspects of nature. My purpose is also to create photographs that will be exhibited and used to decorate homes and offices.

Audience

The audience that will view the portfolio must be considered.

An audience does not necessarily consist of a large group of people. Some of us have small audiences, consisting of only a few persons, while some of us have large audiences, consisting of thousands or millions of people. However, regardless of the size of the audience, we must consider the relationship between our work and our audience.

To help you understand your relationship to your audience ask yourself the following questions:

- Which images do I want to show to my audience?
- Are there images I want to leave out and not show to my audience?
- Does my work address a single audience, or do some of my photographs address one audience while other photographs address a different audience?
- What kind of response do I want from my audience? Do I want to please my audience, surprise them, challenge them, shock them, etc.?

Your goal, purpose, and audience may or may not be similar to mine. It is important to be aware of the existence of our audience and to recognize their significance. Deciding on the contents of a portfolio will be much easier if we know our goals, our purpose, and our audience. Knowing these things allows us to make informed choices in regard to the photographs we choose and the artist's statement we write.

Keep in mind that not all work is appropriate for all audiences. While landscapes are most likely to please the wide majority of viewers, we do have to accept the fact that to enjoy landscape photographs viewers have to like nature and the outdoors. Why anyone would not like nature is beyond me, but I am sure there are such persons.

A body of work may focus on a subject other than on nature. Or, the work may consist of landscapes, as well as other subjects. In this case, there may be two different audiences being addressed – one that likes landscapes and the other that likes the other work, be it still life, nudes, architecture, etc.

If this is the case a decision must be made whether or not to include the different subjects in a single portfolio, or if several portfolios should be created, each featuring a single subject.

◄ **Example 3:
Oliver Award
Portfolio**

▲ These 16 images are part of my Oliver Award portfolio. All photographs were created with Hasselblad cameras, using Zeiss 38 Biogon, 60 Distagon, and 150 Sonnar lenses and Afga Ultra color negative film. The image I selected for the cover is the fourth one from the left on the second row.

This portfolio was created for a single purpose: as a submission to the American Rock Art Research Association (ARARA) Oliver Award. The Oliver Award is an international award given to a single photographer for excellence in Rock Art Photography.

The portfolio I submitted, which was unanimously awarded the Oliver Award in 1998, focused on a single rock art site: Little Petroglyph Canyon in the Coso Range mountains near Ridgecrest, California. Three visits to the Coso Range were necessary to complete this portfolio, which was difficult due to the fact the Coso Range is located in the midst of the China Lake Naval Weapons Station, thereby requiring clearance and special permission to gain access. The portfolio consists of 16 photographs. The prints were made on an Iris printer, since at the time, desktop printers were only available with dye inks, thereby not offering satisfactory archivability. Each print is 10x10 matted to 16x20.

Photographic portfolios submitted for the Oliver Award must demonstrate a mastery of both art and science. The photographs need not only be beautiful, but rock art researchers must also be able to use them for research purposes. To this end, I included a CD ROM with the full size scans of each photograph. I also wrote a 20-page essay detailing the equipment and the process I used to create each image in the field, to scan the film, to optimize the images in Photoshop, and to print them. This essay served as the basis for my presentation during the 1998 ARARA conference at which the award was presented. This essay was subsequently published in the conference proceedings. The portfolio prints were framed, displayed, and sold during the conference. As I explain in this chapter, little additional work was required to prepare for my conference presentation, for the exhibit, for the sale, and for publication since nearly all the work was done by the time the portfolio was completed.

Portfolios Are Not Necessarily Aimed at Showcasing a Photographer's Best Work

I started this chapter referring to the reasons why relatively few photographers create portfolios of their work. This is because there seems to be a myth that goes something like this:

A portfolio can only show the best work a photographer ever created.

The problem with this belief is three-fold:

- Firstly, it is difficult to know what our very best work is. As artists we are understandably biased about our work, making such a selection challenging to say the least.
- Secondly, it is difficult to tell whether or not we have enough excellent work to put together a "best work" portfolio.
- Thirdly, many photographers find the concept of a "best work ever" portfolio both pretentious and intimidating. As a result they postpone creating a portfolio of their work preferring to wait until their photography "gets better."

The end result is that many photographers will do nothing, rather than face this endeavor that is perceived as difficult and one that should be reserved for the "great photographers" of this world. They put off the "task" for later rather than face the critiques which they believe are sure to surface should they engage in such an endeavor.

Needless to say, this belief – that portfolios can only be used to feature one's very best work – is inaccurate. This is not to say that portfolios cannot be used to showcase the work of a master photographer over his or her lifetime. Portfolios have been used for this exact purpose since photography was invented. However, this is only one possible use of a portfolio.

Here, I propose a much wider range of uses for portfolios:

Portfolios can be used to show the results of specific photographic endeavors and to present one's work up to the time a portfolio is created.

When approached in this way, portfolios are easier to assemble and far less daunting or frightening. It also becomes clear that there can be many uses for a portfolio, each one tailored to a specific goal, purpose, and audience.

For example we can create:

- A portfolio that includes photographs from a single camera format (35 mm, medium format, large format).
- A portfolio that includes only black and white or sepia photographs.
- A portfolio of images that are radically different from one's "regular" work and which will surprise your audience.
- A portfolio of images created over a specific period of time. This can be a short time (a one week photo trip for example), a specific year (2002, 2003, etc.), or another specific time frame.
- A portfolio of photographs all of which were taken in a specific geographic area. For example, I created a portfolio of images of Isle Royale National Park in Michigan in 1996 when I was Artist in Residence.

The Contents of a Portfolio

Photographs are only part of the total content of a portfolio. After all, this is our opportunity to express ourselves in ways other than with photographs. It is our opportunity to write or talk about what we do, and to explain why and how the images were created. Here is a short list of what can be included in a portfolio:

- An artist's statement
- A title list of the photographs included in the portfolio
- A cover image representative of the portfolio as a whole
- Thumbnails of each photograph
- A nice portfolio case
- A music CD to be listened to while viewing the photographs

Some Important Questions About Portfolios

There are many things to consider when creating a portfolio. I decided to present some of the aspects I have not addressed thus far in a question & answer format:

When is a portfolio complete?

In my eyes, a portfolio is complete the minute the artist considers it ready to present to their audience. I am often asked whether one can add extra images to a portfolio later on. To me this sounds like a second thought, a little like a writer who calls the editor years after a book has been published and asks if he can add an extra chapter or two. I recommend doing our best to make the portfolio complete then close the box, show it to our audience, and move on. If the need is later felt to add to the portfolio, it most likely means it is time to create a new one.

Should portfolio photographs be matted or not?

This really depends on one's personal taste, as well as the type of paper on which the photographs are printed. I personally mat photographs printed on glossy or semi gloss paper because they are easily scratched and do not lay flat if they are not mated. With photographs printed on heavy fine art paper, such as Crane's 300 gram paper, I present the photographs unmatted, and separated with interleaving tissue. I sign each photograph and number them if they are part of a limited edition. I also add my embossing stamp to images printed on fine art papers.

If the intention is for the portfolio images to be framable right out of the box, then matting is a must. Matted photographs can be framed directly, while unmatted photographs will have to be matted first. This is because a mat is necessary to separate the print from the glass or the Plexiglas.

Should all the photographs and mats be the same size?

Traditionally, if photographs are matted then the mats are all the same size. If photographs are not matted then all the sheets of paper are the same size. The image size and dimensions can and do vary, as it is not uncommon to crop images or use different camera formats in the same portfolio. However, having the mat or paper size consistant brings a sense of uniformity to the portfolio.

Example 4: ▶
Print of the Month
Portfolio
A partial display of the print of the month portfolio on beautiful-land-scape.com

Number 1,
January 2003
Antelope Light Dance

Number 2,
February 2003
Yucca at Sunrise, White Sands National Monument

Number 3,
March 2003
Clearing Spring Storm over Canyon De Chelly

Number 4,
April 2003
Navajo Mustangs in Canyon de Chelly

Number 5,
May 2003
Sunset From Yavapai Point, Grand Canyon National Park

Number 6,
June 2003
Eternal Presence, Antelope Canyon

Number 7,
July 2003
Rainbow Over Isis Temple

Number 8,
September 2003
Squaw Creek Ruin,

▲ Each month I add a new image to my Print of the Month Portfolio. I don't know which image I will choose ahead of time, although I do keep a short list of images to consider. This is a very interesting way of creating a portfolio since it makes the selection much easier. It does, in one way, fail to meet one of my criteria since it is not complete at the time it is offered. In fact, this portfolio will not be complete as long as I keep the idea alive and keep adding to it. One solution to this endless portfolio approach is to create an annual portfolio, which would include only images released from January to December of a given year. Images created with all camera formats are included in this portfolio.

How many photographs should be included in a portfolio?

This depends on one's own taste and on one's opinion regarding how many photographs are enough. I personally consider anything past 25 images to be too many. This is not to say that there may not be more images worthy of being included in a portfolio. But the audience will tire after viewing the 25th photograph or so, if their attention lasts that long. Believe me, I have been there. As photographers, many of us are capable of looking at prints all day long, but we must remember that non-photographers rarely have what I call "photographic endurance." In fact, most viewers get tired after looking at 10 to 20 prints.

There is another aspect to consider: if 50, 100, or more photographs are included in a portfolio, the audience is, in effect, being asked to make the final selection. Part of the benefit of creating a portfolio is learning how to make a selection oneself. While this is not necessarily easy to do, it is definitely a worthwhile lesson, as it will teach us to be able to select a few photographs among the many we like.

What is the relationship between a portfolio and a show of my work?

If everything I recommend in this chapter has been carried out, (including a written artist's statement, selection of a cover photograph, matting the images, etc.), the difference between a portfolio and a show is that the images in a show are framed and hung on walls, while portfolio images are matted and displayed in a folio or a box.

What I am saying here is that if one's portfolio is carefully assembled, it can literally be taken to a gallery to be considered for a show. All that will be required to exhibit these images are frames and hanging the work. Very little, if any, additional work will be required.

This is one more reason why the number of photographs in our portfolio should be kept relatively small; 12 to 25 images is a number most galleries will find reasonable. More than that and it may be necessary to eliminate some of the photographs. Fewer than that and there will not be enough images to make a strong impression.

Where do you get your portfolio supplies?

Most essential supplies can be purchased from Light Impressions:

http://www.lightimpressionsdirect.com

What solution do you recommend for storing and presenting the prints?

I personally favor a clamshell design, cloth-covered portfolio box. However, there are many other options available, including portfolio binders, folders, carrying cases, etc. A look at the Light Impressions catalog will show most of what is available. The exact choice depends on one's personal taste. See my remarks on this subject in the conclusion of this chapter.

Photographic Skills Enhancement Exercises

Exercise 1
Selecting photographs to include in your portfolio

One of the most difficult aspects of creating a portfolio is selecting the photographs you want to include in your portfolio. Just like selecting keepers, the easiest way is to make a gradual selection and go through stages. The difference between selecting keepers and se-

lecting images for a portfolio is that a portfolio selection is made over several shoots while a keeper selection is made over a single shoot. Depending on the scope of your portfolio this selection may be made over tens or hundreds of photography shoots covering several years.

However, the process is roughly the same: start by selecting the images you really like by going back through your files, either looking at originals on film or at RAW files, prints, digital images, etc. Pull out all the ones you like and put them all in one place. You may have a combination of prints, transparencies, and digital images on screen. At this stage this is not a problem.

I find it helpful to consider which images are truly representative of the body of work a specific portfolio is about. I focus on finding the images that best show what I was trying to say and accomplish at the time I took each photograph.

I also consider which images are repetitive. I do this by asking myself if my selection contains images that all "say the same thing". If yes, I place these images next to each other to isolate them from the others. I then select the strongest one amongst them.

The key here is to be "tough" with yourself. Some of your favorites will make it and others will not. The goal is to assemble a portfolio that achieves the goal and purpose you previously defined, and that will address the audience you have in mind.

Here is the process I recommend as a starting point:

1. Decide how many images you want in your portfolio. I recommend a relatively low number, about 12 to 25 images, so that you have to make a rigorous selection. If you decide to include 100 images for ex-ample, the number is so high that it will not allow you to make a rigorous selection.

2. If you use several camera formats decide if you want to focus on a particular format (35 mm, medium format, or 4x5 for example). If this is not the case skip this step.

3. Make your selection progressively. Start by selecting 100 images, or so. Then clear your mind, relax, and when you are ready, go back to your selection and reduce it to 50. Do a third round and now limit your selection to only 12 or 20 images.

Take a break, between each selection, at least a day before returning, each time pulling out your favorite images from the selection you previously made. I know, these are already all favorites. This is where it gets tough. You must narrow your selection down to the favorites of the favorites.

4. Making the final cut is the most difficult part because it means eliminating images that you like very much. If making the final cut from transparencies or digital files is too difficult, make small prints (8x10's) from your selection and make the final selection from these prints. Make high quality prints so that you are making a decision based on what your portfolio images will actually look like. I personally make relatively large prints (20x30) because larger prints make it easier for me to decide which images are my favorites.

5. Get feedback from friends, family members, and fellow photographers to find out if they agree with your selection. Show them both the final selection (if you have completed it) and the original "best 50" selection, in case you did not include something that everyone else believes should be in your portfolio

6. When going through this process keep in mind that as photographers we are not necessarily the best judges of our work. In saying this I am not trying to put anyone down. Not in the least. Rather, I base this remark on my personal experience. Had I listened solely to photographers, I would have never printed what are today two of my most popular images. Two other extremely popular images were printed 3 years or more after I created them. Another image was so difficult to print I gave up on it until last year. A friend of mine now calls this image "my signature image." The bottom line is that learning to identify your strongest work is not easy. I used to think that a photograph was good if it had been difficult to create. For example, if I had to hike for several days to get to the location, had to overcome problems with malfunctioning equipment, or couldn't return to the location for years due to lack of time and other imponderable events, then the photograph stood out in my mind as one of a kind. However, my audience does not know all the events I attached to such images. When someone looks at my work, they do not know unless I tell them, how difficult any given photograph was to create. And even if I tell them it rarely changes the viewer's opinion about an image.

I therefore recommend that you not only distance yourself from your work as much as possible (I know how difficult that is) but that you also ask other people which of your images are their favorites. If several people like the same image, it is very likely that you have a winner and that you should include it in your portfolio, even if this image isn't at the top of your personal list. Of course, you are the final judge, and there may be instances in which you want to make a different choice. However, my personal experience has taught me to carefully listen to my audience.

Vary your Portfolio: Consider ways to vary the way your subject will appear to your audience. Select images that show as many different aspects of your project as possible. For example, include photographs taken with different focal lengths. Include close ups and wide angle views, details and wide scenes. In this approach you are not only looking for your best images, you are also looking for images that complement each other, images that work well together when viewed as a set. Don't forget that a portfolio is a collection of images, and that these images need to stand out on their own as well as fit into the theme of the portfolio.

Cover Image: Finally, select one single image as the "title" or cover image. This may be the most difficult part of all, but it is one of the most important aspects of this project. This image needs to stand for what the portfolio represents, for the message you are sharing through your work. The cover image must be strong as a single image and be representative of the portfolio as a whole.

Exercise 2
Portfolio Ideas
Here is a list of possible portfolio ideas. Pick one idea from this list, or come up with your own portfolio idea, then create a portfolio based on this idea. This list is similar to the list on page 122.

- Create a portfolio that includes photographs from a single camera format (35 mm, medium format, or large format).

Example 5: ▶
Navajoland Portfolio
Antelope Light Dance,
Navajoland Portfolio, limited
edition of 50
Linhof Master Technika,
Schneider 75 mm f4.5,
Fuji Provia 100F

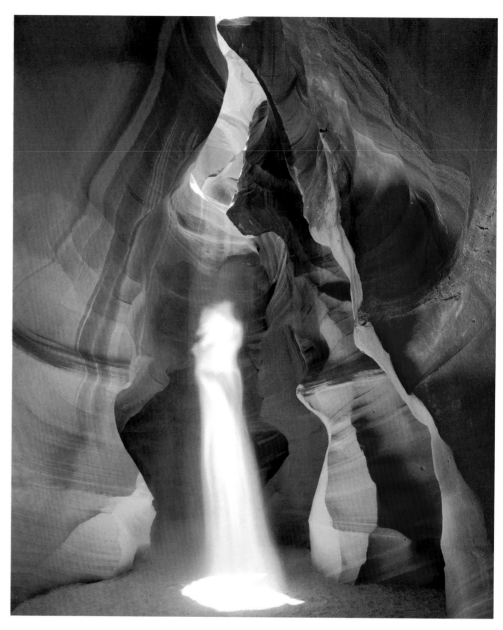

▲ My new Navajoland portfolio, limited edition of 50, expands on my Print of the Month portfolio. In essence, only my favorite images from the Print of the Month portfolio made it to the Navajoland Portfolio. In that sense, I am using the Print of the Month portfolio as a way to make a first selection. I then use the Navajoland portfolio to make the final choice. I do reserve the right to add images to the this portfolio that do not appear in the Print of the Month portfolio. For me keeping a free and open approach to portfolio creation is critical.

- Create a portfolio that includes only black and white or sepia photographs.
- Create a portfolio of images that are radically different from your "regular" work, a portfolio that will surprise your audience.
- Create a portfolio of images that were all created this year. Include the year in the portfolio name.
- Create a portfolio of photographs from a specific area. For example, I created a portfolio of images of Isle Royale National Park in Michigan, when I was Artist in Residence there in 1996.

Conclusion

Creating a portfolio is an important aspect of being a dedicated and committed photographer. It is also relatively easy once the hurdles that have stopped so many have been pushed out of the way.

Creating a portfolio allows us to see what we have accomplished thus far and where we're at right now. It also allows us to plan what we want to focus on in the future. In this sense it is a landmark event that will stay as a record of what we accomplished in photography up to this point. Once completed, the portfolio will make it easier for us to chart our course, plan our future assignments, and schedule upcoming shoots. Our sense of purpose and direction will be enhanced once the completion of a successful portfolio is behind us.

A portfolio is also something we can return to later to visualize how our work has changed over time. In this sense, a portfolio stands as a mark in time, allowing us to see the progression and the changes in our photography over the years.

Countless details come into play when creating a portfolio and for this reason no two portfolios are alike. What separates one portfolio from all others is the photographer's personal style. How to discover, develop, and refine one's personal style is the subject of the next chapter.

How to Establish a Personal Photographic Style

Style has no formula, but it has a secret key.
It is the extension of your personality.

ERNST HAAS

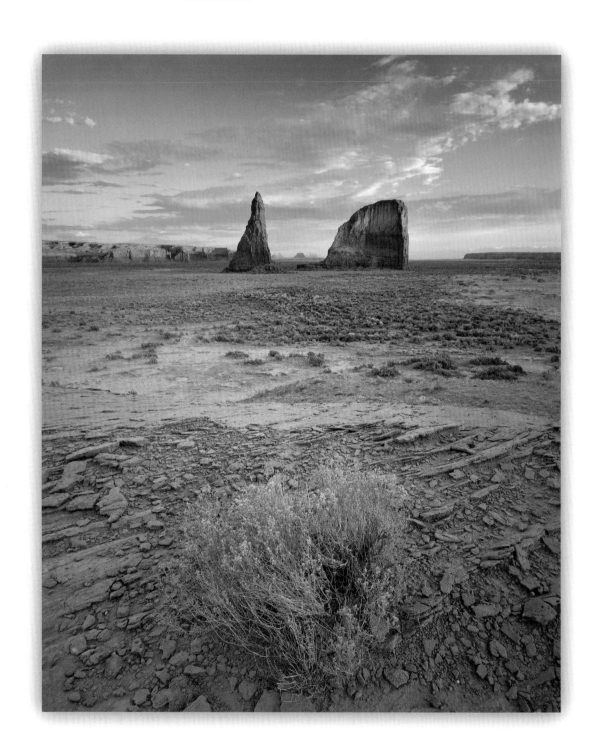

Introduction to Personal Style

Personal style: The term "personal style" has meant different things to me over the years. When I studied at the Beaux Arts in Paris, personal style had the feel of something unreachable, the feel of something one sees and finds in museums, the feel of something which others – those who have "made it" and who have been recognized as the masters – possessed. Personal style had the feel of something that students – those who had not yet made it, those who were studying, trying and working their way up – did not possess.

I was not the only one to think that way. Most Beaux Arts students felt the same. We all struggled with the concept of personal style as well as with the perceived necessity to somehow acquire a personal style. I remember the discussions among students, first at the Beaux Arts where I studied painting and drawing, then later at the American Center, also in Paris, where I studied photography. These discussions centered on our desire to develop a personal style and how this was going to happen. At the time, we could not visualize what that style was going to be or if it ever would be developed. Our discussions regularly ended with the belief that personal style developed over time, that we had to be patient, work at our current projects, and expect a unique vision to emerge from our hard work at some point in the future.

Personal style at that time in our lives was a mystery. The masters had it, but how they got it was unclear. We knew that time and work were involved. We knew that developing a personal style was important to make each of us unique, to help us to stand out, and to acquire a visual presence of our own. But whether that was going to happen or not was a mystery.

Who Are We?

During the discussions we had as students we forgot one crucial element: ourselves. We focused on others, on the Masters, on the recognized, on the accepted, on the artists whose work was collected by museums. What we actually needed to do was to focus on ourselves. We needed to think about what motivated us to study the arts, be it painting, drawing, or photography. We needed to focus on our personal history and on the path we wanted to follow. We needed to consider our family and our past, and from there move on to consider our expectations and our future. We needed to carefully analyze what we liked and disliked. We needed to make a list, of the subjects each of us enjoyed to paint and to photograph. We needed to become aware of which subjects we were ready to spend hours, days, or years working on.

Those subjects were most likely different from those we were asked to work on at school. At the Beaux Arts subjects were used as teaching examples; as exercises designed for us to practice specific skills and understand specific concepts. Yet at the time, as is often the case in school, we couldn't quite separate the two. We were fascinated by our studies more than by our personalities. Our efforts and attention were oriented outwards rather than inwards. Certainly, studying the work of those who have been recognized as masters of their art is important. But when it comes to developing a personal style, what matters most is finding out who we are, what we like and dislike, and what we want to do with the time we devote to our chosen medium.

Driftwood and Glowing Sandstone, Antelope Canyon ▶

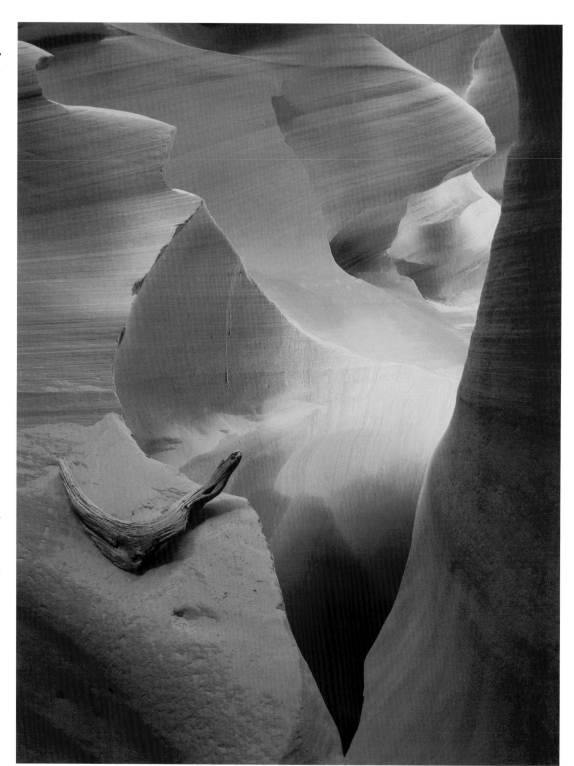

I love returning to the same locations time and time again to create images different from all those I previously created. This image of Antelope Canyon was created during my most recent visit, in late Fall 2004. I had not seen the light effect shown on this photograph prior to that day and had not tried this composition either. ▶

Who Am I?

Who am I? I thought this book was about photography!

The questions I listed above are not easy to answer. To some they may appear as having little to do with becoming a better photographer because they are not related to equipment, technique, or craft.

Keep in mind that we are at chapter 9 of a 13-chapter book. So far, we already looked at many aspects of photography in regard to equipment, technique, and craft. We studied many ways one can become a better photographer. If the reader is starting this book with this chapter, it would be advisable to go back and read the eight previous chapters first. If the first eight chapters of the book have been read, I assume the reader is ready to learn how to develop a personal style.

Again, the questions listed above are not easy to answer. This is because we are rarely asked to answer these questions in the context of learning how to improve our photography. In fact, I was not asked to answer these questions when I studied painting and photography in Paris, although my studies were conducted in world-class institutions. In regard to personal style I was asked to study the works of the masters and the history of art, that was all. Fortunately, I come from a city that fosters the arts, has numerous museums, and holds world-class exhibitions year-round. My studies in art history and my countless visits to museums and galleries have provided me with a broad understanding of art and have allowed me to compare the styles of many different artists. This knowledge has proven invaluable in terms of reflecting upon my own personal style.

However, at the time of my studies in Paris, not once was I asked to consider what I personally liked to paint or photograph, nor why I chose to become a painter or a photographer, nor "who I was" as a person. Why, I really don't know. I assume this is due to the way art is taught. Somehow, over time and through trial and error, beginning artists are supposed to discover who they are and what they like to paint or photograph. This is fine when we have plenty of time on our hands and when the only thing we do is art. But when art is only one of the many aspects of our lives, when time is limited, when we are getting older, or when we need to learn how to develop a personal style, this approach does not work very well.

This chapter is about helping the reader develop a personal style. As we will see, there are a number of potential errors one can make when considering what personal style is. I will try to define personal style by describing what, in my opinion, personal style is and what personal style is not.

A Personal Style is a Unique and Personal Way of Seeing

People don't watch enough. They think. It's not the same thing.

HENRI CARTIER-BRESSON

While visiting a street art show last year I was amazed at how many of the exhibiting photographers had merely copied the styles of famous photographers. I surmise they had done so in order to give a unique "quality" to their work and perhaps, to allow them to stand out among the many other photographers who exhibit at art fairs. Among them I found several "Ansel Adams," several "David

▲ I aim at conceiving my own compositions rather than duplicating those other photographers have created before me. I thought of the composition above during my first visit to this location. While I have seen images of this location by other photographers, I have not seen this composition done by anyone else as yet.

▲ **Celestial Sunrise**
Linhof Technikardan 4x5,
Schneider Super Angulon 75 mm f.56,
Fuji Provia 100F

Muench," and at least one "Jerry Uelsmann." The shows that were held in the Southwest included a large number of landscape photographs on display. But if the subject had been portraiture, wildlife, travel photography, or other mainstay photographic subjects, I believe I would have found a similar attitude in regard to other famous photographers. I do understand that this approach is legitimate from a legal perspective. After all, these artists all create original works of art and do not sell copies of images created by the originator of the style they emulate. However, it is difficult (if not impossible) for me to remember these artists for anything but a pale imitation of the masters they copy.

At this point, the reader may be wondering what personal style actually is. The above story is an introduction to a very important statement in regard to personal style; a statement that, for the purpose of this book, I will be using as a working definition for developing a personal style:

Developing a personal style is not copying someone else's style.
Developing a personal style is finding out who you are and making your work become an extension of your personality.

Don't get me wrong. There is nothing wrong with being influenced by another artist's work or by trying to copy or duplicate this other artist's work as part of one's learning process. In fact, making copies of famous paintings is part of the training young painters go through. Before visiting art museums became a social activity, museums were mostly visited by art students who set up their easels in the museum's aisles and proceeded to copy the paintings in front of them. They were not try-

ing to become faussaires i.e. artists who make a living making forgeries of famous paintings. These students were simply trying to understand how the master composed the piece, selected the colors, and applied specific brushstrokes. They were learning by doing; by practicing the craft someone else had mastered before them.

However, there is a difference between making a copy as part of the learning process and making a career out of imitating another artist's work. I believe that personal style is the extension of one's personality. In photography, I believe that personal style is our personality presented though the photographs we take. If we merely copy someone else's style, we negate our own personality.

Choosing a Subject is Not Developing a Personal Style

Every man's work is always a portrait of himself.
ANSEL ADAMS, CARMEL, CALIFORNIA, 1979

As we will see later in this chapter, choosing a subject that we enjoy photographing is a factor in developing a personal style. For some this is the first step towards developing a personal style.

However, choosing a subject that we like to photograph is not the same as developing a personal style. To verify this point, one only needs to look at the work of photographers who photograph different subjects while maintaining a coherent style across the various subjects they photograph, with allowance made for the specific requirements of each subject.

For example, deciding to photograph landscapes is not enough to develop a personal style; deciding to photograph Formula One races is not enough to develop a personal style; and deciding to photograph Alaskan wildlife is not enough to develop a personal style. You get the idea. To develop a personal style one must photograph his or her subject of choice in a *style* that is unlike anyone else's, a style that can be recognized as being that artist's personal style.

This brings us to the subject of style, and to the difference between subject and style:

Subject is what you photograph.
Style is how you photograph it.
You can photograph several subjects in the same style.

Choosing a subject is answering the question "What do I want to photograph?" Subject choice is about *what* we photograph.

Choosing a personal style, or rather *developing* a personal style, is answering the question "How do I want to photograph my chosen subject?" Style is about *how* we photograph.

Developing a personal style is not the same as choosing a subject. These are two different concerns: the former is easy, the latter is difficult. If a subject has not yet been chosen, I recommend doing so *before* considering what one's personal style might be. Of course, doing things in this order is not an absolute requirement. One can develop a personal style while shooting a variety of subjects, without having a particular predilection for any of them. However, if a structured environment in which to develop a personal style is desired, choosing a subject first will make things a lot easier.

As I said earlier, different subjects may be photographed with the same style. This means that potentially, a personal style can be developed while shooting a variety of different subjects at the same time. While this is feasible and may result in success in terms of finding a personal style, it will also make things more complicated due to the necessity of thinking about how to photograph several entirely different subjects. Therefore, I recommend working with only one subject while developing a personal style.

Choosing a Subject Is Not the Same as Choosing a Genre

In the previous section we learned that *subject is what you photograph* and that *style is how you photograph it*.

One more concept needs to be introduced, and that is *genre*. Genre, in art, is another term for "art movement". For example, Impressionism is an art movement and therefore a genre; so is Surrealism, Dadaism, Cubism, and any other art movement.

Genre defines how you look at your subject from the perspective of the art movement you embrace

For example, Impressionism seeks to express how it feels to be at a specific location, or how it feels to be engaged in a specific activity. For a surrealist painter, the goal is not to reproduce reality in its minute details. The goal of the surrealist is to bring forth that aspect of reality that will cause an emotional reaction in the audience when they look at the painting in front of them. Different techniques have been developed by surrealist painters to achieve this goal including pointillism, in which dots

of colors rather than brushstrokes are used; expressive brushstrokes, which show the painter's gestures as much as they show the subject depicted in the painting; and saturated colors juxtaposed in a calculated manner so as to create a different impression when the painting is viewed close up or from a distance.

How does this relate to photography and to landscape photography in particular? For one, genres – photographic movements in this instance – are a part of photography just as much as they are a part of painting and other visual arts.

The Group f/64 of photography is one of the most famous photographic movements. If this movement (genre) is embraced, we will seek to emulate its masters, be it Ansel Adams, Edward Weston, Willard Van Dyke, Imogen Cunningham, Sonya Noskowiak, John Paul Edwards, and others. The tenets of this movement, also known as *Straight Photography* or *Pure Photography*, were defined as being the elimination of any "qualities of technique, composition, or idea derivative of any other art form." In practice, f/64 photographs are characterized by lack of image manipulation; careful rendering of delicate tonalities and image details; extreme depth of field; and the refusal to use softening filters or lenses, heavily textured papers, and printing or retouching processes that involved altering the overall appearance of the photographic image.

The decision not to use softening filters was one of the major tenets of f/64 that was created as a reaction toward the *Pictorialist* movement headed by Moriarty. The pictorialist genre endorsed the use of soft lenses and diffusing filters in order to give the image a soft, poetic look. The pictorialists also endorsed the use of veils, setups, props, and other artifices, either in the studio or outdoors, including

in wilderness settings. f/64 endorsed photographing the subject in its natural state, as it was found, without altering it in any way.

Notice that a genre is subject-independent. It is defined by an approach, a methodology, a way of seeing and representing the world. What is represented within this genre is up to the artist. In the case of f/64, the subjects chosen by the various members of the movement covered the gamut from landscapes to portraits to nudes to reportage to cityscapes and more. What brought all these subjects and artists together was that they adopted the same genre and thus were part of the same photographic movement.

Do we have to choose a genre? While this is certainly not an obligation, one's work will sooner or later fit into a specific genre, whether we choose to or not. This is because as we look at various photographs, as we decide which ones we like and don't like, and as we make choices for our own work, we slowly but surely start working within a specific genre. This process is sometimes conscious and sometimes unconscious. I am sure there are numerous black and white photographers out there who are not aware of the influence f/64 had on them, or that their work is really part of that genre.

Personally, I believe it is better to know which genre our work is moving towards or becoming part of. This knowledge will allow for informed decision-making, including the decision of not want to be part of a particular genre, of wanting to depart from it, or of wanting to make changes to its set of tenets. For example, a number of contemporary color landscape photographers were originally influenced by f/64, but they decided to work in color instead of in black and white. This simple change makes them less recognizable as em-

bracing the f/64 genre. Yet, when one looks closely at their work, besides not working in black and white, every other tenet of f/64 is present: small apertures are used (the tenet behind the adoption of the name f/64), depth of field is carried throughout the image, and softening or diffusing filters are not used. Notice that, although created by a group of black and white photographers, there is no statement that f/64's *Straight Photography* approach must be done in black and white.

Personal Discovery Is Not Personal Style

It is common for artists to discover new ways approaches, and techniques of creating images. Often, these new approaches or techniques will lead to the creation of images that the artist had never seen or done before.

I have experienced this there several times. The first time was, during my studies at the Beaux Arts where I "discovered" painting techniques and styles that I considered to be *breakthroughs* in the world of art, guaranteed to bring me fame and fortune. And later, when I purchased my first camera and experimented with various lenses, films, and darkroom techniques, I achieved results that I believed guaranteed me posterity and worldwide fame.

I was wrong in both instances, a fact my teachers promptly made me aware of. What I had thought was my own discovery had not only been previously discovered by other artists long before me, it had also been elevated to a level of perfection I could only dream of. My teachers recommended that I study the work of these other artists at length and that I not only learn to duplicate their art but also become a world-expert on their work. Only

then would I be able to go beyond what they had discovered, and, perhaps, make discoveries of my own.

The same rule applies to any artist working in any medium. The process of discovery is a part of the journey toward developing a personal style. It is not personal style.

A Personal Style Is a Combination of Choices

What we photograph, the genre we embrace, and how we photograph our subject are all part of developing a personal style. To this end, one can say that personal style is the combination of multiple choices made in regard to the equipment used, the subject photographed, the photographer's personal taste, and countless other variables.

To better understand this point, let us take a look at how the choices made by two specific photographers helped to define their style. I purposefully selected photographers with fundamentally different styles to better illustrate my point. For simplicity's sake I divided the variables into five categories: equipment, background, approach, subject, and quality of light. I did not include a section on genre as both photographers follow a straight photography approach.

If we removed the names of the photographers below and showed the list to a photographer familiar with their work, that person could easily guess who these two photographers are. Their personalities are apparent in their choice of equipment, subject, approach, and light.

◀ **Clearing Snow Storm over Spiderock, Canyon de Chelly National Monument**
Hasselblad SWCM-CF,
Zeiss Biogon 38 mm f.3.5,
Fuji Velvia 50

◀ My first and foremost passion is the grand landscape and I seek to be out there when unique events take place so I can both experience and photograph them. This photograph of Spiderock, taken just as a winter storm started to clear, represents such a moment

▲ **Old Factory, Pantin, France**
Canon 300D, Canon 18-55 dedicated zoom

▲ **Rue Cartier Bresson, Pantin, France**

Style is the extension of one's personality and one's personality is, in part, defined by one's childhood.

◄ Cartier Bresson grew up in Pantin, a suburb of Paris, where a street is now named after him. His parents owned a factory; maybe the one above located on Rue Cartier Bresson, and used today as a city vehicles depot.

◄ David Muench grew up in Santa Barbara, California with the Big Sur Coast in his backyard.

After comparing the locations where both photographers grew up, is it really surprising that one chose to photograph street scenes, and the other chose grand landscapes?

▲ **Big Sur Coastline, California**
Olympus OM4T, Fuji Provia

Henri Cartier Bresson

Equipment

- Small, lightweight camera (35 mm Leica M)
- Normal or semi wide lens (35 mm lens; he often used one lens)
- Black and white roll film – can shoot up to 36 images without reloading

Background

Cartier Bresson was born in the Paris suburb of Pantin. His parents owned a factory and were financially successful. He did not need to work for a living and could focus on his passion for photography. At the same time he had direct contact with city life through the workers employed by his parents, through living in a working area, and through his daily contact with the Parisian environment.

Approach

- Camera is used handheld
- His photography is spontaneous
- He moves around fast and works the subject from multiple angles
- He pays close attention to details when composing in the viewfinder because his goal is to create images that will be printed full-frame, without any cropping
- His goal is to capture the "decisive instant"; the moment when disparate human and non-human elements in the scene suddenly come together to form a coherent whole
- He photographs only in black and white
- He moves around the scene continuously in search of the perfect moment when composition, point of view, people, and other elements come together

Subject

- People are present in each image

- He works where people are present, be it in cities, parks, the countryside, or while traveling

Quality of light

- He uses the light present in the scenes he finds. While quality of light is important, it is secondary to his subject. In other words, the situation comes before the quality of light. Capturing a decisive instant in poor light is better than capturing a common (my expression) in ideal light.

David Muench

Equipment

- Heavy and cumbersome large format camera (4x5 Linhof Master Technika)
- Variety of lenses from wide to telephoto with a predilection for super wide-angle lenses
- Color sheet film; able to take only one photograph at a time

Background

- Member of a family of landscape photographers. David is the son of Josef Muench and father of Marc Muench, both very successful landscape photographers in their own right. The Muench's follow in each other's footsteps, so to speak.
- Recognized for his work worldwide

Approach

- He is known for his near-far compositions using extremely wide-angles
- He also uses a variety of recurring compositions
- He works almost only in color
- Careful planning is part of creating most of his photographs. This planning includes:

- Researching hard-to-reach and never-be-fore-photographed locations with photogenic qualities
- Returning to the same location year after year
- Being at a specific location at a specific time of the year
- Knowing when and where the sun or moon will rise or set at a specific location
- Knowing when spring flowers and fall colors will be at their peak in a specific location

- Intimate knowledge of Northern American landscapes as well as their geology, botany, flora, fauna, etc.
- Stays in one place and waits for the perfect moment

Subject
- He photographs essentially landscapes together with some historical sites
- He focuses on national parks, recreation areas, wilderness areas, and other protected areas
- He keeps informed of the designation of newly protected areas
- He participates actively in protecting sensitive natural areas
- He is a member of several protection groups and associations

Quality of light
He carefully selects the best light for a specific subject. While the subject and composition are important, light quality comes first. In other words, the perfect composition and scene will only reveal themselves in the ideal light. This means finding the subject and either waiting for the light, or coming back when the light is at its best for the location.

A Personal Style is Fine Tuning Choices to Fit Your Own Personality

In many ways personal style is refining choices that can be made by other people. By refining our choices we end up creating something unique because of the time spent considering all the issues, refining our approach, and polishing our style. On the surface, what we do may seem simple, easy, and effortless. But underlying the polished and effortless impression, our work projects countless hours of research, months of trial and error, and years spent testing, experimenting, and attempting to succeed through various means.

In the comparison images on page 140, I selected two photographers whose subject, approach, and style is so entirely different that one could say they are nearly opposite. Again, I have done so purposely to better illustrate my point and to do so in a concise manner.

However, in practice, when one focuses upon a specific photographic subject, the style of individual photographers working with the same subject becomes increasingly similar. At that point the comparison above no longer applies because one needs to compare artists who are using nearly similar equipment, approach, subjects, and quality of light.

To remedy this situation, and to demonstrate how *refinement* actually results in creating different styles, I will now expand the comparison above by comparing the style of two large format landscape photographers: David Muench and Jack Dykinga. In this second comparison I will be using the same four categories I used previously.

This comparison focuses on minute points that may or may not be noticeable by the casual onlooker or admirer of both photographers', work. In a way, this comparison is closer to an

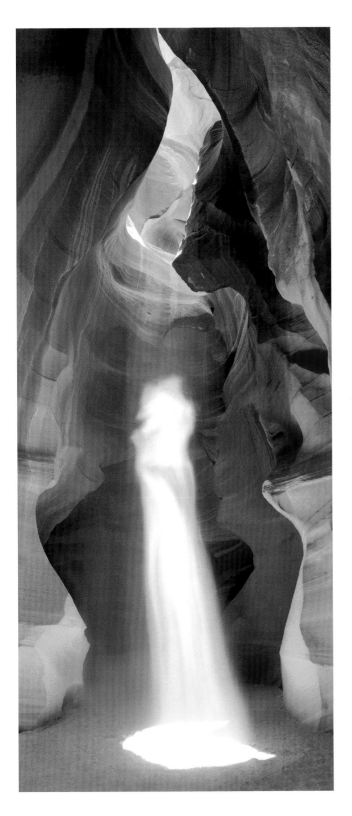

◄ **Antelope Light Dance Vertical Panorama**
Linhof Master Technika 4x5,
Schneider Super Angulon 75 mm f.56,
Fuji Provia 100F

◄ I like to try different compositions from the same photograph, as shown by this vertical, panoramic version of one of my most well known 4x5 photographs.

exercise in comparative literature than to a visit to a photography exhibit. It is also a comparison that shows how important it is to fine tune personal choices.

David Muench

Equipment
- Linhof Master Technika 4x5 (folding flatbed 4x5 camera)

Background
- See above

Approach
- Large format landscape photography nearly exclusively
- Almost all photographs taken while using a tripod

Subject
- Frequent thematic photographic organization by States (Colorado, Utah, Arizona, etc.)
- Nationwide coverage
- Strong affiliation and focus with National Parks, recreation areas, wilderness areas, etc.
- A definite orientation towards images to be used for commercial purposes
- Market is stock photography, and publishing first and fine art prints second

Quality of light
- Very diverse light qualities. Light choices evolved during the course of his career. Backlight was favored earlier on for its strong and bold quality. Later, softer and subtler light qualities were selected. Dramatic light is still a favorite. David favors storms and active weather. David once said, "Bad light means good photographs".

Composition
- Arguably the originator of near-far compositions in photography. Definitely one of the strongest advocates for this composition and style. Near-far compositions usually use a foreground element which is centered at the bottom of the image. The majority of Muench's near - far compositions are verticals ("portrait" orientation)

Jack Dykinga

Equipment
- Arca Swiss Monorail 4x5 and Deardoff 4x5 (folding flatbed 4x5 camera)
- Favors the latest Schneider lenses. Chooses lenses that have the largest covering power (image circle) with the latest design features, such as lenses that allow him to shoot straight towards the sun, even including the sun in the image, without causing flare

Background
- His background in journalism shows in his current style, which may be described as a more journalistic approach to landscape photography. He is motivated to show facts rather than emotion in his landscape photographs
- Received Pulitzer Prize in photojournalism

Approach
- Will reconnoiter and select a place, and go back day-after-day to get the shot
- His use of a monorail camera allows him to use more drastic camera movements than with a flatbed camera
- More "verbal" than Muench in regard to his technique. Published a book on 4x5 tech-

nique entitled "Large Format Landscape Photography"

Subject
- Focuses mostly on the western United States, especially Utah and Arizona

Quality of light
- Uses a wide array of light qualities
- Favors what he calls "horizontal" light at sunrise and sunset
- Muted and pastel colors in comparison to Muench, using colors that please the eye rather than shock and startle

Composition
- Makes use of near-far compositions but does not necessarily center foreground images at the bottom of the frame. Instead, nearby objects are often placed off-center, to the right or left side of the image, or across the entire width of the bottom part of the image. Also, near-far compositions are often horizontal images ("landscape" orientation), with the foreground object usually placed off to the right or left side of the image.
- Use of compositions that are less "in your face" than Muench's, less "dramatic" perhaps. This is not a factor of the exact focal length used, but more a factor of the photographer's intent

A personal style is not just about capturing facts. Personal style is also about expressing emotions

To be able to really see, one must open not only one's eyes. One must above all, open one's heart.
GASTON RÉBUFFAT, FRENCH ALPINIST

The above study of the respective styles of David Muench and Jack Dykinga opens the door to two very interesting remarks. The first remark addresses the concept of subjective versus objective and of emotion versus facts.

As we just saw, Dykinga has a more "journalistic" approach to formal, large format landscape photography than does Muench. This is due to Dykinga's background in journalistic photography. Dykinga's work demonstrates a desire to give a feel for the nature of the location, something achieved by a strong desire to recreate, the feel and ambiance of each location by photographic means. Dykinga, in my opinion, does this in a factual manner rather than an emotional manner. The facts that would be found in a journalistic text, are found in Dykinga's photographs through his careful composition of each image and his use of carefully chosen details to show the exact nature of each subject.

This is in contrast to Muench's approach, whose desire seems to be more about presenting us with scenes that, while real, seem impossible at first. To achieve this, Muench is constantly on the lookout for natural events that have not been previously photographed: the sun or the moon rising or setting in locations where we never thought they did rise; incredible storm clouds; an interplay of light and shade upon a specific scene that we never would have guessed is part of the natural realm; scenes so perfect, so stunning, and so rare that we would never have thought they could exist without the skilled intervention of an experienced artist.

In comparison, Dykinga's style presents us with scenes that, although stunning on their own, are much easier to accept as "natural"; scenes that are more understandable, and that

require less of a stretch in our conception of what is natural.

If we were to make a comparison with literature or with writing, Dykinga's photographic prose makes use of fewer *adjectives* than Muench's does. Adjectives are words that indicate a subjective, rather than an objective, opinion. In journalism adjectives are often avoided, especially qualifying adjectives. Walter Cronkite, for example, said in a recent interview that when he was first hired, his network asked him not to use adjectives. Journalism is about reporting facts and events. The reporter is there to give a factual description of the scene and of what happened; he is not there to reveal his or her personal opinion. Again, Dykinga's background as a journalistic photographer is reflected today in his landscape photography through his controlled use of *photographic adjectives*, we might say.

The second remark above addresses the fact that choices in equipment, approach, subject, and light are only one aspect of personal style. Why? Because, after all, these variables are external to the photographer. As such, they can be chosen – or imitated – by other photographers, as I explained earlier in this chapter, in my street art show narration on pages 133 to 135.

What cannot be imitated by other photographers is the personality of the artist: not what the artist does, but who the artist is. This statement begs the question: how does this play out? It plays out in the artist's behavior, in what one likes and dislikes, in what inspires the artist, and in how the artist responds and represents scenes they are seeing for the first time. The best way to explain this is to use myself as an example. I will do so in the context of describing my personal style.

My Personal Style

The reader may be wondering how I see my own style and how I would describe it, and which is a fair question. Here is my answer in terms of how I approach my subject, the choices I make, what I like and do not like to do when I photograph, and what I consider to be meaningful characteristics of my personality and hence of my style:

- I have no interest in taking photographs that look the same as those taken by other photographers. I can simply buy their prints. When I visit a location my goal is to create my own images.
- I find that using 4x5 gives me the highest image quality and an enhanced state of creativity and reflection upon the scene I intend to photograph.
- I enjoy using smaller formats, such as medium format and 35 mm, either jointly with 4x5 or by themselves.
- I believe that each camera type has advantages and disadvantages, and that no single camera can do it all.
- I use both film and digital cameras.
- I like to photograph using several cameras at the same time, often setting up two cameras on separate tripods to capture my subject in different shots at the same time. This allows me to maximize the opportunities presented by a single sunset or sunrise.
- I always carry at least one medium format or 35 mm camera in addition to my mainstay 4x5 view camera, for those shots where only the ability to photograph quickly and handheld will allow me to capture the moment.
- I enjoy using a digital SLR as a light meter for the histogram function and LCD preview it gives me.

- To make a personal comment on the use of adjectives: I love adjectives. My goal is not to use them less but to use them better. In my work, this translates into photographs in which capturing emotions comes before capturing facts.
- I favor living in the locations I photograph in order to develop a personal affinity with each place and to have plenty of time to explore these locations in depth and on my own time.
- I enjoy waiting at a location until the light is at its best. I consider myself to be very patient when it comes to waiting for the best light.
- I enjoy simply spending time at a beautiful natural location and not photographing. I believe there are many different ways of experiencing a place and that photography is only one of them.
- I do not tire of returning to the same locations year after year, sometimes several times a year.
- I make it a point to create a new image, one I have not created before, each time I return to a location I have previously visited.
- I adopt an opportunistic attitude when looking for photographic possibilities in a natural location. To use a metaphor based on the food gathering methods of prehistoric American cultures, I see myself more as a hunter and gatherer of light, compositional elements, and photographs, than as an agriculturalist. I gather and find what nature offers me throughout the year; the seasons and the locations. I do not cultivate crops or affect how and what nature offers.
- I believe there is no bad light or bad subjects, just different and more or less challenging opportunities.

- I believe unplanned circumstances more often than not offer unplanned opportunities.
- I work primarily toward creating fine prints and being able to enlarge these prints to very large sizes.
- I believe I do not fully know what I have captured until it has been printed, preferably a large print.
- I currently favor color over black and white, although in the past the opposite was true.
- I love the improvements brought about by digital technology, and improvements in all domains, that address my creative and business life.
- While my primary focus is landscape photography, I also enjoy photographing street scenes and people in their natural, non-posed situations.
- I pray I never have to photograph a wedding. So far my prayers have been answered.
- The same comment applies to posed portraits in which the sitter decides which images they want.
- I would enjoy emulating Richard Avedon's style and approach in regards to portraiture.
- Fortuitous attempts have helped me define my style. See below:

Fortuitous Attempts and Defining Images

Les chefs-d'oeuvre ne sont jamais que des tentatives heureuses
(Masterpieces are always fortuitous attempts)
GEORGE SAND.

Establishing a personal style takes time. It does not happen overnight. Unlike a new camera, one cannot simply order a new personal style, have it delivered, unpack it, and

immediately start photographing to see what one can do with it. While companies that are unrelated to us make cameras, a personal style comes from within and is generated by us. There is no equipment designed to help us create a personal style. Fortunately, there are approaches and actions that can help us.

In my case, establishing a personal style has been largely dependent upon the two things I mention in the title of this section: *fortuitous attempts*, as George Sand says so well, and *defining images* which I humbly declare have often been the results of these fortuitous attempts. Before I go on to explain what I mean, I want to first metaphorically tip my hat to George Sand, the female French author who, although forced to use a man's name in order to be recognized in what was a man's literary world, was fully aware of what it took to create something unique. Let us note that there is, when it comes to personal style and masterpieces, absolutely no difference between literature and photography.

So what do I mean by defining images? To me, defining images are images that, quite simply, have allowed me to define my style. What I allude to above when quoting George Sand, is that these images were not created for this purpose. When I created the photographs that ended up defining a new direction in my work – a new personal style – I did not intend to do so. In this respect, these defining images were fortuitous attempts. These images were created because, at the time, they were the photographs I wanted to take, and were the images that embodied the strongest way I could think of seeing. They were created because, these were the images I was truly excited to capture. It was only in retrospect, when looking back at what happened after I created these images, that I understood how

they opened my eyes to new possibilities and to a new way of seeing. It was only later that I realized how creating these images changed the way I photographed from then on.

Photographic Skills Enhancement Exercises

It is time for some Photographic Skills Exercises. In the context of style, these exercises are designed to help the reader reflect, and to help define one's own personal style.

Knowing who you are, your likes and dislikes, and which equipment to use are structural foundations upon which you can build a strong personal style. For this reason I urge you to complete all three parts of Exercise A before continuing on to the subsequent exercises:

Exercise 1
Defining your style

- **Defining your style part 1** – *Personality*
 Using the first four pages of this chapter, list the main characteristics of your personality, as you see it. You may also refer to the section, "My personal style", found on pages 146-147, where several personality traits are listed.

- **Defining your style part 2** – *Approach*
 Using the explanations found in this chapter on pages 135 and 136, define what subject (or subjects) you want to photograph and what genre you want to embrace. You may have to do some research about both, as I do not provide a list of all possible genres or subjects in this chapter.

- **Defining your style part 3** – *Equipment*
 Using the examples on pages 136-138, found in this chapter "Choosing a subject

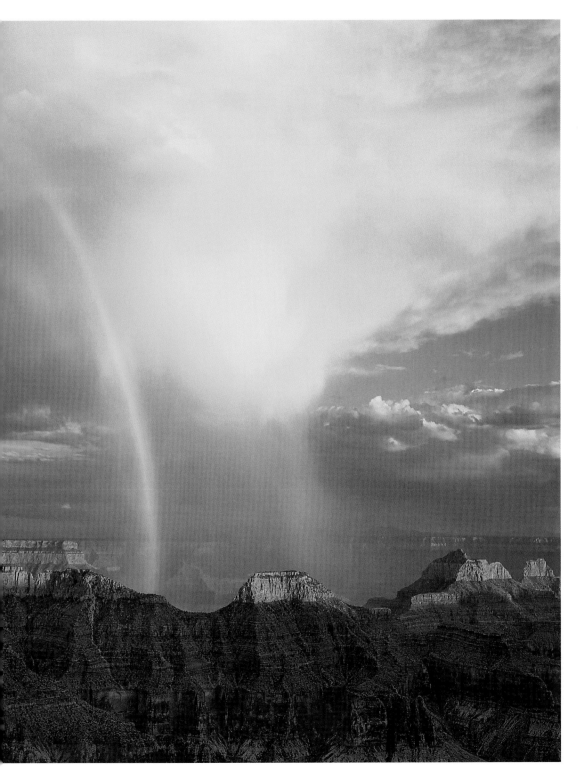

◄ Bright Angel Rainbow, Grand Canyon National Park
Hasselblad 500C, Zeis Distagon 60 mm f.3.5, Fuji Velvia 50

◄ This image represents a fortuitous attempt. I was there to photograph the sunset on that day but it was raining and clouds obstructed the sun until minutes before sunset. When the sun came out I was not prepared for the sight of this rainbow. I first tried a close up of the rainbow, then shot this wider view of the whole scene. Until I received my film back from the lab. I was convinced the close up was the best image.

is not the same as choosing a genre", make a list of the elements that best define your style including camera equipment, subject matter, approach, locations, etc. You can list equipment you currently use or equipment you would like to use. Similarly, you can list subjects you are currently photographing, or subjects you want to photograph but haven't yet had the opportunity to photograph.

- Expand on the example I gave in the section "Choosing a subject is not the same as choosing a genre" (see page 136), by selecting several photographers whose style and images are particularly appealing to you and find out what equipment they use, what approach they follow, what subject they favor, and what light they prefer.

Exercise 2
Attend Workshops

- I strongly recommend you attend workshops. Not just one, but several. Style develops over time and you cannot expect to develop a personal style over the course of a single workshop. Workshops will allow you to get personal answers to your questions and to work on areas that are particularly challenging. They also allow you to work with accomplished professionals who have faced the difficulties you are facing and who can offer effective solutions.
- Seek a mentor, someone who is where you want to be and who is willing to help you and work with you.

Exercise 3
Try new things

- Try new and different things. Try things that you like, but also try things you have not yet done. Try to do what is challenging to you. Photograph subjects you have not yet photographed. Even better, photograph subjects you haven't photographed yet because you were waiting to "be a better photographer" before photographing them.
- Do not be afraid to fail. We all have to fail before we can succeed. Success is not lack of failure. Success is overcoming failure. Nobody starts as a master in anything. We all work our way up to that level. We all must learn before we can master a technique, a style, or any endeavor for that matter. What makes the difference between failure and success is not being afraid to make mistakes. In many ways we learn through mistakes. We can devise ways to avoid mistakes, but eventually we must make mistakes in order to get to the next level. You know you are getting better when you are getting close to having made all the mistakes.
- Do not be afraid to take bad photographs. You have to start somewhere. Mistakes are the normal process through which we learn how to do something new. No one starts as an expert. We all work our way up to it through our attempts. For each success a number of failures must be expected.
- Regrettably, we rarely get to see the failures of famous photographers. Why? Maybe because they do not wish to share them; maybe because their publishers do not want to show them; maybe because this is the way photography has been presented thus far; maybe because photography as a whole is a medium that hesitates to show its attempts. In painting we regularly see entire exhibitions focused on the artist's attempts; namely the artist's sketchbooks. We rarely see half completed paintings because a canvas is often re-used later on, thereby covering the previous attempt. But, occasionally, an exhibition will feature a partially

completed piece. When was the last time you saw a photographic exhibition in which there was a half completed photograph? Mistakes, half completed attempts, trials and errors, and "sketches" have been one of the best kept secrets of the photography world. However, mistakes do happen in photography, even if we do not get to see them because they had been discarded, filed away, or otherwise kept from the viewing audience. I think it is time for a change, and in my future writings I plan to show, not only completed photographs as examples, but also the various attempts, the other images I created while in the process to create the photograph which I eventually came to select as the best of the lot. I think there is much – if not more – to be learned from these attempts as there is to be learned from studying the final piece.

Exercise 4
Study the work of other artists

- If you find that your work tends to look like the work of another artist, then you should become the world's expert on this particular artist. Learn everything there is to learn about this person, and if possible, meet him or her personally. Study with them. Make them your mentor.
- Look at medium other than photography for inspiration. Look at arts produced for reasons other than aesthetic, such as tribal and primitive arts. Look not only at photographs. Look also at paintings, sculptures, and drawings. Listen to music, etc.

Exercise 5
Create assignments for yourself

- Self-generated assignments – especially assignments that you have not seen done before – are powerful motivators in developing a personal style. You cannot develop a personal style by only redoing what others have done before.
- Take a chance and discover what you can do with a specific subject, without knowing beforehand what you are going to do with it. Too many photographers know what they will photograph and which images they want to bring back *before* they start a new photography trip. Where is the discovery in this approach? And without discovery, how can one develop a personal style?

Conclusion

Finding a personal style is more of a journey rather than a destination. As we have seen, there are several parts to it: subject, genre, and style. Firstly, we must find what we want to photograph (subject); secondly, we must find how we want to photograph it (genre); lastly, we must bring our own personality into the equation (style). Only then will we be able to photograph the subject of our choice, within the genre we decided to embrace, and in our own personal way. If we can achieve this, then personal style will follow. A lot of work is involved in this endeavor including acquiring the specific equipment needed and becoming educated about the work done by other photographers before us. To succeed in this endeavor it is necessary to be passionate about one's work and to be willing to seek help from those who have ventured down this path be-

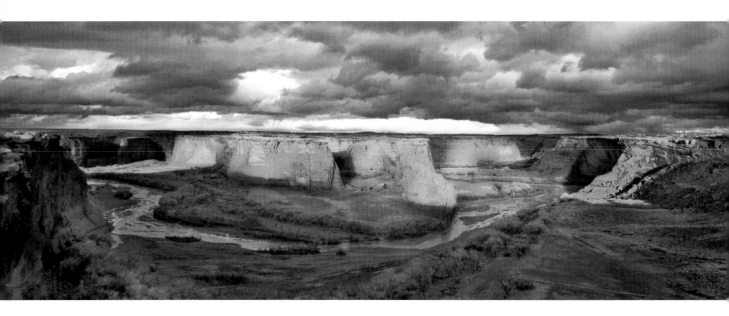

▲ This photograph, as well as "Grand Canyon Rainbow", ended up defining an important direction in my work, although, both were *fortuitous attempts*. I never intended to create this image, I just saw the dramatic relationship of storm clouds and isolated light shafts. I used the only camera I had with me at the time, a 35 mm Olympus, and later cropped the image to a panoramic composition. This photograph was the reason why I acquired a Fuji 617 panoramic camera.

▲ **Clearing Spring Storm, Tsegi Overlook, Canyon de Chelly**
Olympus OM4T, Zuiko 18 mm, Kodak Royal Gold 25

fore us. Above all, it is necessary to be patient, as results will only come forth over time.

A personal style is the extension of one's personality. Our style reflects who we are, what we like, what we dislike, what we find important, etc. A personal style is a way of seeing which differs from other artist's way of seeing. It is one's personal way of seeing the world.

A personal style reflects what we see, what we find important, and what we want to capture in our photographs. Our style may change as we change and as our relationship to the

world changes. I truly believe that most artists are quite aware of their personal style. Why? Because, as artists, we create our own style. This style is the result of our efforts, our endeavors, and the choices we make. It is we who work each step of the way toward a particular result. It is we who make all the necessary decisions to insure that the image on paper matches, as closely as possible, the image in our mind; our pre-visualization, if you will.

I am constantly amazed at how much knowledge most photographers have about cameras

and photographic equipment, whether it is equipment they own or do not own. Often, they know far more than I do, to the point that I wonder if there is something wrong with me and whether my work would be better if I knew as much as they do about the pixel count of a specific camera, the exact reference number of a specific Gitzo tripod (being French is not enough to fully master Gitzo's numbering system), or the exact advantage of one lens over another.

On the other hand, I am constantly amazed at how little is said among photographers about the work of other artists, except for a few names that come back regularly such as Ansel Adams, David Muench, and a few others. I am also amazed at how little is said among photographers about the other arts. While I consider painting to be one of the main influences in my personal development as an artist, and while I regularly discuss how certain paintings have influenced my decision to become a photographer, I find that relatively few photographers share my interest in comparing different types of art. Similarly, in the days of Ansel Adams, many black and white photographers listened to classical music while printing. Some even listened to classical music while photographing in the field. This practice is still alive today among the remaining students of Ansel Adams. However, photographers who come to the craft today seem to have lost this connection with other art forms, be it music, painting, sculpture,

or other media. It appears we are moving in the direction of photography being just about photography, without external references to other arts.

I believe it is important that we work toward reversing this trend. If photography is an art form, then it is important to be able to relate photography to other arts, and to enjoy it together with other forms of art. If this is to happen, then it is important to be knowledgeable in other art forms, not just in photography. While this is not the subject of this chapter, I believe it is related to developing a personal style. It is also a subject I expand on in the next chapter: "Being an Artist".

Being an Artist

If you ask me what I came to do in this world, I, an artist, will answer you:
I am here to live out loud.

EMILE ZOLA

Introduction to Being an Artist

This has to be the most difficult chapter I have written thus far, not to say the previous chapters were easy. The truth is that each one has become increasingly difficult to write as I progress toward the end of this book and move from technical considerations, such as "Exposure", "Film Choice2", or even "Seeing Photographically", to more elusive and personality-based aspects of photography such as "Selecting Keepers", "Creating a Portfolio", and most recently "Developing a Personal Style".

As I progress toward completion of this book, I have managed to balance the "perilous" act of presenting information coming from personal experience in such a way that this information is useful to those who do not have direct experience with the subject. I believe I succeeded in this endeavor even when discussing something as private as personal style. It was a difficult act, somewhat akin to walking a tight rope, but it was feasible.

When it came to describing what "Being an Artist" is, the difficulty increased ten-fold. At first, I assumed that I was facing the same difficulties I faced with the previous chapters; that I was covering a subject on which little had been written, and for which I had to create nearly entirely new material. But, as I toiled down the road, working on this chapter, I realized that the problem of describing what being an artist is was more complex. Why? It is more complex for three main reasons.

Firstly, because defining what being an artist means, is a difficult endeavor. By definition, artists are difficult to categorize and often defy classification altogether. Therefore, any attempt to define what it means to be an artist is bound to be challenging at best and problematic at worst. Eventually, there are just as many "definitions" of what being an artist is as there are artists. While we may agree on some main common characteristics, how these characteristics are implemented in our lives, the importance we place on one characteristic versus another, and what we consider of primary or secondary importance depends on each individual. It varies according to our unique situation, our personality, and our previous experience. Someone who has been an artist all his or her life does not see being an artist the same way as someone who is just becoming aware of the possibility of being an artist. In the end, all artists are unique individuals and each has a different idea of what being an artist is.

Secondly, because being an artist is not an activity one can do on the side. It is a lifestyle and a profession. While anyone can, to various extent, learn how to see photographically, select keepers, create a portfolio, or develop a personal style, to name but a few of the aspects involved in doing photography as an art form, being an artist is a choice one cannot make "in passing" so to speak. Being (or becoming) an artist is a decision that requires a high level of commitment.

Thirdly, because when I tackled this subject I did not realize how difficult it would be to describe what I do on a daily basis. I now know that doing something intuitively and being able to describe it accurately are two entirely different things. I also know, from having written this chapter, that one can be an artist without having the ability to precisely describe what being an artist is.

These three difficulties, which I just pointed out did not become clear to me until I had been working on this chapter for several months, as they troubled me to no end. They

▲ **Antelope Canyon**
Panorama 1
Fuji 617,
Fujinon 90 mm,
Provia 100F

troubled me because this whole book is based on the premise that readers will be able to do what the text describes. It is built on the guiding principle that readers, while maybe new to the concepts introduced in each successive chapter, will be able to successfully implement the contents of each chapter if they expend the necessary time and effort.

I had to complete this chapter, and to do so I had to find the necessary freedom to express myself and say what I wanted to say. To gain access to this freedom, I concluded that there was no way I could cover the subject in such a way as to avoid making this chapter anything else other than a personal, educated statement about what being an artist is. I therefore say it loud and clear, right here, right now, before we delve into the heart being an artist: this chapter represents my opinion of what being an artist is. Your opinion might differ. My way is not the only way and your opinion may be just as valid.

However, I add one additional comment to the recognition that I can only write about my own personal experience of being an artist: I

have extensive experience being an artist. I have thought about the issues that follow long and hard. I have considered the many aspects of each issue with great care. I have spent a lot of time, years in some instances, weighing the pros and cons of taking a specific position in regard to each of these aspects. Not knowing what those issues are yet, the reader may find this last comment somewhat superfluous. It isn't, but if it appears superfluous at this time, I encourage that this introduction be re-read after the reading of this chapter has been completed.

Before I conclude this introduction, let me say that while reading this chapter, keep in mind that it was written by an artist. Maybe better than any of what I actually say in it, maybe more important than any of the actual contents I make in this text, is the fact that this chapter is an embodiment of the concepts I describe here, an enactment of what I consider to be the main characteristics of an artist.

Therefore, what follows are my views of what being an artist is. These views are based

upon my personal experience and reflections, as well as upon discussions I have had with artists and friends. As you read through it, keep in mind that this chapter, while a stand-alone chapter, is actually part one of a two-part chapter. For reasons that I describe below, I decided to separate the chapter "Being an Artist" from the second part, "Being an Artist in Business". Let us now go where few have gone before and dive right into my opinion of what being an artist is all about.

Freedom of Expression: Let Us Be Artists

There is no must in art because art is free.
WASSILY KANDINSKY

In the previous chapter, "How to Establish a Personal Photographic Style", we saw that personal style is about personality. In this chapter we are going to see that *being an artist* is directly related to personality because being an artist is about expressing your personality. To put it in a concise manner:

Personal style is about personality.
Being an artist is about being free to express your personality through art.

Feeling free to express what you want to express is central to being an artist, and we are going to look at what this means and how you can find space for creative freedom in your life.

Being an artist is about being free to express one's personality through art. Clearly, one can express themselves in numerous ways, but to be considered an artist, one must express himself or herself through an artistic endeavor. At

this point, some readers may remark that this leads to the question, "What is art?" It certainly does. However, the answer to this question is a completely different subject which I will not tackle here. Let us just say for the present time that photography is an art form and that we will consider photography as the medium of choice for the purpose of this chapter. Clearly, artists can express themselves in a variety of media, so we will also take it as point of departure that while photography is our primary concern, we may very well, as artists, be creative in other media as well.

With this being said, the main difficulty of being an artist, in my estimation, is firstly feeling free to express oneself, and secondly, being free to express more and more of one's personality, or one's character. Why? Because, there are a number of things that stand in the way of achieving this. Let's look at what those obstacles are right away.

People often tell me they want to become artists. However, the next words they say are a list of all the things they feel they cannot do. The conversation often goes something like this: "I want to be an artist. But, of course, I can't do this, I won't do that, I certainly do not intend to go that way," and so on. The problem with this attitude is that even before they actually start on the path toward becoming an artist, most people limit what they will be able to do as artists. They start their artistic career by limiting their artistic freedom.

Art is about freedom of expression and creativity. Being an artist is first and foremost about feeling free to create. It is about expressing what is inside us, expressing something that others may not have expressed before or may have expressed in a different way. It is about expressing what we want to express and maybe even what we need to express. If an

Antelope Glow ▶
Canon 300D, 17-40 F4 L

I consider Antelope Canyon to be one of the areas most conducive to photographic creativity anywhere. Each time I go there I find myself creating new photographs. This one is no exception as I had never seen this particular composition and light glow before. ▶

artistic career is begun by listing all the things that cannot be done, one's creative freedom will be reduced, while it really needs to be expanded.

I certainly understand there are subjects that one truly, and for reasons unrelated to creative freedom, does not want to address. I often feel this way. For example, I made the decision a number of years ago that I would not express negativity in my photographs. However, this does not limit my freedom. Instead, it defines my personality. When I talk about this subject I do not say, "I cannot photograph this." Instead I say, "I choose not to photograph this." In other words, I feel perfectly free to photograph negative subjects but I have decided not to cover such subjects at this time. I remain free to change my mind in the future if I choose to. And I know that should I decide to cover these subjects, I may create excellent photographs. In other words, and to conclude on this aspect of being an artist, what is at work here is nothing but my personal, moral decision not to photograph certain subjects.

As an artist, the reader may make similar decisions with regard to subjects, styles, or images that are found to be personally objectionable. Doing so is normal and acceptable as long as it is part of one's character.

What is not normal or acceptable is to rule out certain things as unfeasible due to the belief that "only the masters can photograph them"; "I am not good enough"; "I don't have the proper style for that"; or "I will never get there." In other words, before setting limitations, ask why these limits to what can be done are being set. Is it because A: you morally object to photographing certain subjects, or is it because B: you feel inexperienced and insecure about your abilities, or you are unsure of

the outcome of your efforts? In my opinion, reason A is perfectly understandable, while reason B needs to be studied carefully. The underlying motivations for reason B should be exposed and then discarded on the pile of "creative freedom reducing obstacles" that all artists have to contend with.

Being an Artist Is a Lifestyle; Not a Temporary Situation

At different moments you see with different eyes. You see differently in the morning than you do in the evening. In addition, how you see is also dependent on your emotional state. Because of this, a motif can be seen in many different ways, and this is what makes art interesting.

EDVARD MUNCH

Art is a lifestyle, not just an activity. One's art and one's life are ultimately inseparable. One cannot be an artist without living a lifestyle that is conducive to being an artist:

Being an artist means having a lifestyle that makes creativity and art part of your everyday life.

One cannot be creative eight hours a day, from 9:00 AM to 5:00 PM. Similarly, one cannot schedule "creative time" say, from 4:00 PM to 5:00 PM every Thursday. While we certainly can write this down in a planner or in a PDA, whether inspiration will be felt on that particular day, at that specific time, remains to be seen.

The fact is, the muses visit whenever they please and not necessarily during "business hours." It is therefore very difficult to schedule creative time the way one would schedule a business appointment. It can certainly be

Celestial Star Trails ►
Linhof Master Technika,
Rodenstock 210 mm,
Provia 100F

▲ There is no limit to the number of possible images one can create
from any given subject. I have never seen this composition before
and responded only to my own creativity when I decided to do a star
trail composition at this location.

done, but there are no guarantees that one will feel creative during that time. To guarantee success in our creative endeavors we must be aware of our creative impulses and design a schedule that works around them; not a schedule that demands creativity to occur within a particular time frame.

Therefore, being an artist means implementing a lifestyle that favors creativity, impulsivity, and freedom. Because this may conflict with other activities, being an artist means learning how to organize one's life so these potential conflicts may be handled successfully.

Today, and specifically with landscape photography, workshops and photographic expeditions are an excellent way to schedule creative opportunities. A workshop is a block of time set aside to work only on photography, usually in a place away from where we live, and with like-minded people who share similar goals and interests. Workshop time is creative time, free from the constraints of everyday life. It is during this time that we can focus solely on photography and on creating art. The first and foremost goal of a workshop schedule is to offer as much creative time as possible to the participants.

Being an Artist Does Not Mean Making an Income from Your Art

Your pictures would have been finished a long time ago if I were not forced every day to do something to earn money.
 Edgar Degas in a Letter to Jean-Baptiste Faure, contemporary art collector, 1877

There is a widespread belief that a "real" artist must make a living from his art. In my view, being an artist does not imply making an income from your art. Making an income from any activity, art or otherwise, is being an entrepreneur, a businessperson, etc; it is not being an artist. I said earlier:

Being an artist is about being free to express your personality through art.

This can be achieved without selling one's art because, according to my definition, being an artist and making an income from one's art are not directly related. One is not a requirement for the other.

I was an artist long before I began making an income from my art, and I will still be an artist if I stop making an income from my art. This situation is very common. Children create art without any idea that art can be sold. As they grow up and discover the income potential in their art, a choice is made to create and sell their art or to continue creating art without attempting to sell it.

I so firmly believe that making art and selling art are two different activities that, as I also mentioned earlier, I decided to write two chapters on the subject of being an artist: "Being an Artist", which you are currently reading, and "Being an Artist in Business", which will be the next chapter in this book. I made this decision because I believe it is important to separate *creating art* from *selling art*.

This understanding came to me because of a question I am quite often asked, "How can I make it as an artist?" It took me years to realize that this question actually consists of two questions in one. The first question is "How can I be an artist?" The second question is "How can I make an income from selling my art?" These two questions are unrelated. The first question is the subject of this chapter.

The second question, which can be translated as, "Am I a business person able to market art?" is the subject of the following chapter.

Very often, the decisions to create art and to sell art are made at the same time. Such decisions make things twice as difficult because it means learning two professions at once: the profession of Artist and the profession of Art Marketer. It is my recommendation that one begins by creating art and that later, once a portfolio has been assembled, the decision to sell one's art may be made. While doing both at once is possible, it will make things twice as difficult and may create an extremely stressful situation.

The ability to make a living from selling one's art is not what defines one as an artist. Rather, selling art defines one as a business-person. Too often, making art and selling art are considered together. The true test of whether someone is an artist will not be found here. The true test of being an artist is in finding the freedom to express your personality through your art.

Being an Artist Does Not Mean Exhibiting or Publishing Your Work

I hear that my friends are preparing another exhibition this year but I must discount the possibility of participating in it since I have nothing worth showing.

CLAUDE MONET

Just as being an artist does not mean making an income from one's work, being an artist does not mean exhibiting or publishing one's work. Granted, many artists, if not most, do publish and exhibit their work. However, doing so is not a requirement for being an artist.

It is a frequent and desired outcome for many artists, but it is not a requirement.

This is especially important to understand when starting a career as an artist, or when one is unable or unwilling to exhibit their work. Pressing the issue by trying to get a showing of one's work in a gallery or a museum at all costs, and encountering tremendous difficulties while attempting to achieve this goal, can be very discouraging, and may erroneously lead to the conclusion that one should stop doing art.

I say "erroneously" because what is being experienced is not the lack of success in creating art, rather it is the lack of success in organizing a show of one's work. Since we have seen that creating art is central to being an artist, one's potential success at being an artist is actually quite high. By the time we try to have a showing of our work, we should have created enough artwork to fill the exhibition space we have in mind.

It may be argued that the reason people do not agree to show our work is because our it is not good enough. This may or may not be true. There are numerous reasons why a gallery, museum, or other exhibition space may not want to organize a show of our work. These reasons include, in no particular order, the fact that our work may not be the kind of work they usually exhibit; the fact that their exhibition calendar is filled several years in advance; the fact that they only exhibit artists whose names are already well known; the fact that our work is not matted and framed and that they do not want to cover this expense; the fact that they believe, rightly or wrongly, that our work will not sell; and so on. Note that these reasons have nothing to do with the actual artistic quality of our work. Instead, these reasons have everything to do with either the

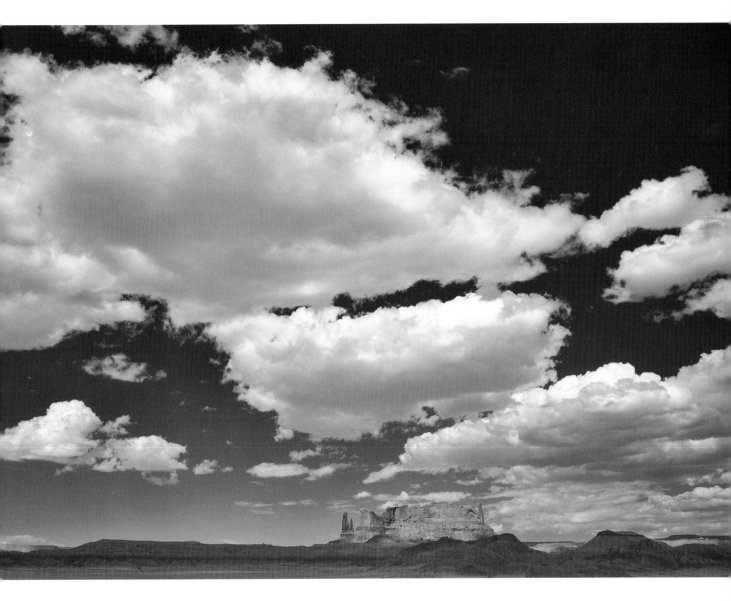

▲ Part of my Navajoland Portfolio, the original idea for this image first came to me in 1987, but was not created until 2004. At the time I only had a 35 mm with me when I saw similar clouds hovering over this rock formation. I had to wait nine years to witness and photograph a similar scene, this time with large format.

▲ **Round Rock Clouds, Navajoland**
Linhof Master Technika,
Fuji 90 mm, Provia 100F

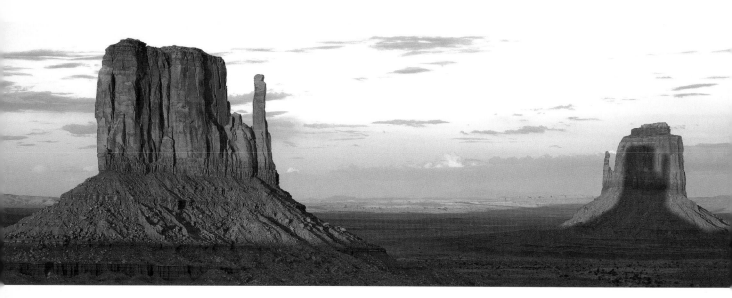

▲ This lighting situation occurs only twice a year and can only be witnessed and photographed if there are no clouds. I have seen other photographs showing only the Left Mitten but I wanted to photograph both together to show the cause and effect behind this light phenomena.

▲ **Monument Valley Shadows**
Linhof Master Technika,
Rodenstock 150 mm, Provia 100F

business side of photography, something we will address in the next chapter, or with the concept of audience, which will be addressed in the following section.

Being an Artist Means Having an Audience

There are always two people in every picture: the photographer and the viewer.

ANSEL ADAMS

The concept of audience is problematic to many students. When I taught English 101 at Northern Arizona University and at Michigan Technological University, I had the hardest time in the world getting students to under-

stand that they needed to write for a specific audience. When asked who was going to read their papers they inevitably answered, "Anyone who feels like reading it." What they meant was that I, as the teacher, was their reader. Who else was going to find and read their papers? Since this was not the answer I wanted to hear, I had them describe a specific reader as closely as possible, down to the clothes this reader wore, the job this person had, the car that person drove, the house... you get the point. Yet, they continued to write for me because, eventually, I was the one who they believed had control over their grade.

We are now past English 101 and it is tempting to find this story amusing. However, let me ask this question: who is your audience? Who do you photograph for, who do you want

to look at your photographs? Often, when I ask this question during a workshop, participants tell me that they photograph just for themselves. They tell me that they enjoy the photographs they create and that they are not concerned with what anyone else thinks. Yet invariably, those who gave me this answer bring prints to the print review for me and all the other participants to look at and comment upon.

Conflict often indicates problems, and there clearly is conflict in the above account. If work has been created solely for one's own enjoyment, then why would one wonder what others think of it? Personally, I don't have a problem with photographers creating work just for themselves, and never showing their work to anyone else. But, I do have a problem with someone making the statement that they create work solely for themselves, then asking for feedback from others, be it a workshop participant or someone else.

On occasion, I also have had photographers tell me, just like my English 101 students, that they photograph for whomever wants to look at their work. Just like my English 101 students, they are at a loss when asked to define a specific audience. They state that they are not discriminative and do not try to rule out anyone, and that they photograph for anyone who may find their work interesting. Yet, when asked who they show their work to, or who has a chance to see their work, it turns out that their audience is severely limited to either family members, other photographers, or a small group of individuals accessible because of their profession.

In regard to the above account, here is what Al Weber, personal friend and long time workshop assistant to Ansel Adams, has to say

about the subject. I think Al's statement says it as well as can be said:

No artist can reach every person out there. It is common knowledge that the most successful artists are those who have a known audience and can communicate directly. Trying to please or talk to everyone would be the same as making post cards to look at while eating a TV dinner.

AL WEBER, IN PHOTOGRAPHIC NOVELS, THE WORK OF MARTIN BLUME. MAY 2000

I also see a problem with photographers claiming to be artists, yet saying they do not need an audience. Because, in my view, in addition to the previous partial definition of what being an artist is:

Being an Artist is sharing your view of the world with a specific audience.

This is true even when sharing it with an audience of one. Why? Because being an artist means *sharing* your vision with others. It can be argued that the artist is one's own audience; that pleasing oneself is the only aim; and that one does not care if their work is seen by anyone else. That is fine and I don't have a problem with it. But according to my view – that being an artist is, among other things, *sharing your view of the world* – then if we are our own audience, and we do not show our work to anyone else whatsoever, we are not artists, i.e. someone who makes art. If we think about this carefully we will find there are few people that actually fit in this category. Virtually all of us show our work to other people, no matter how few. In fact, when someone says they are their own audience and they do not want to know what others think of their work, what they are really saying is that they

are either afraid of what others might say or are not willing to face comments about their work.

Eventually, as artists we are indebted to our audience because we need an audience to *communicate* with. Being an artist is about sharing, and having an audience is being able to share our work with others. As such, we are indebted to our audience for giving us the opportunity to share our work and our endeavors, for being willing to listen to us, and for engaging in the dialog that we engage in through art. But above all, and with all due respect to our audience, artists eventually owe their loyalty to the pursuit of their vision. It is therefore important to remember that as you pursue your vision, your audience can and may change to reflect your own changes in style, approach, presentation, etc.

Being an Artist Means Having an Appreciation for the Arts

Without poets, without artists, men would soon weary of nature's monotony.

GUILLAUME APOLLINAIRE

There is a widespread belief in our society that being an artist is not a real job, and that there is no real use for artists in society, as opposed to doctors, lawyers, engineers, or any other "accepted" profession.

One of the purposes of this chapter is to challenge this belief. Firstly, as we have seen, being an artist does not imply making a living from one's art. This negates the belief that artists need to get a real job. They may already have a real job! Secondly, we need to acknowledge the fact that art is just as important as any other aspect of our lives. What would our

lives be without art? What would our existence be if we did not have music; if we did not have movies or theater plays; if our walls were bare of any paintings, drawings, photographs, or any other type of décor; if our public parks or private gardens were void of landscaping and outdoor sculptures; or if wearing jewelry was not an option, just to name but a few of the instances in which art is present in our lives. Clearly, art is as important as any other aspect of our lives. The first step towards being an artist is to understand this. One cannot be an artist unless one values art and the importance art plays in everyday life.

To me, being a professional means the ability to follow the standards required by a specific profession. In other words, and to take examples from professions other than art, it would be preposterous for one to say, "I am an engineer" without having the education, the training, the experience, the job position, the responsibilities, etc. that are expected of an engineer. In other words, being an engineer is more than just saying that one is an engineer. Being an engineer means having the ability to prove through one's actions, performance and professional conduct that one has the required knowledge, experience, abilities, and training to perform the work expected of an engineer. The same applies to any other profession.

Interestingly, expectations are different when it comes to artists because most people are unclear what the requirements are. Most are unclear about the training, the education, the experience, the job position, and the other responsibilities of being an artist. They are unclear about it because the professional responsibilities of an artist are rarely discussed, because artists represent a minority, and because what *being an artist* entails is something that few people are familiar with. They are also

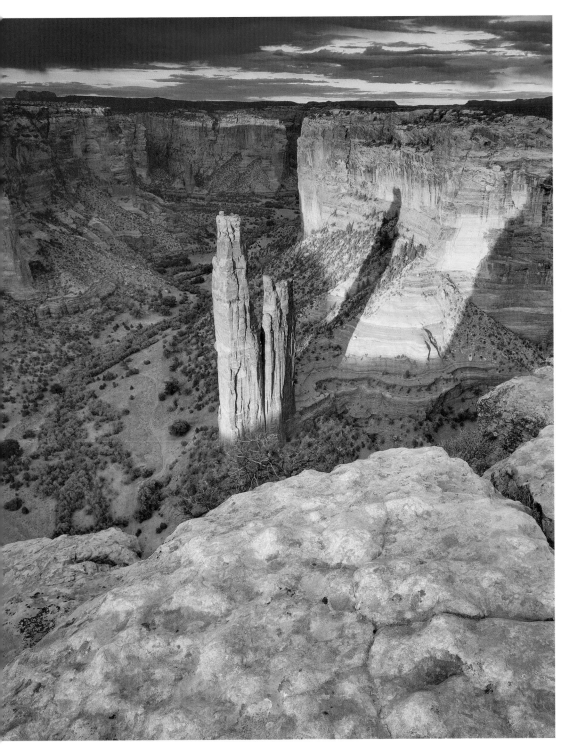

◄ **Spiderock Sunset**
Linhof Master Technika,
Schneider 75 mm,
Provia 100F

◄ The first time I saw the unique lighting situation depicted in this image was only seconds before the sun disappeared below the horizon. As a result. I could only capture it as a snapshot using a hand-held digital camera. I returned six months later, knowing the lighting conditions would be similar, and had my 4x5 setup and ready although the weather was overcast. Seconds before sunset, the sun came out then disappeared after a minute or two. This image shows what happened while the sun was out that evening.

unsure of what qualifies an artist as a *professional* because this is rarely discussed or listed as a set of rules.

Let's outline several things that make an artist a *professional* artist, in no particular order:

- Education
- Training
- Dedication
- Skills
- Achievements
- Responsibilities
- Professional position
- Integrity

When looking at this list it becomes clear that these requirements, in their general nature, do not differ from the requirements of any other profession. What does differ are not the fundamental requirements that are asked of an artist, but rather how people perceive what being an artist is all about.

In light of the above remark, it becomes important to make sure that people take us seriouly as artists. If people do not consider being an artist a legitimate activity, and therefore do not take us seriously, they will not respect us or our work, and will therefore not enable us to succeed. Instead they will undermine what we do and will work against us. If the minds of such people cannot be changed, we should get away from them as fast as we can. Don't push the issue; just let them be. We should seek people who understand what being an artist is about, people who respect us, take us seriously, and are willing to help us.

It is also important not to feel guilty about being an artist, about creative freedom, or about doing what we like instead of getting a "real" job. Being an artist is just as difficult as any other occupation, if not more difficult.

There is nothing about it that makes one more privileged, or more fortunate, than if one had chosen another occupation. When someone tries to make us feel guilty, it is nearly always because they are not happy with what they are doing, hence they are jealous that we are doing what we enjoy. This is a reflection of their choices, not of ours. There is no reason to feel guilty about having made the right choices for oneself. If anything, we may tell these people to make different choices in their own lives; to change their lives so they will stop resenting what we do and start liking what they do, and let us live our lives without feeling the need to make us feel guilty about it.

Being an Artist is Knowing How to React When You are Told that "Artists are Lucky!"

It is essential to do the same subject over again, ten times, a hundred times. Nothing in art must seem accidental, not even movement.

EDGAR DEGAS

The belief that those who are successful are lucky is quite widespread, and artists are particularly plagued by it. I have yet to find an engineer being regularly accused of "being lucky" with his or her engineering. Bridges, cars, buildings, power plants, machines, computers, software, etc. are rarely said to be the result of plain luck. Most people realize without being experts, that much thinking, knowledge, training, effort, know-how, planning, money and more are behind any successful engineering endeavor.

However, when it comes to art in general and to photography in particular, luck is very

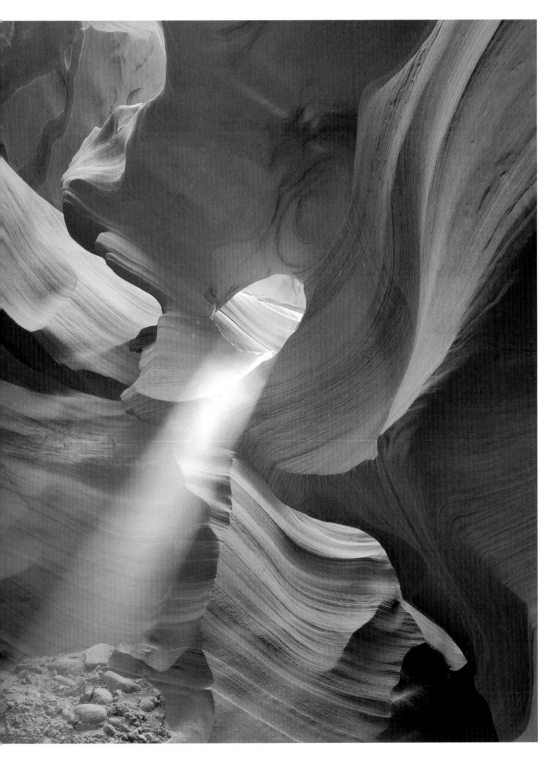

◄ **Antelope Arch Light Shaft**
*Linhof Master Technika,
Schneider 75 mm,
Provia 100F*

◄ I have photographed this arch in numerous different lighting conditions, but this is my first successful image with the light shaft going through the arch. The creative possibilities offered by Antelope Canyon are endless and the technical difficulties offered by the location offer a true challenge to any artist.

often cited as the reason behind the existence of a particularly stunning image or series of images. At shows and exhibitions, or during personal conversations, I regularly hear statements such as, "I guess you just hang out at [insert your favorite location here] and get lucky." Or, "You can't plan that [meaning a rainbow, lightening strike, snowstorm, etc.]. You just have to be lucky to be there and have everything work right for you." Or, "Luck plays a big part in what you do, doesn't it?"

The belief that "luck does it for artists" extends beyond the artists' creations and right into the artist's life. In this regard it is common for me to be told, "You are lucky to be doing what you like. I, on the other hand have to…" or, "You are lucky to make a living doing what you like. I on the other hand, have to…"

I used to argue endlessly about the lack of validity to the comments above. In fact, I built a library of quotes, remarks, and smart comments about the uncanny nature of luck, such as "luck favors the prepared mind", "luck is preparedness in the face of expectation", "the older I get the more lucky I seem to become", "I wonder why I am so lucky and you are not", and so on.

Last year I finally saw the light, and made a decision which transformed my existence. I decided, quite simply, that in regard to discussing luck, resistance is futile and that it is better to submit rather than eternally argue a moot point. I gave up my arsenal of counterpoint quotes about the nature of luck and I adopted a very simple response to any and all statements about being lucky in any and all aspects of my life. Today, when I hear any of the above statements, my answer is automatically a resounding "Yes." "Luck plays a big part in what you do, doesn't it?" I answer, "Yes." "You can't plan that, you just have to be

lucky. Right?" I answer, "Yes." "You are lucky to do what you like, me, on the other hand…" I answer, "Yes." "You are lucky making a living doing what you like, most people have to…" I answer, "Yes."

Two things happened after I switched to "yes" as the answer to the assumption that success as an artist is the result of plain luck. Firstly, I freed myself from the desire to argue the point. When we agree 100% to something there is no argument possible. I agree, therefore you are right, case closed. Secondly, these conversations now end just as fast as they start. Obviously, those who make such comments about luck are interested in seeing what my reaction will be and when they realize that I agree with them they lose interest.

But something else happened which I find to be the most interesting consequence. After hearing me say "yes", a number of people will go back on their initial statement and start to say things such as, "Well, I guess it's not that simple." Or they may say, "Luck is only part of it, you have to know what you are doing." In other words, they start defending the case I used to defend. From my unwavering "yes" answer, my lack of concern for arguing the point, my agreement to their preposterous statements, they deduce – and rightfully so – that something is amiss and they go back on their statement, amending it ever so slightly.

My point is that if someone is willing to believe that the results of a lifetime of study, passion, devotion, effort, and much more are caused by pure and simple luck, there is nothing I can do about it. To disprove such a belief will take more time and effort than I am willing to spend. I much prefer to save my energy to create art. Laughter, in this instance, is the best remedy. Let's laugh at the preposter-

ousness of this statement, and let's laugh by agreeing with it.

And then, after all, maybe I am lucky. Who knows and who cares? Does that change anything? No! I still must know what I am doing; I still must do everything I was doing so far; I must still have the knowledge, experience, passion, devotion, drive, etc. that are required in order to do what I do. Maybe I am lucky! Well, if so, great. I'll take the luck because it can't hurt. Why fight it? Why not free myself from the belief that my art must be the result of hard work? If certain people want my work to be the result of luck, I see nothing wrong with it. After all, *luck* may be just another term for *inspiration*.

The final point is that it doesn't really matter to me, as an artist, how good art comes about. What matters most is that it does come about and that it exists. That some people explain the creation of art as luck is fine with me. That others explain art as being the result of talent is fine with me. That others explain art as being the result of fortuitous situations is equally fine with me. That others say that, thanks to my parents, I led a sheltered life and therefore was able to preserve my artistic sensibility is similarly fine with me. And if some want to believe that art is the result of years of training designed to foster an inherent talent, that is also fine with me. In short, any and all explanations about how art comes about are fine with me. Why? Because, I am an artist, not an art critic. How this position plays out is the subject of the next section in this chapter.

Being an Artist does not Mean Being an Art Critic

The painter must enclose himself within his work; he must respond not with words, but with paintings.

PAUL CEZANNE

Being an artist and being an art critic are two different professions. When one is an artist whose work is shown to an audience, people will write, talk, and make comments about the work. Don't fear this, welcome it. Avoid labeling your work or explaining it too much, for in doing so, the mystery that others perceive in your work is removed. Allow the viewers to interpret and discover the work on their own. Provide an open door through which people can look at your work in different ways. Keep the door open for your audience to interpret your work. This goes along with claiming one's freedom and with providing this freedom to one's audience as well.

As we have seen, being an artist is defined by the ability to create art and live a lifestyle conducive to art. Now, what defines being an art critic? For me, being an art critic, when looked at as a whole and from a distance, is having an opinion about what is good art and what is bad art. In some ways, being a critic is like seeing the world in black and white, as a dichotomy, in terms of what the critic likes – and is therefore "good" – and what the critic dislikes – and is therefore "bad." Being a critic is not about shades of grey, about nuances, or about slight variations between tones. It is about sharp demarcations, about taking sides... about being *critical*.

Certainly, being an art critic is also, and ideally, being knowledgeable about the history of art, about art theory, and in respect to the

visual arts, about visual art theory. A good art critic will be intimately familiar with the writings of Roland Barthes, John Berger, Walter Benjamin, Edwin Panovsky, and many others. Yet one may have read all these authors and not necessarily be a critic, as we are going to see.

At this point you may want to say, "I can do both. I have knowledge of art history and theory and I have an opinion about what art I like and dislike. I like to share my opinion with others, and I think that all this is part of being a well-rounded artist." You can say that, and if you do you are 100% right. All this is true.

However, what matters is *who* you are. Are you first and foremost an artist, or are you first and foremost an art critic? That is the real question, and it is for the reader to answer, not for me. Personally, I know that I am first and foremost an artist. However, as I just said, I am very well read in art theory, having worked on a PhD. in Visual Theory I have a comprehensive knowledge of both the history of art and the history of photography, and I spent countless hours reflecting upon what is art as well as studying the work of many other artists in numerous mediums. I also have an opinion regarding what art I like and don't like. Notice that I don't say "an opinion about which art is *good* or *bad*." To me, that is for the critics to decide. Personally, I know what I like and what I don't like. That is all.

Finally, I have a desire to share my opinion in these matters. However, I don't do this as a critic. I do this as a teacher and as an artist who wants to share his knowledge. Again, I am first and foremost an artist, then a teacher who is knowledgeable about art theory and history. What I am not is an art critic. As I said, who you are is for you to decide. My goal is to help you make the distinction between artist and art critic, not decide which one you are.

We may add that many artists are highly critical of their own work. And we may ask, "does that make them art critics?" My answer would be that it depends on how their critical outlook on their work manifests itself, what shape this outlook takes, and what appearance it presents.

Allow me to explain. It is normal, expected, and encouraged for an artist to reflect on his or her work. After all, this is how we progress, evolve, and move forward in general. We need to be able to say, "If I did this again I would do things differently. I would try this other approach, for example." Or we need to be able to say, "I wish this cliff wasn't so red, or this water so blue, and I intend to change that." But notice that we make these comments to ourselves or to others only in passing, as if thinking aloud. This is part of the process of growth that all artists experience.

When such comments about one's work are made in public, it becomes a different matter. Imagine an artist giving a talk at the opening of a gallery show of his work, and imagine hearing this artist say that his work isn't very good because he wishes he had done this and that differently, that the work would be better if he had got the foreground sharp instead of blurry, that he would have a much better print quality had he used ImagePrint instead of the Epson print driver, and so on. This attitude, which it turns out is rather commonplace, is not part of being an artist. Instead, such an attitude is indicative of an artist who has become his own critic. My point is: do your art and leave the critique to the critics! Don't do their job for them. If your points are valid, if the "flaws" you are concerned with are indeed visible in your work, let the critics discover it

▲ Another example of how Antelope Canyon can be continually rediscovered if one visits this incredible place with fresh eyes and an open mind. For this chapter I purposefully selected a large number of photographs from Antelope Canyon to illustrate the fact that certain locations foster creativity more than others.

▲ **Antelope Canyon Panorama 2**
Fuji 617, Fujinon 90 mm,
Provia 100F

for themselves. They should be able to see the flaws. If they don't notice them, your concerns are most likely due to your fears rather than to actual shortcomings in your work.

The point is that what one is so concerned about may not matter at all to the audience. The "defects" pointed out may be more the result of one's own lack of confidence and insecurity, than the result of actual shortcomings. The thing is that no matter where we are from a technical or artistic standpoint, we can all improve. In that sense, there is always something that needs improving, something that is not working as well as we wish. Let it be and let the critics find out about it. That is their job. Our job, as an artist, is to create art. The job of a critic is to critique art. While we may be aware of our own shortcomings, we should keep them to ourselves. Not because

doing so is "hiding the truth" or being dishonest about your art; it is not. After all, what we have done is visible to all in our work. It is hard to hide the contents of visual arts since it is by definition visual! Rather, keep these feelings hidden because bringing attention to what we perceive as "defects" will in turn bring our audience's attention to that aspect of our work and will very possibly reduce their enjoyment. The audience, or critic, may never have noticed a defect had we not drawn their attention to it, but after it has been pointed out they may not think of anything else.

I recommend that we let the audience and the critics be the judges. I also recommend that when we talk about our work we focus on positive aspects rather than on what we think we did wrong or what we think doesn't work. When we listen to what people have to

say about our work, we will be surprised at how few actually share these concerns. We will also be surprised at what else they see that we didn't notice, probably because we were so absorbed in finding all the "mistakes." Don't forget that mistakes are the foundation of art. As Picasso one said, the goal is not to prevent mistakes but to foster them.

What About Talent?

Genius is the ability to renew one's emotions in daily experience.

PAUL CEZANNE

I once had a discussion with two friends. One said, "Art cannot be taught." The other said, "Art can be taught." These two friends asked me for my opinion. I said they were both right because while talent cannot be taught, there is much to be learned about art before one can make use of their potential talent. Granted, talent may arguably be responsible for making a huge difference in the final outcome, and in the creation of (or lack of) a masterpiece. However, without the required artistic knowledge on which to base one's potential talent, no work of artistic value will be created.

So what is talent? In a way talent can be defined as follows:

Talent is the ability to make the best artistic use of the resources that are available at a specific time.

Talent, by definition, involves competition. How could we tell we are talented without comparing ourselves to those we believe are not talented? Similarly, how can we be more talented than others if we do not compare ourselves to others? Mozart was, or so we are

told, more talented than Salieri. We are asked to believe that Dali offered himself as the leading painter of the Surrealist movement and as the one whose talent was showing the way. Others, such as Magritte, followed suit. Ansel Adams and Edward Weston "traded paint", with the generally accepted conclusion that while Weston was unquestionably a pure artist, Adams had a more well-rounded set of skills which eventually allowed him to gain fame and fortune, while fame and fortune eluded Weston all his life.

Was Mozart more talented than Salieri, Dali more talented than Magritte, Adams more talented than Weston, or vice-versa, for each of these three pairs of artists? The fact is, we don't know, can't tell, and are left with personal opinions about which artist(s) we like or dislike. Talent cannot be quantified. One either has it or not; it is that simple. Any discussion of talent, when it comes to comparing artists of a certain caliber, is eventually an exchange of opinions and not a scientific conversation.

Talent is present in all disciplines, not only in art. Talent is the "spark" that some have and others do not. It is this elusive quality that makes all the difference between something good and something great. It is the ability to use available resources in a way that no one else has thought of, whether that use is more creative, more all-inclusive, more thorough, or something else altogether. Talent has different names in different disciplines. For speakers and writers it is eloquence. The story of Demosthenes, a gifted orator in Ancient Greece who learned to overcome stuttering by practicing speaking with pebbles in his mouth, shows perhaps better than any other story the relative importance of talent versus physical limitations, as well as the importance of talent versus training. Cyrano de Bergerac, whose

▲ I have been asked why I photograph Antelope Canyon so much and not other comparable places such as The Wave, a favorite of many photographers. I see no limit to creativity in Antelope Canyon, while I find other locations more limiting, at least at this time.

▲ **Antelope Canyon Panorama 3**
Fuji 617, Fujinon 90 mm,
Provia 100F

eloquence is at the epicenter of Edmond Rostand's story, overcame a physical malformation, namely a huge nasal appendage, by learning to make fun of himself better than any of those who were trying to ridicule him.

In many disciplines, talented practitioners are simply referred to as *gifted* or *brilliant*, or as *geniuses*. What is similar in all professions is the lack of a specific definition, the absence of a consensus of what this gift, this brilliance, this genius actually consists of. Talent, eventually, is a mystery. While we enjoy its presence and its outcome we can say little about its implementation.

Yet, what are those "resources" that talented individuals make better use of than common mortals? It depends of the field one is involved in since talent is present in any discipline. There are talented engineers, accountants, race car drivers, pharmacists, masons,

mechanics, etc. And of course, there are talented artists working in all artistic mediums.

So what makes a talented photographer? Well, for one, as the story I first told shows, talent is but little without technical excellence. Why? Because talent cannot make up for a lack of knowledge. If talent is being able to best use the resources available at a given time, then one must learn exactly what those resources are made of and how they can best be implemented. It is necessary to become an expert in what these resources consist of. Then, and only then, will it be possible to go above and beyond what anyone else has done so far with those same resources.

What is too often the case in art is believing that talent alone will make up for any and all shortcomings. It will not. Talent is not a substitute for lack of knowledge, lack of study, lack of work, lack of passion and so on. Talent

is the icing on the cake so to speak. Therefore, one must have a "cake" for talent to shine. Talent is the creative application of inspiration, imagination, thinking outside the box, etc. Talent is the ability to exceed one's limitations and those of one's equipment. If we follow Formula One racing we know that no amount of talent on the part of a driver will allow that driver to turn a Minardi into a Ferrari. One may become the best Minardi driver there is, only to be outdone (greatly) by a less talented driver in a Ferrari. That's just the way things are. It is not necessarily fair, but it needs to be understood for what it is.

Photographic Skills Enhancement Exercises

Exercises for this chapter are somewhat more challenging than for the previous chapters. This is because, as I explained in the introduction, this subject is far more involved and requires a more important commitment on the reader's part.

Nevertheless, I planned the exercises below so that they prove of value toward helping you discover if you are an artist, or toward helping you become a more well-rounded artist, whichever your situation may be.

Exercise 1
Write an artist statement.
There is nothing quite as useful as explaining why you do what you do, how you got to be where you are, and where you plan to go from here.

Exercise 2
Write a history of yourself as an artist
Compile a "history" of your life as an artist. Find old drawings, photographs, sculptures, paintings, or any other artwork you did over the years, from the time you were a child until today, and put them together in a collection. If you no longer have these works of art, describe them in writing as concisely as possible on a single page of paper, and add this page to the collection in place of the original. Better yet, re-create the missing piece now, as best you can. It will be different from the original but this re-creation may lead to some interesting artistic breakthroughs.

Exercise 3
Portrait of the artist as a young man (or woman)
Describe yourself as you were, or as you remember yourself to have been, when you first embarked on your artistic career. The age you were at that time will vary from one person to the next. This may be you as a young child, you as a young adult, you at middle age, or later, or earlier, or at some other time. This is personal, but what is important is that you describe yourself as precisely as you can – the way you looked, what you thought, what your dreams, goals, and aspirations were at that time. This is a sort of "resurfacing" process; a sort of going back to the source and remembering what things were like back then, before the baggage of life accumulated upon you, your goals, your aspirations, your dreams, etc. It is a return to the source; to the spring of inspiration. The key to this return is your memories of this past time. Describe these memories as vividly as possible. If you do not feel like writing, then draw, paint, sculpt, compose a musical piece, or create anything else that embodies

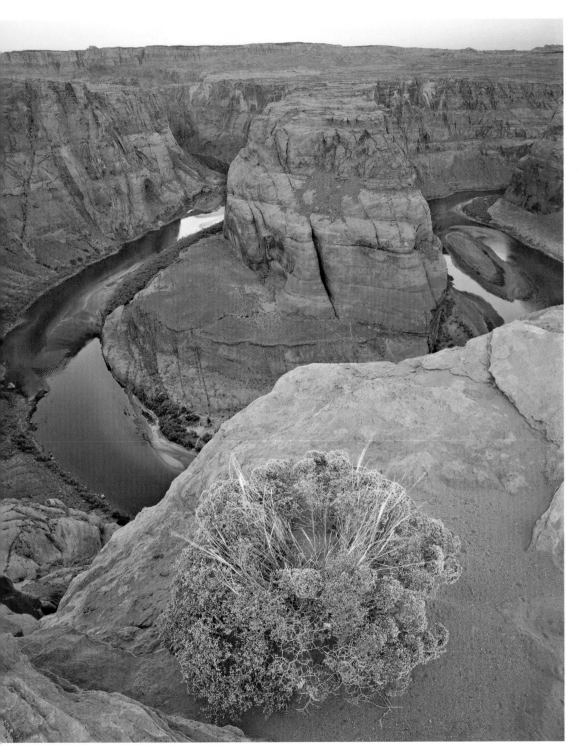

◄ Horseshoe Bend with Flowers
Linhof Master Technika, Schneider 75 mm, Provia 100F

◄ This is my most creative photograph from a location I visit just as often as Antelope Canyon. It is also the least "classical" in the sense that to include the flowering bush I had to hide half of the Horseshoe Bend. However, in doing so I created tension and conflict in the image while inviting a visual comparison of circular shapes: the flowers in the foreground and the Horseshoe Bend in the background.

your memories. Do not let the disappoint-
ments of life, the many twists and turns of
your existence between then and now, prevent
you from making as complete a description
as you can. You need to return to the state in
which you were back then.

Exercise 4

Make a list of the misconceptions you had
about art before reading this article.

Exercise 5

Do you hesitate about whether or not to be an
artist? If your answer is yes, what stops you
from becoming an artist? Make a list of what
stands in your way.

Exercise 6

What is your position regarding to "being
lucky"? Have you been told by other people
that you are lucky in regard to your photogra-
phy? Do you think you are lucky? Take time to
reflect upon this issue. Specifically, consider
how your opinion about luck influences your
own work and the way you look at the work of
other artists.

Exercise 7

Go out and create the photograph(s) you have
always wanted to create. Do it right now!
We all have photographs or artwork that we
have wanted to create for a long time, but we
have put them on hold until "we get better at
it." With this final exercise, I ask you to *wait
no longer* and instead, go out and create this
artwork or photograph right now. Don't hurt
yourself and don't do anything silly, but do
face your fears and the reasons you have not
yet created these images. In my estimatation,
the only true manner to face these fears is to
go out and do it. Art is about creating, not

about thinking when we are going to create.
So, go out and create the one image or image,
you have wanted to create for years. I know it
isn't easy, but if not now, then when?

Conclusion

We live in a world that fosters the technical
rather than the artistic, the mechanical rather
than the organic and a financial rather than
a mecenistic approach. Art goes against all of
that. While it can have a technical aspect, such
as digital photography has, art is ultimately
about expressing yourself, about what inspires
you, and about sharing your view of the world
with others. The medium you use, as well as
all the technical intricacies of this medium,
eventually fade away when compared with the
message expressed in your work. Who knows
the size of the chisels used by Michaelangelo
and whether they were made of hardened
steel, Damascus steel, or some other metal.
Only experts know which film Ansel Adams
used to create Moonrise, Hernandez, NM. I
am sure you can find additional examples to
further this argument. If you can, you know
how little people will care ten years from now
about whether you used Microdrives or Com-
pactFlash cards to store your RAW files. Case
closed.

We also live in a world that loves placing
boundaries on what we do. By definition, be-
ing an artist is not having boundaries about
what we can create. However, this is less and
less the case these days due to the limitations
that artists impose or see imposed upon them.
During a recent workshop, while talking about
my Paris photographs, I was asked for my
definition of landscape photography. My an-
swer was "just about any subject that is found

outdoors." This question surprised me until I realized that it emerged out of the perceived conflict between my wilderness landscape photographs and my Paris (or other cities) landscape photographs. I had never perceived this as a conflict as I consider the Natural Landscape and the Urban Landscape (to simplify) as both being Landscape photography. However, to a "purist" I suppose there can be a difference. Not to me though, and that is my choice to decide. Many photographers feel bound by similar limitations. If you are not free to create, how can you be creative? And if you are not creative how can you be an artist?

On a different level, art cannot be judged by how much money it earns. Whether you make no money at all, or make an obscene amount through the sale of your art, these are not accurate commentaries on the actual artistic quality of your work. I have experienced both, and I know that neither situation was generated by the quality of my work. The artistic quality of your work, and the amount (or lack) of money your work generates, are two separate things.

Finally art is by nature a mecenistic activity. I believe one doesn't choose art as a career. Instead, art chooses us, for better or for worse as they say. In this regard you have to make the best of a difficult situation and in this endeavor several options are open to you. You can decide to try and make a living with art. Some are very successful at this, and in this respect I can only send you back to paragraph two, above, of this conclusion.

You can also decide that art is something you want to do for yourself and for a limited audience, without trying to make money with it. That is a fair decision, one that will go a long way towards protecting your artistic sensitivity from the school of hard knocks

that you will be forced to attend should you want to make an income from your art. That decision will also go a long way towards freeing a lot of your time from activities such as marketing, salesmanship, show attendance, record keeping, taxes, and other activities that are required of you as an *artist in business*.

You can also decide that art is art, that it is your "sacred haven" the part of you no one but a select few will ever get to see. You can decide to shun the public spotlight, the *ten minutes of fame* promised by the media that lure many of us towards creating a public identity and presence. This last choice, which in a sense is the opposite extreme of the "art for riches" approach, is maybe the one that will give you the most creative freedom. Whether the results of this choice are worth it or not is for you to decide.

Finally, keep in mind that art is supposed to be a fun and creative endeavor. If doing art is stressful, problematic, gives you headaches and keeps you awake at night, you are definitely not doing it right. You need to free yourself from stress when you are trying to be creative.

I mentioned the expression *artist in business* and in this chapter I made a sharp distinction between being an artist and making a living from your art. This is because I truly believe that those are two entirely different activities. The former involves being an artist while the latter involves being a businessperson. Exactly what these differences consist of is what we are going to explore in the next chapter.

How to be an Artist in Business: My Story – Part 1

Your pictures would have been finished a long time ago
if I were not forced every day to do something to earn money.
EDGAR DEGAS IN A LETTER TO JEAN-BAPTISTE FAURE,
CONTEMPORARY ART COLLECTOR, 1877.

Introduction to Being an Artist in Business

In the previous chapter I made a sharp distinction between *being an artist* and *being an artist in business*. The reasons for this distinction will be clear by the time you reach the end of this chapter.

As I was writing this rather difficult text, I realized that it was getting longer and longer. This is due in large part to my decision of structuring this chapter around an account of my story as an artist in business. I pondered a long time about which format to use for this chapter, and finally concluded that telling my story was the best approach for several reasons.

Firstly, several times while writing this book I felt that telling my story was important. This is my last chance to do so and I don't want to miss it.

Secondly, what better way is there to show what it is to be an artist in business than by telling the story of how I came to be an artist in business? Business is really a hands-on activity. It's not so much about theory and ideas than it is about doing it.

Thirdly, everyone likes a success story, and this is such a story. So make yourself comfortable, settle into your favorite chair, and get ready for an interesting read.

Before I start, I want to mention that the goal of this chapter is not to offer a photography-marketing course. For this I offer a number of resources on my website (www. beautiful-landscape.com), such as a marketing CD, marketing workshops, and a one-on-one consulting program. Rather, the goal of this chapter is to help with the understanding of how *selling art* differs from *making art*; to show how I found myself following the *path less trav-eled*, to use Robert Frost's metaphor; and to describe what happened along my path. As Edward Abbey says in the introduction to Desert Solitaire, and I paraphrase, "How I got here no longer matters. What happened here is what this book is all about". Let's see what this is all about.

This chapter is structured as an account of my personal journey from student to professional photographer, a journey that covers nearly 20 years. I started this journey when I founded Beaux Arts Photography in 1995. We are now in 2005, the tenth year anniversary of my being *An Artist in Business*. I did not plan it that way. Clearly, when I started I had no idea that one day I would be writing about being in business for a worldwide audience. Yet, this is exactly what I am doing now. As we will see in the course of what follows, one never knows exactly where an important decision may lead.

Travels

My favorite thing is to go where I've never been.
DIANE ARBUS

I am tempted to say that all good photographs start with a great journey. At least mine did. Journeys open the heart, the soul, and the eyes. And with open eyes one sees clearly, sees a new world, a world that, for those who have lived in it forever, is no longer visible.

In June of 1983 I flew from Paris to Los Angeles, bought a used Ford Pinto for $600, and drove it for 6 months through Wyoming, Utah, Nevada, California, Colorado, Idaho,and Arizona, not necessarily in that order and not in equal amounts in each of the aforementioned states.

▲ **Surprise Pool, Yellowstone National Park, 1983**
Arca Swiss 4x5, Rodenstock 90 mm, Polaroid Type 52

In late August 1983 I drove from somewhere in the Western Colorado Rockies to Arches National Park. The trip was long and night fell before I could reach Arches. Yet, motivated to see with my own eyes what I had seen so far only in magazines, I decided to press on. It was a moonless night, and I knew I had arrived in Arches only because of the sign that read "Arches National Park." I parked across the road from the sign and proceeded to set up my tent at the base of a sand dune. When driving to Arches it is easy to find my camping spot right in front of the park's entrance:

the sand dune has become a favorite place for visitors to slide down on. In retrospect, I can hardly believe I camped there, and I wonder that a police officer or a park ranger didn't ask me to leave. Maybe the night was too dark to be seen, maybe there was no county ordinance against camping there (after all I was not in the park, just very close to it), or maybe I was just lucky (*Yes!*).

Who knows and who cares. What's done is done. What matters is what happened the next morning when I woke up to the other-worldly sight of towering sandstone walls, rock spires stretching towards the sky on top of the mesa in front of me, and color, color, and more color. Reds in hues I had never seen or imagined before; reds streaked with black stains of desert varnish running down the sandstone walls for hundreds of feet; sparse vegetation that clung to the sandstone walls for dear life; and the sky, blue as can be, filling the space above the mesas with just enough soft white clouds to make the scene irresist-ible. The road, the ranger station, the US flag, the signs ("Do not park along the road" - "No Firearms" - "No Camping") were, in the pho-tographic passion that this view generated in me, invisible to me and thus did not detract from the beauty that was all around me.

I packed my tent and proceeded into the park unhindered by rangers who were not yet on duty ("Entrance Station Opens at 8 am – Please Proceed"). Having driven up the sand-stone cliff, I soon found myself surrounded by the delight of sandstone. This was a foreign world, a world that a photographer could never forget; a world that required time to be understood and photographed well. I knew then that I would have to return to this loca-tion; that this trip, no matter how long or how intense, would not be enough.

Beginnings

If the path be beautiful, let us not ask where it leads.

ANATOLE FRANCE

Come back I did in 1986, three years later. In 1986 I relocated from France to Flagstaff, Arizona to study photography at, Northern Arizona University (NAU). When I showed my portfolio to the head of the photography department and asked which classes he suggested I sign up for, his answer was "any class you like, including graduate classes." To me, his answer meant that none of the photography classes offered by NAU was worth my time and that I wouldn't learn much from any of them. Why? Because how could I qualify for a graduate class when I just entered the American University system? I made the decision right there and then to switch my major from photography to journalism, and to study landscape photography on my own. After all, I was in the right place to do so, having chosen Flagstaff based on its proximity to the Grand Canyon and countless other stunningly photogenic, natural locations.

Journalism turned out to be an interesting major and in many ways it helped me tremendously with grammar and the mechanics of writing. But the theory part, which is what interested me most, proved to hold my attention for no more than a year. At that time I decided to switch my major to English, in large part because I found it one of the most challenging majors available to me at the time.

English proved to be my final destination in terms of my academic studies. I also discovered that while literature was interesting rhetoric was fascinating. After receiving my Bachelor's Degree in 1990, I decided to work

▲ **Courthouse Towers, Arches National Park, 1983**
Arca Swiss 4x5, Rodenstock 210 mm, Polaroid Type 52

on a Masters in Rhetoric. I received my MA from NAU in 1992, at which time I moved to the Upper Peninsula of Michigan to work on a PhD in Rhetoric and Visual Communications at Michigan Technological University (MTU). At the time, MTU offered the only program I could find on Visual Rhetoric. What is Visual Rhetoric? This is the exact question that was asked by my PhD dissertation committee director the first time we met. I told him that if I was photographed while sitting in front of a poster of Vladimir Lenin, then I was photographed while sitting in front of a poster of Ronald Reagan, the two photographs would tell something entirely different about myself (provided we had only the photographs to look at and no other information).

He agreed that visual rhetoric was a reality and we moved on to design a course of study and we assembled a committee. However, his question – which to me was a non-issue – raised my suspicions about the level of intel-

An illustration I created for the "Rhetoric and Technical Communication" Program at Michigan Technological University ▶

▲ The idea was to depict the program as a bridge (literally) between practice and theory. I was originally offered to have the image credited to my name as payment, but I insisted on getting "hard cold cash." A phone call to the department chair inquiring about the budget for this project turned out that $2000 had been placed aside for this illustration. I was paid this amount for creating this image.

ligence of his department. After all, they had already accepted me into the program on the basis of a carefully written letter describing my goals, a letter in which I explicitly stated I wanted to focus on visual rhetoric. So why ask what visual rhetoric was now, rather than before I moved half way across the country? Today, as I look back at all this, I cannot help but think of a flyer I saw posted in a real estate agency near Holbrook, Arizona. On this poster a photo of Tom Cruise and a photo of an aging, toothless, disheveled man, were placed side by side. Under the aging, toothless, disheveled man it said, "I run East". Under the photo of Tom Cruise it said, "I only run West." I wish I had seen this poster before moving to Michigan. I wouldn't have run East so quickly.

By now you have a good idea of what is to come next, but the specifics aren't clear yet. You are correct. Stay tuned, it's coming.

An Attempt to Merge Art and Studies

Artists live in an imperfect world where affairs of the heart must sometimes be compromised with business.

SARA GENN

My goal, when I applied to MTU, was two fold: first, to study an academic area of high interest to me, namely how photographs are used to shape our understanding of the natural world, to express how specific cultures per-

ceive nature, and the role photographs play in society. Second, I sought to bring together my two interests: academic studies and landscape photography. I had assiduously practiced and studied photography while at NAU, building a body of work consisting of tens of thousands of photographs, most of them in medium format, a size I found to be compatible with hiking while delivering the quality I wanted. I had shows of my work, and during that time, I had written extensively about photography, more in an attempt to reflect upon the subject than with the goal of publishing my writings.

I had also excelled academically, maintaining a 3.87 GPA as an undergraduate and a 4.0 GPA as a graduate student. I had submitted papers to numerous conferences and had been accepted to all of them (a 100% track record in terms of conference submissions is uncommon). The PhD, as I saw it, was my last chance to bring my studies and my photography together. Being "a terminal degree" it represented to me both the end of the road in terms of academic studies and a final commitment to be an academic and not something else. Thus, I thought I better get it in line with my photography, otherwise my energy, no matter how high, would not be enough to sustain professional work in both fields, i.e., academia and photography.

MTU attracted me because my idea of merging the two disciplines in which I was working was well received by the faculty, at least in the feedback I received from them by mail. I had been accepted on the basis of my stated goals to design a course of study on visual rhetoric while focusing on photographs as "texts." It all sounds very academic now, but at the time it was very real and was at the forefront of what I could conceive of. I had also been offered a position at MTU as a teaching as-

sistant, teaching photography classes and running the darkroom.

Things always look good from a distance, and the distance is great between Flagstaff, Arizona and Houghton, Michigan. When I arrived in Houghton I found out that not only would I have to teach photography classes and run the darkroom, as it turned out, I would actually be the *entire* photography department by myself. The previous teacher had retired, the one hired after him had gone back to New York, and there was nobody but me to take care of this aspect of the Humanities course load.

Not that it bothered me. In fact, I enjoyed the responsibility and I perceived this to be proof that I was trusted to do the job. Sometimes, and certainly in this instance, being overloaded with work can be perceived as a sign that one is deemed capable above the norm. Thus, I proceeded to clean the darkroom from 30 years of accumulated "photographic debris" to put it pleasantly. I also proceeded to hire darkroom assistants and tend to the darkroom budget that I was responsible to balance. I became, in this respect, introduced to the concept of the "ballpark figure" in terms of getting the budget to a point that made sense to all. Yet, getting financial figures in the ballpark, an area quite large when you think of it figuratively (and the reason why sending the ball out of the park is such a feat), can be somewhat challenging. I could never quite get used to it, and as a result I always strived to get the figures right on. I couldn't operate effectively without knowing precisely how much money was available to me. I did not know it at the time, but this approach was going to prove very useful later on when I became an artist in business.

▲ **Landscape Curl**
One of the first digital images I created.

Since only one photography course was offered per semester, I had to teach two other classes – English 101 as it turned out – to meet my Teaching Assistant responsibilities, which were to teach 3 classes per semester. The fact that I had to be in the darkroom a certain number of hours each week to supervise my darkroom assistants, to balance the budget, to order darkroom supplies, to place ads looking for darkroom assistants, to interview prospective assistants, and to sometimes find replacements when the assistants some-

times left during the middle of the term, did not count toward my three-class obligation. I mentioned it to the department chair to no avail. The rules were the rules and the fact I taught a class that had more work than others was not a reason to change the rules. Case closed, deal done: get back to work.

And get back to work I did, moving along with my studies (three PhD level classes per semester), completing the various requirements for my PhD (committee meetings, oral exams, written exams, etc.), completing homework assignments (tests, papers, finals), applying to conferences (at least one per semester). Of course I did all this while teaching two subjects (English and Photography), then three subjects as I added a digital photography class, and finally four subjects when it was deemed necessary that I teach a Technical Writing class in addition to Photography, Digital Photography, English 101, and English 102. My workload kept increasing.

By the beginning of my second semester at MTU I had raised the darkroom fees enough to afford a film scanner and a copy of Photoshop 2.5. With this equipment available, I created the first digital photography class at MTU. It was so revolutionary (at the time) that Harper Collins published my syllabus. I had also, by 1992, moved to digital photography myself. I continued to shoot film (digital capture was not a reality yet) but processed and printed my photographs digitally. I gave conference presentations, wrote syllabuses, read hundreds of books, and maintained a 4.0 GPA as a graduate student. In addition, and to conclude this part of my story, I never misbalanced the budget, had students complain about my teaching, or had any complaint whatsoever from my professors. All in all, and despite the overwhelming workload I was under, I managed to

keep it all together, trudging along relentlessly and, I must add to my surprise, quite happily.

Except for one thing: financial reward. My salary then, as a teaching assistant, was a meager $500 per month, if that much ($485 sounds more like it). With this income I had to pay for all expenses, which meant that my car was a beater, my house a disaster, and my personal photography expenditures was supported by credit card companies. I could have applied for a student loan, a solution most of my fellow students chose to embrace; however I didn't. My wife, Natalie, already had student loans and the idea of adding debt to debt wasn't something I looked forward to. In addition, Natalie's income was supplemental to mine and between the two of us we could absorb most expenses. We weren't getting anywhere financially, but we were maintaining ourselves. At least that's what we thought. Natalie was a 7th grade substitute teacher by day and a bartender by night. I will let you ponder the philosophical implications of this situation. Some Junior High educational problems have origins that are challenging to pinpoint unless you know the full story.

The Beginning of a Career

Art and business may be strange bedfellows, but an artist must make room in her bed for both.
 Eric Maisel

Digital photography is expensive. Unlike chemical photography, equipment must regularly be updated, not just cameras, but also computer, software, printers, etc. Plus, one cannot afford not to upgrade. Doing so means being left with antiquated equipment, not just in terms of photography, but also in

terms of everything else, since the computer is, in a way, the nexus of one's operation. An antiquated computer doesn't just mean we are not at the forefront of digital imaging. But also that we are not at the forefront of web design, page design, color calibration, computing speed, operating system, web access, and so on. Older computers aren't just "older", they are also unable to run the latest operating systems or the latest software. An outdated computer is unable to take advantage of the latest and fastest connections such as, USB 2, FireWire, optical connection, Ethernet 1000, and so on.

I still have the Apple Quadra 840 AV I originally purchased in 1992. There is nothing technically wrong with it, and it will continue to work the way it was designed to work for as long as the hardware holds up. But it has a SCSI connection, which already sounds like something from a Computer History 101 course; it is unable to accept more than 1 Gb of ram, which is currently what you might get with any computer purchased right off the shelf; and it has a 40 MB hard drive, hardly enough to install Photoshop CS. It also has a 250 MHz processor, a small data bus, Apple OS 7, and so on. In other words, my old computer is perfectly fine if I want to forever live, operate, and do business in the digital world of 1992. But if I want to operate and do business in today's world I need to get one of today's computers.

This is not so with cameras, at least as far as film is concerned. A film camera can potentially serve a photographer, who is protective of his equipment, his or her whole life. Certainly, over the course of this photographer's career, improvements in bodies and lenses will be made, such as autofocus, image stabilization, auto exposure, and so on. But these

Hunt and Arrowhead ▶

This image is part of a series on rock art that I created in 1993. Images in this series were modified through numerous layer mode combinations.

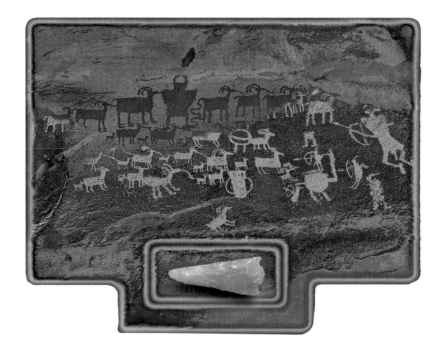

improvements will not be introduced each month. Rather, they will be introduced once every few years. And, it is possible to buy the latest lenses and use them on the original camera body. Because a film camera can accept any film, it provides the opportunity to save on the camera, and instead, spend money on good quality film.

Upgrading a film camera is also more of a necessity in some types of photography than in others. In sport photography, or any field in which shooting speed is important, upgrading to the latest models is a must to stay at the top of the field. But, in landscape photography, where speed is not so important, this is far less the case, especially if large format is used. While large format lenses have seen improvements over the past ten years, such as Schneider's introduction of remarkable lens designs in recent years, few if any, changes were made to the basic design of a 4x5 view

camera. So much so that many landscape photographers today use relatively older 4x5 cameras with newer lenses mounted on them. The same holds true with film. When Velvia was introduced in the early 80's, many landscape photographers saw little need to look further in terms of their film of choice. One could stock up on Velvia without fear of being overextended. If kept frozen Velvia was good forever, and one could consider their stock of Fuji film an investment rather than an exercise in over-confidence.

All this to say that digital photography was much more expensive than film photography, because the equipment had to be replaced so often. It quickly became clear to me that if I did not generate an income from digital photography, I would not be able to continue. I had to have some cash coming in. It couldn't all be going out. To achieve this there was only one solution: I had to sell some of my work.

◄ Six Hands

This is one of the first images I sold. It is part of the same series as "Hunt & Arrowhead."

◄ In the Boundary Waters

My exploration of Northern Michigan and Wisconsin provided the inspiration for numerous images, such as this collage of three photographs, the sky being imported from an image taken in Arizona prior to my move to Michigan.

That was the only solution since my teaching assistant paycheck was not able to cover my digital photography expenses.

I had never sold my work so I made all the usual peregrinations, mistakes, and errors. I started, as can be expected, by seeking gallery representation. Finding galleries was easy. Giving them artwork, keeping track of inventory (who had what and how many of each) was more challenging. Getting paid – if and when they sold something – was even more difficult. It quickly became clear that galleries were a poor solution to my cash flow problems: I had to pay for inventory up front. I had no guarantee they would sell anything. If they did sell something I had to wait a month or longer to get paid. I needed to reinvest some of that money in new inventory. I only got 50% of the selling price. Except on rare occasions, I did not know who the buyers were. Finally I could not, per my contract, sell directly to gallery customers without giving 50% of each sale to the gallery.

I tried shows and direct sales and I found that this approach worked a lot better. At shows I got paid when the sale was made, I got 100% of the selling price, and I knew who bought my work, which enabled me to build a customer base and opened the possibility of making repeat sales to the same customers. It did not take me long to find out which system was more advantageous to me.

But making sales was not enough in my opinion. I thought that I also had to make a name for myself. I therefore sought interviews and articles in local and national newspapers, magazines, publications, cover stories, and the like. I was quite successful in this endeavor only to discover that these publications did not result in additional print sales. Certainly, there were people out there learning about me

and about my work, but these people did not pick up the phone to order photographs, even though my contact information was in each article. I did not know it then, but I was confusing fame with fortune, as we will see later in this chapter.

I also applied and was accepted in two Artist in Residence programs at Isle Royale National Park and at Apostle Islands National Lakeshore. This proved to be one of the best things I ever did. While it can be said that it promoted my name more than my fortune, this is not a completely true statement because it opened the doors to sell my work wholesale in several National Parks. Wholesale was a venue that was unknown to me at the time, so having access to park gift stores and bookstores as a venue for my work was a breakthrough.

The Straw that Broke the Camel's Back

At any rate, whether I was doing photography or pursuing my studies, I was working very hard. I did not complain. After all, this was my choice. I could have stopped, done something else, or reduced the number of activities I was involved in. Hard work did not bother me.

So what gave? What gave was one of my graduate teachers demonstrating a racist attitude towards me. This took the form of him calling me a frog during a graduate teaching class in which I was giving a presentation on that particular day. I was so absorbed in my presentation that I did not notice. It was the other graduate students – my classmates – who came to me after the class and explained what happened. I was so far away from considering it a possibility that a teacher would be racist towards a student that I did not believe them at first. However, when confronted with

▲ Sand Island Light

A collage of five photographs, this image was created during my Artist in Residence stay at the Apostle Islands National Lakeshore. This image was sold as a poster and notecards in the Apostle Islands giftstore. A limited edition print was donated to the Lakeshore and featured in the Visitor Center.

the facts, and having stepped back from my sole focus for the class, which was doing my best during my presentation, I had to admit they were right. Furthermore, why would fellow students – not one, but nearly the entire class – take the time and effort to point this out to me unless they thought something wrong had taken place?

I took the matter to my PhD committee, who suggested I address it with the teacher. Needless to say, I did not see how this was going to help. I then took the matter to the chair of the department, who suggested the same. I finally took it to the equal opportunity department who, once again, suggested I try to address the issue with the teacher. I wasn't getting anywhere.

To this day, I dislike talking about this event, and for this reason I have kept the description of what happened to a minimum. I dislike to discuss it so much that I put this chapter on hold, at the start of this section, for for quite some time. This is not fiction. This is real. This is an event that affected my

Island Fishing ▶

A second collage created from photographs taken during my residency at the Apostle Islands. Natalie and I were given use of a cabin on Sand Island where we stayed for three weeks. We were ferried between all 12 islands on National Park Service boats, and stayed in lighthouses and other park housing when unable to return to our cabin the same day.

life and caused me to make significant changes to my life. As we will see, these changes have been for the best. In many ways, these changes freed me. But it didn't look this way to me at the time.

Doing What I Love

It was during this time that I had what some call an epiphany, but which I personally prefer to call a mind opening realization, a vision, or a moment of enlightenment. I realized, in the flash of a second, that no matter what activity I would pursue – be it studies, photography, or any other endeavor – from the most ambitious to the least ambitious, I was going to encounter serious difficulties. There were going to be people who would try to discourage me and people who would be jealous of my success.

At that time it was racism coming from one of my teachers. Tomorrow it would be something else. Finally, there were others who wanted the same thing I wanted and with whom I would have to compete.

What I realized right there and then, on that day, in the moment when the straw was going to break the camel's back, was this:

Since anything you choose to do to the best of your abilities will present difficulties, you might as well do exactly what you like.

I realized that I might as well choose to do precisely what I wanted to do, without caring much about what others thought or what my chances of success would be, because it was going to be difficult no matter what. By choosing to do what I loved, I actually placed one more asset to succeed on my side, and

◄ Canoe on Isle Royale

Part of my Artist in Residency Portfolio for Isle Royale National Park. At Isle Royale we were responsible for our own transportation and were provided with the canoe shown in this photograph above for that purpose. We used it daily.

that asset was my extreme motivation to succeed. Nothing can motivate someone to succeed more than trying to be successful at doing what one loves. I realized that I may or may not succeed, but at least I would have done something that I loved. If I did anything else, the same chances of success or failure were present, but without the reward of doing something I enjoyed doing.

I might as well fail at doing what I loved rather than fail at doing something I disliked. And again, who said I was going to fail?

Why Didn't I Think of this Before?

This realization made me wonder why I didn't think of it before. Why didn't I decide to do what I love before? I thought about it for a week before the answer came to me. When it did I was shocked:

I had carried with me the unconscious belief that I couldn't make a living doing what I really wanted to do. Others could do it, but I couldn't.
That belief had prevented me from even trying.

Why didn't I think of doing what I love before? Simply because I believed, unconsciously, that I could not make a living doing what I loved. I had to do another job, another activity, then I could do what I really wanted to do on the side. Others could do it, but for some reason I did not include myself in this group.

This belief had been with me for many years. Interestingly, it only took days for it to disappear when I became aware of it. In a way, becoming aware of this unconscious belief was the key to eliminating it. Awareness, some

may say, made it vanish. Within days I was talking to others about it, within weeks I had left it behind and moved on.

Opportunities Often Come Under the Guise of Hard Work

The most common money-related mistake artists make is a reluctance to invest in their own careers.
 MICHELANGELO

I talked about all this with Natalie and we decided to move back to Arizona (remember, I was studying in Michigan) at the end of the semester, which was only a few weeks away.

We moved back to Flagstaff, where Natalie's sister lived, and stayed with her for a month or so. More precisely, we rented a U-Haul truck, loaded all our belongings in it, then drove as leisurely as possible from Michigan to Arizona, using all the travel days the U-Haul company allotted, plus some extra days. In Flagstaff we rented a storage unit, unloaded the contents of the U-Haul into it, returned the truck to the rental company, and started our new life. We spent some time at the house of Natalie's sister, which became our mailing address, but mostly we spent our time camping, relaxing, exploring, and photographing Northern Arizona. We had both come out of a pretty difficult time in our lives and we needed this time off. Natalie applied to several teaching positions on the Navajoland and Hopi reservations and there was nothing much to do for us besides wait for the call, or the letter, and go to the interview.

Our travels throughout Northern Arizona eventually brought us to the Grand Canyon. How can one not make it there? It is, after all, a world-famous location. During our visit to

Grand Canyon we walked in front of the North Porch of the El Tovar Hotel. On this porch, located less than 50 feet from the rim of Grand Canyon, were two artists selling their work. I looked at their displays, looked at Natalie, then said, "this would be the perfect place to sell my work". Little did I know that not only was I 100% correct, I had also found the one location that was about to change my life forever.

Natalie eventually found a teaching position in Chinle, in the heart of the Navajo Nation. I found a teaching position at NAU in Flagstaff but turned it down because the higher cost of living in Flagstaff meant that even if Natalie found a teaching position herself in Flagstaff we would have made less money than with Natalie alone teaching in Chinle. So we decided to move to Chinle, and once there, have me focus on my photography. It was a gamble but it paid off.

The Best Place to Start a Business is on the Navajo Reservation

Artists are often excellent businessmen. They have to be. Otherwise they do not remain artists.
 A.Y. JACKSON

Chinle had its good side and its bad side. You probably already know the bad sides so I won't mention them. Let's look at the good sides instead. I have always said that Chinle is the best place to start a business. Why? Because all the major reasons that cause a new business to go under are not available in Chinle. Firstly, there are no distractions of any sort – no movie theater, no disco, no nothing. So, one must focus on what they are doing. The only distraction, other than doing nothing, is to work. So

◄ Canyon de Chelly Collage

One of the first images I created after returning to Arizona.

I worked. I worked on my photography and on a million and one things aimed at getting it ready to sell. Secondly, there is no stigma attached to a man staying home while their wife goes out to work, or vice versa. In fact, this is a very common situation on the reservation since there are few jobs and most households are lucky to have even one member working. So, having me stay home and do my thing did not bring uproars, screams of anger, claims of spouse abuse, or other allusions to laziness on my part. Rather, when people asked, "What does Alain do?", Natalie told them that I worked on my photography, and they would nod in approval. I had a goal and I was doing something that mattered to me. All was well in their view.

The third thing that makes Chinle the ideal place for starting a business is that business loans are not available, and therefore, a business must be profitable right away. Why can't you get a business loan? Because a white person is not supposed to have a business on the reservation. Only Native Americans can have a business. So, in this situation, why would I ask for a business loan? It would be similar to asking for a loan to buy drugs. "Sorry, can't do it," would be the answer from the loan officer as they discreetly push the secret red button under the desk to alert the police officer standing nearby. Nope. Not an option. So, what is one to do? Well it is necessary to finance the operation out of one's own pocket, or from the profit generated by the business.

The fourth reason that makes Chinle the ideal place to start, not just a business, but a landscape photography business is that it is unnecessary to travel anywhere in order to find some of the most photogenic places in the world. They are right there at your doorstep, so to speak. In my case it was a ten minute drive to Tsegi Overlook, and a twenty minute

drive to Spiderock, two of the most stunning locations in Canyon de Chelly. If I felt more adventurous, I could drive one and a half hours to Monument Valley or, should I really decide to go all out, drive half a day west to Zion, Bryce Canyon, Escalante-Grand Staircase, or the Grand Canyon. I could also drive half a day east to Mesa Verde, Chaco Canyon, Bisti Badlands, etc. There was no shortage of subjects, and I didn't have to worry about travel costs. I was already there.

Others were coming to Chinle, driving thousand of miles, or flying half way around the world to see this landscape. I was already there. Hey, I lived there! Not only did I not have to drive any further than I would to drive to the grocery store, I could visit these places at any time of the day or night or on any day of the year. I could – and did – get up the morning after a snowstorm or during a late summer monsoon storm, or any time I pretty darn well pleased, and I could photograph my heart out. If I had not lived there, I would never have gotten some of the photographs I captured. The probabilities of finding oneself in Canyon de Chelly the morning after a snowstorm are small. Firstly, it doesn't snow all that often. Secondly, the perfect conditions for a photogenic snow scene are rarely present all at once. Thirdly, one does have to be there, which can only happen in three situations: 1 – You live there. 2 – You know the storm is coming and you are able to drive there, something more difficult than it seems because the roads are not always plowed. 3 – You are just plain lucky. Clearly, living there is the best solution and the one that gives the photographer an edge. It was my situation, and it did give me an edge. Was it fair? You bet. I was paying my dues big time back then so any edge I might have had was fair.

The fourth reason why this was "the place" is called motivation. Many people lack the necessary motivation to succeed. When I lived in Chinle, motivation was staring at me right in the face. All I had to do was look out the window and I would be motivated. The dilapidated houses, the trash in the streets, the dogs running amuck and barking endlessly, the cannibalized cars, the piles of worn out tires, etc. The poverty, unkemptness, and desolation were my motivation to get to a better place. It was what kept me going if I needed something to keep me going. Eventually, it proved too much to handle and I had to get out faster than I thought. We'll get to that in the next chapter, but I just couldn't help but mention it here. What a place!

The fifth reason is that operating a business in Chinle involved no overhead. We operated out of our house (read mobile home) and the rent plus utilities was only $205 a month. Furthermore, this was automatically taken out of Natalie's paycheck, which meant that, after a while, we got used to Natalie getting paid a certain amount and we stopped thinking we were actually paying rent. At any rate, it was a very low amount, and to make things even better it never increased during the seven years we lived there.

And there is a sixth reason why Chinle was the perfect place for me to start a business. There has to be a sixth reason. I just can't end the list on negativity. That sixth reason was the Navajo people themselves and their unique, ageless I should say, approach to life. In two words: their permissiveness and their lack of judgment. On the reservation (on any reservation I would think, but definitely on the Navajo Reservation), being an artist is accepted. It is OK to make a living by selling art. It is OK to make art and nothing else. It is OK

to stay home all day to do so. They would often ask me, at the Kindergarten Center depot where I went to pick up packages that somehow had ended up there, "So you are an artist?" They would see the huge rolls of bubble wrap, which came 5 rolls at a time for quantity discount, and measured thousands of feet all together, and they knew that somehow this wasn't for home consumption. They could put two and two together. I was packing artwork. I was protecting it for transport. What artwork, for whom, to where? All this wasn't known to them and wasn't all that important. What mattered, what raised their curiosity, was that I was an artist and that I was doing well with it. That was OK. That was part of normal life. Being an artist was not off-the-wall. Their uncles, brothers, sisters, and parents were artists: weavers, painters, sculptors, and kachina carvers. They were artists from generations past and their children would be artists. Art was a way to make a living on the reservation, not something one finds in a museum or in upper education classes. Art was life and as an artist I was part of life.

The Navajos believe that one shouldn't judge someone else. That one shouldn't say that something, and even more importantly someone, is good or bad. Things can be liked and disliked. That is, opinions are acceptable, but judgments are not. Judgments are similar to branding someone with an indelible label; a label that is there to stay, a very sticky label that one can never completely peel off. Some of the glue sticks so well it never leaves. The paper stays on, some of the inscription stays on, and after years of trying to pull it off, the message told by the label can still be read. The mark of time, the tears, rubs, and the damage one did to the label while trying to remove it, show better than any speech how long it has been there and how hard the bearer has tried to make it go away.

No, the Navajos don't judge. In fact, the mark of a good person is in part determined by a person's ability to not judge. The mark of a good person is to show that one doesn't judge. It is OK to show that one has opinions about what one likes or dislikes, about what one believes and does not believe in, but one should stop just before the line where judgments are passed. So it was with me. I was who I was, I did what I did, and there was no judgment passed upon my actions. Not that I was doing anything "wrong". I wasn't. I wasn't breaking any law or doing anything illegal or coveted. But in many cities, in many societies, not breaking any laws, not doing anything illegal or coveted isn't enough to not be judged. In fact, it's not even a prerequisite. People judge because they judge. They judge anything and everything. They judge all day long, as a matter of fact, and those that are judged have to live with the judgment, suffer the consequences, live with the results of their actions, whatever those actions may be, no matter how inconsequential or inoffensive they may be, no matter how important those actions are for the doer. And art is a very important action for the doer.

There is one last thing, at least as of now, that really made Chinle the place to be in terms of starting a business as an artist: I was living in a place where art was being created and sold on a daily basis. People here were making a living as artists. I was inspired.

How to be an Artist in Business: My Story – Part 2

People think that at the top there isn't much room.
They tend to think of it as an Everest.
My message is that there is tons of room at the top.
ROBERT DE NIRO

The Break

According to McDonald's we all deserve a break, and we deserve it today. We should take it right here, right now, and preferably in a McDonald's restaurant. The fact that McDonald's are ubiquitously present in cities and along main highways makes this approach very convenient. McDonald's certainly had marketing considerations in mind when they came up with that line. However, getting a break does have some truth in the context of our considerations.

In business, we all need a break to get started. Why? Because we need a way in, a ramp-up, a motivating factor, something to make us feel like we have a chance to succeed, something to make up for the fact we have no experience and (in my case) no funds to give us a financial advantage. Such was my situation and my break was being able to sell my work on the North Porch of the El Tovar Hotel at Grand Canyon National Park. By being allowed to sell at the Grand Canyon I was able to bypass years of attempting to make a living in second class, or third class, or even lower venues. You see, in selling there are venues and then there are *venues*. In selling art, as in selling real estate, location is very important. And the Grand Canyon is a prime location, especially the El Tovar Hotel, which on top of being the premier hotel in Grand Canyon National Park, and listed in the National Register of Historical Places, is located 60 feet from the rim of the Grand Canyon, with many of its rooms and suites having a direct view onto what is considered to be one of the wonders of the natural world.

The People

But location alone, while being crucially important, is not enough for success. The best location in the world is nothing without traffic that brings in qualified customers on a daily basis. The El Tovar delivers just that. Located at the top of a hill overlooking the Grand Canyon, the El Tovar is on the path of just about every Grand Canyon visitor.

Firstly, the Grand Canyon Railroad Terminal is located just down the hill from the El Tovar Hotel. After getting off the train, passengers – who in the summer can number up to 3000 per train with two or more trains per day – come up the path to the El Tovar because it is the most direct route from the train station to the first overlook. They then walk in front of the El Tovar, and, you guessed it, by our display. They stop, look, and purchase photographs. Some purchase them right then and there, while others purchase them on their way back.

I have always preferred customers who purchase on their way back because the train only gives passengers a three-hour stopover at the Grand Canyon. When passengers realize it is time to return and they stop by our booth, they usually have only minutes to spare and must make a decision right then and there. It is do or die, sink or swim, buy it now or have regrets forever. Many sales to passengers who were running "late for the train" and were at risk of being left overnight at the Grand Canyon (what a drag) were made on the basis of, "Can you frame it and pack it in three minutes? My train is leaving right now!" And we could. I would frame the piece and Natalie would package it while I wrote the receipt and processed their card or gave them change. In less time than it takes to say, "All aboard!"

White House and Ollas ▶

The pottery depicted in this image, as well as in the last image in Part 1 – "Canyon de Chelly Collage" – is part of the archaeological collection of the University of Arizona. I photographed it after obtaining special permission.

they were running down the hill with a photograph under their arm. We never had a "late for the train customer" negotiate the price, try to not pay sales tax, or ask for a cash discount. I am sure many thought of doing so but time was running out. The expression *impulse purchase* was never more accurate.

Secondly, there were the hikers. Never discount the hikers! They may be sweaty, covered with dust and pulverized donkey poop, sometimes haggard, and nearly always suffering from a bad case of Kaibab Shuffle; the unmistakable swagger that develops the day after climbing 7000 vertical feet and makes your lactic-acid-loaded-legs unable to climb stairs because you cannot lift your feet more than an inch above the ground, forcing you to walk with legs locked at the ankle, or the knee, and in particularly extreme instances at the hip, legs that can only be moved sideways and forward, as any flexing of the muscles that allow you to bend your legs has become impossible. The Kaibab Shuffle became our best friend, because hikers afflicted with this painful and debilitating condition were easy prey to any and all possibilities of sitting down. "Would you like a seat?" became for them the best news in the world. A seat, and the knowledge they were on top of the hill and that as long as they stayed there they would not have to go up any further, was the best news they could ever get at this specific time in their lives. And since we were located on top of the hill, and because we had seats, specifically large, historical benches located on the porch of the El Tovar, we were the bearers of good news. Almost any hiker that would take us up on our offer to "take a seat" became a customer.

Hikers would come in droves, equipped with complete explorer outfits and larger than needed backpacks, asking if we could

ship. And we could. We had large signs that read, quite simply "We Ship!" Those signs were ubiquitously pointed towards the trail so hikers on their way down into the canyon could read them. They would make their actual purchase after they returned, most afflicted by then with the Kaibab Shuffle as I just describe, now seeking to bring back home with them one of our photographs, as a memento of their trip. If their finances allowed it, this memento was going to be as large as we could make it, so that its size would be metaphorically proportional to the suffering they endured below the rim. The longer and the more difficult their hike was, and the least likely it would ever be repeated, the larger the purchase. I once had a father who bought our largest piece –a seven-foot panorama of the entire Bright Angel Trail — and who mentioned, after announcing his decision "Two of them. One for me, one for my daughter. We did the hike together." "Yes sir. And would you like a couple of companion prints with that?" Actually, I didn't say that. I just said "Thank you. That is a wonderful gift to your daughter and to yourself", and I proceeded to write the receipt. But I certainly thought it. Sometimes, it is really challenging to know when to stop talking. Usually, I was able to do quite well. But on occasion, I did digress. Not that time though.

The El Tovar is the second-closest lodge to the head of the Bright Angel Trail, the most traveled trail in the Grand Canyon. The closest lodge is Bright Angel Lodge, about a half mile past the El Tovar. You may ask, "then the Bright Angel Lodge should be a better location, shouldn't it?" Well, not really. You see the Bright Angel Lodge is not in the same caliber of lodges as the El Tovar. The El Tovar is where the wealthiest visitors go. Since art is a luxury, it is those with the highest amount

▲ Tsegi Spring Storm
Olympus OM4, Zuiko 18 mm, Kodak Royal Gold 25

of disposable income that will buy the most expensive artwork. Furthermore, just about every one who stays at the Bright Angel Lodge comes up to the El Tovar because it is along the path to other overlooks, because it is a beautiful, world-renowned historical lodge, and because it has what I consider to be next to the two nicest gift stores in The Grand Canyon: the Hopi House and Verkamps. Visits to both stores are "required" of all Grand Canyon visitors. In fact, when exiting the park a receipt from one of those two stores must be shown, and if one cannot show such a receipt the park entrance fee must be paid a second time. At $25 this exceeds the cost of a tee shirt, or other affordable souvenir, making shopping in those stores a no-brainer (just kidding).

Thirdly, are the walk-in visitors. This may be the largest category, but not necessarily the most profitable. Walk in visitors are basically just about anyone who drives into the park, parks their vehicle, and walks along the rim, into the stores, and into the historical buildings. They are sightseeing without a further goal in mind, unlike hikers who may be walking along the rim, but are doing so waiting to start their hike either down to the river and back, or across the canyon, or on some remote wilderness trail following their own itinerary.

Walk-in visitors is a misleading term because they are really "driving-in" visitors. However, by the time we meet them, they are on foot, their car parked somewhere far away.

The average Grand Canyon visitor spends twenty minutes looking at the Grand Canyon and three hours shopping in the stores along the rim; the three main stores being Verkamps and the Hopi House (required as I just mentioned), and the El Tovar whose gift store,

although selling higher-end merchandise, is also very popular. Together with Natalie, I worked very hard at lowering the average time people spent looking at the Grand Canyon. After five years, and based on extensive surveys conducted by the National Park service (survey based on passing over 7 million questionnaires to Grand Canyon visitors) we succeeded in lowering this average to 15 minutes. We were on our way to 10 minutes, and going strong, when the El Tovar show was terminated (just kidding, although the show was terminated; more on that later). For now, let us look at a fourth traffic category: the hotel guests.

Hotel Guests were among our best customers. First, they were a "captive audience" so to speak, for the duration of their stay. The North Porch being the most direct way to the rim of The Grand Canyon, nearly all of them walked by our show several times a day. Most of them looked at our work on their way in or out, and it was only a matter of time until they purchased something. Some made their purchase on their first visit to the show. Others made their purchase as they departed the hotel. Most made purchases during the middle of their stay, after having carefully made up their minds about which piece they wanted to take home with them. A surprising number made repeat purchases throughout their stay, often at the beginning, middle, and end. Highly recommended! By the time they departed the Grand Canyon for the next destination on their itinerary, they had become close friends of ours. Some even recommended us to their entire family. I once sold artwork to each member of a family reunion numbering more than fifty. All together, they purchased nearly 100 pieces.

What is most important to understand about the El Tovar guests is that they were

qualified customers. As I mentioned, because the El Tovar is the most expensive hotel in the park, only the wealthiest guests stay there. This means that they are the ones with the most disposable income, and because art is often purchased with disposable income this means they were our most likely customers. Further, they obviously liked the El Tovar Hotel otherwise they would have elected to stay somewhere else. It therefore made sense that they would like most other aspects of the hotel, including our art show. And finally, the fact that we were showing at the El Tovar Hotel, instead of in a lower-category hotel, said something about us. Clearly, the hotel picked only artists that met the high standards that had been set for this hotel. This, in turn, justified the prices we charged and guaranteed the service we provided. In short, we were the ones when it came to buying photography. The fact that we were the only ones in the park to sell fine art photography didn't hurt either. Not that most people looked anywhere else. But for the few that did, it was a one-way trip back to our show. In short, and when everything is taken into account, we were the ones when it came to purchasing original photographs at the Grand Canyon.

The Approach

The best location and the best traffic and two essential elements, and together they are enough to guarantee a certain level of success no matter what your approach to business is. However, a certain level of success wasn't what I was after. Call me ambitious, and if you consider this a crime, notify the proper authorities. In my book it isn't. In fact, I consider ambition a quality. What I was

after was the highest level of success I could reach through this opportunity. I didn't have much experience with art shows at all when I started selling at the El Tovar (I had done one art show in Michigan and a handful of shows (read *Christmas Bazaars*) in Chinle, and that was about it. My other sales had been through gallery exhibits or direct sales to customers. I had placed one ad in an art magazine, and had some success with it, and I had sold note cards wholesale to hotel gift stores in Chinle and Monument Valley. Unless I forgot something, that about sums up my experience selling art at the time I started the El Tovar show.

The El Tovar Hotel provided me with an opportunity to go much further than I had gone before. The question was how to get there. I started in the most obvious manner: by studying how the other artists in the show, those who had been there before me, were doing it. I did this while selling my work at the El Tovar show. The El Tovar Porch was divided in two, along the entryway to the hotel. The first half was called the A side and the other half was called the B side. The A side was larger and was given to artists who had seniority, or were in good terms with the management, as we will see later. The fact is, and this is what I want to convey at this time, that when I started the show there were always two artists on the porch at any given time, one on the A side and one on the B side.

The Progression of the Grand Canyon Show

Content is more than ,subject matter. It is all the feelings and ideas you bring to your painting.
RENE HUYGHE

We sold our work at the Grand Canyon for five years, from 1997 to 2002. When we started the show we were, in the words of one of the other artists who had been selling their work there for several years, "the lowest guys on the totem pole." By the third year we were at the top of the totem pole and every other artist wanted to outdo us. They were also wondering how we climbed to the top. Some of these other artists had done the show for ten to fifteen years, and to be outdone sales-wise by newcomers wasn't easy for them to accept.

What had happened was fairly simple. As I mentioned, there were two sides, physically speaking, on the El Tovar North Porch, referred to as the A and B sides, and separated by the entrance into the hotel. These two sides were allocated to two different artists by The Fred Harvey Company, now Xanterra Parks and Resorts, the company that owns and manages the lodges at Grand Canyon National Park. Because there were about eight different artists showing and selling their work at the El Tovar, each artist was allocated one week a month to show their work (four weeks times two artists per week).

Needless to say, each artist wanted to be allocated as many days as they could possibly get, because more days meant more income. When we joined the show, scheduling was done on a preferential basis. If the people at Fred Harvey who were in charge of the show liked an artist, they were given more days, better days, and side A – the larger of the

▲ **Yavapai Dusk**
Grand Canyon National Park

two sides on the porch. Since we sell what we show, to show more means to sell more (to a point). Again, needless to say, everyone wanted to be on the A side, but only those who were "fuzzy" with Fred Harvey management got to be on the A side.

The same situation was in effect in regard to getting more days on the show. Eventually, once we had figured out our average sales per day, generating a specific income for the year was as simple as taking our income goal for the year and dividing it by our average daily income. The number you got after the division was the number of days needed to show at the El Tovar Hotel. Unfortunately, while the math was easy, getting scheduled for the number of days we wanted was far more challenging. Here too, only those who were "fuzzy" with Fred Harvey management got to have as many days as they wanted. The others got whatever they could get and had to be thankful that they got anything at all.

In 1999 things changed drastically in regard to show assignment when a new retail director was hired, replacing the previous one who had worked there for over twenty years. This new director took a good look at the receipts provided by the El Tovar artists, and realized there was a discrepancy between how much the artists were bringing in and how many days they were assigned on the show. Specifically, some artists were selling over 100 days a year, yet their average sales per day were about half that of other artists (read "us") who were only selling a few days a year.

This new retail director was into maximizing the financial return to Fred Harvey from the El Tovar Show. To sell at the El Tovar, artists were required to sign a contract stipulating that they were to give twenty percent of their sales from the show to Fred Harvey. In order

for Fred Harvey to maximize the income from the show, the logical thing to do was to give the maximum number of days to those artists who had the highest average daily sales. This is exactly what he did; he changed the rules for the following year and put into the contract that show days would be allocated by priority to the top-earning artists.

When the daily income ranking was finalized, at the end of 1999, Beaux Arts Photography was on top of the list. I asked for a week a month, all on the A side, and preferably with a painter rather than a photographer on the B side, to minimize competition. I got everything I asked for. I remember the words of the retail director when he gave me the schedule for 2000, "Rock and roll." I certainly did.

Quantity

Perpetual devotion to what a man calls his business, is only to be sustained by perpetual neglect of many other things.

ROBERT LOUIS STEVENSON

Over the next few years we rapidly moved towards being the "top dogs" at the El Tovar. For several years in a row our sales volume doubled each year. I was taken into this rocket-like assent, to the point where I thought it had no limit. Unfortunately, there was a limit, and this limit was how much artwork Natalie and I could physically produce. The problem was not how many pieces we could sell, for there was either no limit, or we were very far from having reached that limit. The problem was our inability to produce enough artwork to satisfy the demand.

Most artists worry about how many pieces they are able to sell. We worried about how

many pieces we were able to produce. Regardless of how hard we worked, we could not keep up with the demand. Not only that, but there was the framing and packaging, which took time as well, and finally the packing and shipping of sold pieces. Nearly all our customers were traveling, either from another state or from another country, and many were not able to carry their artwork back with them. We tried very hard to do what we could so that the customer would take their purchase along with them, but after each show we had about 50 packages, usually large framed pieces, to package and ship. Because many pieces were sold prior to actually being printed, we first had to print and frame most of the pieces we needed to ship. Furthermore, all this had to be completed within a week, the only time we could devote to that part of our business. Then it was back to preparing artwork for the next show, which took two weeks, and then time to leave again for the El Tovar. This pattern with a one-week show covered exactly one month, and became our normal rotation schedule from one show to the next. We could not have possibly done more than a week of selling each month. As it was, we had time for nothing else. If someone called to place an order, because for example they didn't purchase at the Grand Canyon, their order had to be placed at the end of the queue and was delayed by about three weeks.

To try and meet this huge demand I was printing my work on three different printers, powered by three different computers, and I had all three running simultaneously. While the printing was going on, I would be cutting mats, framing artwork, and packaging pieces. I would also be placing orders for frames, mats, packing supplies, and one thousand other items needed to run our business. I was

also taking deliveries from UPS, Airborne Express, DHL, and other carriers who managed to find their way to our trailer in the middle of the Kindergarten Center, the name of the housing area where we lived in Chinle. Often, they didn't manage to find us, and would instead drop our packages at some strange location in Chinle, either the School Warehouse, the Kindergarten Center, or the Junior High School. I would sometimes get a call from someone wondering what that pile of boxes in their hallway was all about, or Natalie would hear from someone about my packages. If I knew a delivery was expected on a specific day, I would do the rounds, trying to find where the supplies I ordered for my business had been delivered. Usually, this wasn't feasible because shipments to Chinle made it there when they made it there, regardless of what the shipper's schedule might be. A sand storm, a flat tire on the truck, or simply the driver getting lost, or forgetting to pick up or deliver my packages, meant that the delivery was pushed back until their next trip to Chinle, which, if I was lucky was the next business day, but often ended up being several days, and on occasion up to a week later. All in all, it took a lot to hold everything together and running smoothly. Somehow, we managed to succeed despite what at first sight appears to be insurmountable odds. The cost, for there was eventually a cost, was to come later. We will get to that in a minute.

After a couple of years, the problems associated with ordering and delivering supplies had become such a burden that I bought a 10'x12' shed, had it built in Flagstaff over 200 miles away, delivered to Chinle on a flatbed truck, and installed with a forklift. I then started ordering supplies for an entire year, attempting to predict how much to order in January for the coming year. I was usually wrong, erring

**Canyons of the
San Juan 1 ▶**
San Juan River, Utah

regularly on the low side, since I could never quite expect the business growth that each year brought. There was also a limit to how much inventory I could stock. For example, I ordered frames 300 at a time, in sizes from 11x14 to 40x50, and that quantity only lasted about a month. The boxes the frames came in alone were enough to fill the trailer and the shed because we kept each empty box, and the foam peanuts they were filled with, to ship sold pieces. I could not have ordered more, simply because I did not have room to store them. Cash flow was the least of my worries. Storage space was the issue.

Ordering from home, even though I had one hundred other things to do, was a luxury of sorts. Often times, I had to place my orders while I was on the road; often from the basement of the El Tovar Hotel, next to the bathrooms, where the public phones were located (the Grand Canyon had no cellular access at that time). At such times, this was the only way I could schedule delivery prior to my next show, because certain suppliers, including the company from which I ordered my frames, had a two week wait between ordering and delivery.

Wearing Out

The first requisite of success is the ability to apply your physical and mental energies to one problem without growing weary.

THOMAS EDISON

At this point, if you followed the gist of what I just described, you are probably getting the idea that I was wearing out. I certainly was. All I was doing was creating art and selling it. In fact, I could not create enough art to sell. I was having a problem. Unlike most artists, my problem was not that I wasn't selling my work. My problem was that I was selling too much of my work.

I tried everything possible to increase my production capabilities, short of moving on to an assembly-line approach or hiring workers (the El Tovar contract stipulated that we had to create the work we sold there ourselves, so this was not an option). To increase our production, I started by purchasing a computerized mat cutter. I made the decision after starting to feel pain in my right wrist and hand from the repetitive motion of cutting thousands of mats. To me, avoiding serious injury to my hand was worth the $20,000 price tag of the computerized mat cutter.

The computerized mat cutter certainly speeded up mat production and it also enabled me to create much more fancy mats than I previously could. With it I was able to cut a variety of corners, including decorative corners, as well as cut multiple openings, layered mats, and more. I no longer had to spend hours calculating the size of a mat opening, or the spacing of a complex layout. All this was taken care of by the software. Furthermore, I could save each mat layout on the computer, very much like I save image files for future reprinting.

I also moved to compressed air framing tools. This move was initiated by the air compressor that came with the computerized mat cutter. A computerized mat cutter works with electricity and compressed air. Electricity powers the two servo motors that move the cutting head on the x-y axis table. The cutting head itself is pushed down into the matboard by compressed air. Compressed air is also necessary to operate the clamps that hold the matboard to the table.

The compressor is a Silent Air model, meaning it makes no more noise than a large refrigerator. Having it run all day is not a disturbance since we can hardly hear it. The first aircompressed tool I began using was a framing staple gun. This tool is used to fasten the backing board into the frame. Prior to the compressed air staple gun, I was using a hand-operated model. It worked great when I had only a few frames to do, but when I was making hundreds a day, it tired my hand, and here too I faced the risk of getting repetitive strain injury.

I then added a compressed air box stapler to my toolbox. This tool is not often seen other than where large amount of heavy packages are shipped. We noticed that the frame boxes we received were closed with staples which worked great, so we moved to the same approach. Prior to that we were using miles of packing tape to close our frame boxes. This tool made assembling and closing boxes much faster and easier.

We also acquired an electric, cordless screwdriver to screw the wire frame holders to the back of the frame. Finally, we added an anti-static compressed air gun to clean the prints and the insides of the frames prior to framing. This too saved us a lot of time since cleaning a frame of lint and dust can be very time consuming, especially when working with acrylic, which is highly conducive to static electricity.

At any rate, all these tools fixed only part of the problem. They made our work less physically demanding and they allowed us to work faster and more efficiently.. However, it only allowed us to create artwork faster. It did not solve our main challenge, which, unknown to us, was that we were selling too many photographs.

I hired a private marketing consultant, at a high price, to help me solve this challenge. His solution was simple, and in retrospect obvious, although at the time it was scary to implement: we needed to raise our prices. At first, we couldn't do it. We had come to associate our success, not with what we sold, but with how much we charged for it. To change our prices, to *raise* them, was (or so we believed) to ask for trouble and most likely to put an end to our success.

But we were forced to do something. We now understood that we could control the volume of sales by the price, and that lowering our volume could only be achieved by raising our prices. Even if we were scared to do so, we had to do something or we would die trying to meet the impossibly high demand placed upon us. So we did. Timidly at first, then, seeing that it hardly made a difference in the volume of sales, more and more authoritatively.

I decided that since we did not know the maximum price we could ask for our artwork, we would proceed cautiously, raising prices $5 or $10 at a time. But because our prices were so far below what we really needed to charge, at some shows we had to raise prices daily, if not several times a day, as our stock got lower and lower, to prevent this stock from running out before the last day of the show. In other words, we were starting to understand that we had a finite amount of artwork to sell. That finite amount was equal to the amount we could physically produce and transport (by the third year we used two vehicles, each loaded to the brim with artwork). To maximize our income, and to make our efforts worthwhile, we had to sell this artwork for as much as we could, and this for each and every piece. To sell it for less than that was to lose money. The real challenge was finding the correct price.

We not only raised all our prices considerably over time, we also began introducing much higher priced pieces, aware that some of our customers were looking for larger and more exclusive pieces. Subsequently, we were so successful in this endeavor that we had to raise our prices again and again, and this on prices that when first introduced seemed already high to us. Just as an example, by the end of the show in 2002, I was selling one to two $2000 pieces per day, for a total of seven to fourteen in a week. And that was for just one frame size, a size that was far from being our best-selling size.

My success in doing what I love was so incredible that I had no time to do what I love. By 1999 my time was nearly completely devoted to the El Tovar show. I became aware of that while preparing my income taxes for that year. When looking at my total annual expenses, I realized that I had spent a whopping $300 on film and developing for the entire year. When shooting 4x5 film this translates to using one 50-sheet box of film in a year, the cost being about $6 per sheet with development.

Shooting 50 sheets of 4x5 film in a year when one is a professional is nothing. It does not even cover one shoot. In fact, I could not even remember what I shot with that one box. It probably did not even matter. The fact is that I had stopped being a photographer. My bank account was looking better than ever, but I had no time available to do what I really wanted to do. Even raising my prices over and over again did not solve the problem.

I was not aware of it yet, but what was wrong was my endeavor itself. As long as I sold my work at the El Tovar Hotel, I would be tempted to sell as many pieces as I could possibly sell, no matter what. The solution was to quit the show, something that I could not

envision doing in the least, something I could not quite get myself to believe I would do. I remember wishing that, somehow and for reasons unknown, the show would stop just so the whole situation would stop. I did not know it then, but my wishes were about to come true. I am sure all have heard this before, but I need to mention it again here because it is true: be careful what you ask for, because you may get just it.

Transitions: How the End of One Opportunity Can Be the Beginning of Another

Business Art is the step that comes after Art.
ANDY WARHOL

The Navajos believe that if one says what they want out loud, then doing so will make it happen. It must be true because I have personally witnessed it in my own life several times. It certainly was the case with the El Tovar show. Not right away mind you, it did take a couple of years. However, the show that had been in existence for over 15 years eventually came to an end in 2002. By then I was prepared for it, and the transition to what we might call the "after El Tovar show" was smooth and painless.

What I did was prepare myself for the possibility of the show ending. Besides my wishing that the show would end, there were serious rumors that it may end because of new National Park policies requiring that concessionaires, such as Fred Harvey, could not hire subcontractors, such as us.

This policy was finally implemented at the end of 2002 when the 15-year contract that regulated Fred Harvey's operations in the

**Spiderock in
Snowstorm** ▶
Canyon de Chelly
National Monument

Grand Canyon came up for renewal. The new contract stipulated that Fred Harvey could not hire subcontractors. They could only hire employees. For us to stay on the El Tovar Porch, Fred Harvey had to make us employees. There were some weak attempts on the part of Fred Harvey to do so, but the realities of having to pay us a salary, covering our health insurance, and meeting other obligations made them decide against it. Furthermore, our sales would have had to be handled through Fred Harvey's cash registers, meaning that 25% of our income would first go to them before they gave us our share.

By then, the percentage we paid to Fred Harvey had gone up to 25%, and the writing was on the wall that it would continue its upward journey. In short, and when everything was considered, this meant the end of being artists in business at the El Tovar, and the beginning of being Fred Harvey's employees. Well-paid employees, but employees nevertheless. No thanks. I liked it just fine the way it was before.

At any rate, attempts at making the El Tovar artists employees failed miserably, and by the end of 2002 the show was officially cancelled. We were only told the news in Spring 2003, but I did not wait until then to make my move. As usual, it is best to plan ahead. And, as we will soon see, as usual, how we react matters a great deal more than what happens to us.

The Second Best Place to Start a Business is Phoenix, Arizona

My garden is my most beautiful masterpiece.
 CLAUDE MONET

The way in which one reacts is important. Not reacting is even better. Reactions are like knee jerks. They are often uncontrolled, frequently overdone, and almost always out of place and regrettable after the fact. I knew the end of the show was coming, I just didn't know when it was coming. Therefore, the sensitive thing to do was to prepare for the ineluctable, and expect it to happen sooner rather than later. What I wanted to do was what the Boy Scouts recommend: be prepared. Being prepared is far better than reacting, especially in a business situation.

Being prepared in business often takes the form of a healthy stash of cash. There is nothing more effective in this situation than asset liquidity. It allows for quick movement, without having to ask a bank for permission to spend their money. Loans are nice, but not having to ask for money is even nicer. It shortens the time between making a decision and acting upon it to a minimum.

So, I set aside enough money to make the move from Chinle to "some other place more propitious to business." While Chinle was the best place to *start* a business, in my opinion, but as I explained earlier, it wasn't the best place to *grow and expand* a business. In fact, in that regard it probably was the worst place to do so. Supplies were unavailable locally, shipping took days or weeks, the closest city was 100 miles away, delivery was hectic, and most of all I wasn't even supposed to have a business at all, let alone do well with it.

It took me a while to find the ideal place to relocate. I seriously considered just about every town in Arizona. At least I had the state down (Arizona is my favorite state), but being roughly the size of France (understandably with a minuscule wine production and with far fewer roads and villages), it didn't make

**Canyons of the
San Juan 2 ▶**
San Juan River, Utah

my job much easier. My considerations were numerous. Firstly, our location had to fit my budget. I had set enough money aside, but everyone has limits. Furthermore, taste tends to grow just about as fast (often faster) than income. As they say, expenses will always rise to meet income. In fact, they will usually rise to *exceed* income if not carefully watched.

Secondly, there was the issue of the advantage to be close to my suppliers for frames, matboard, packing supplies, and a thousand other things that had to be shipped to me in Chinle at a high cost in shipping expenses and in time. I did not have the leisure to get up in the morning, call a supplier, and get what I needed brought to me that very same day. No sir. I had to plan weeks or months in advance. When something ran out unexpectedly, a red light started flashing on top of the Kindergarten trailer, alerting (to no avail) anyone who wanted to pay attention that something was amiss inside. Well, not really, but you get the point. We were on the brink of disaster if, god forbid, we got a little bit too confident about our stock or if something – anything – went wrong. There wasn't much of a cushion in that respect. In fact, often there was no cushion at all.

Thirdly, there was the issue of stereotypes. Some cities in Arizona are both attractive and expected to be chosen by artists looking to relocate. One such city is Sedona, land of red rocks, real estate, and psychics. Sedona is, in the mind of many people, where I should be. Yet, Sedona is where I am not at the current time. Certainly, I am also not in a number of other so called "artist colonies" in Arizona, such as Jerome or Tubac, to name two of the most famous locations besides Sedona. For this reason it is worth looking at why I am

not in these locations that are supposed to be most propitious to artists.

To live in such a colony is to fall prey, in my estimation, to a stereotype, and stereotypes are dangerous. They are dangerous because, if you subscribe to them, you wholeheartedly and without much thinking, embrace a situation that was created by people other than yourself and for motives that are unclear. Personally I prefer to create my own reality. At least, if I subscribe to it, I subscribe to something that I created. My reality, when it came to relocating my business, was to guarantee the success of my business model while securing my real estate investments. Put that way, it sounds nothing like an artistic endeavor. That is the whole point. Moving from Chinle was not an artistic endeavor. It was a business endeavor. Once again, one must not confuse the two.

Teaching Again

Blessed are they who see beautiful things in humble places where other people see nothing.

CAMILLE PISSARRO

The end of the Grand Canyon show, and the move away from Chinle, marked the beginning of new opportunities. If I had my way at all, and I had my way quite a bit because I was in control of the situation, I was not going to recreate the situation that was ours at the Grand Canyon. In other words, we were going to make a change from selling quantity to selling quality. Not that we strayed very far from quality during our years at the Grand Canyon. However, we were getting awfully close to doing so. Furthermore, I wanted to go further than we had ever gone in regard to quality, and

I wanted to offer a product of the highest quality level.

This move also provided us with the opportunity to start teaching again. Natalie and I both love teaching. We were both trained as professional teachers and hold teaching degrees from NAU and MTU. When we moved to Chinle it enabled Natalie to teach art to 7th and 8th grade Navajo students. However, for me, the Grand Canyon show kept me so busy that there was no time to think about teaching photography, or to think about anything else for that matter.

Not that I didn't have requests. In fact, I had many requests to teach photography and to offer workshops to the photographers who visited my show at the Grand Canyon. The problem was that I had no time to do so because the show consumed all my time and energy. I considered it a success simply to be able to fill the orders and come back for the next show with a full inventory. To offer workshops on top of that was simply not an option.

The end of the show offered the perfect opportunity to incorporate workshops and other teaching opportunities into my schedule. In fact, I did not wait to find out if the show was or was not to take place in 2003. While we were supposed to get the news about the show in March 2003, I started designing and implementing a comprehensive teaching program in January 2003. By the time we got the news in March and learned that the show was effectively cancelled, I had already started taking registrations for my new Beaux Arts Photography Workshops program.

Teaching is important to me because I want to share my knowledge with others. I know how hard it was for me to acquire the knowledge that is now mine. I know how many hurdles I encountered along the way, and I know how much time I spent – literally years – trying to find information that was not available in books, or anywhere for that matter. I also know that photographers – professional photographers that is – can be hard to get a hold of and difficult to contact or ask questions of. I was very intimidated at the thought of asking the people whom I admired, the photographers in my personal "pantheon", so to speak, how they did what they did and whether they would mind explaining it to me. So much so, that I never did ask any of them, preferring to find the answers to my questions on my own; a process that takes much longer, of course.

For all these reasons and more, I am acutely aware of the difficulties that photographers face. My goal is to provide a solution to this problem – an effective solution – by making information available and easily accessible that I believe to be crucial for success in fine art landscape photography. The fact that I am now able to do so through my workshop program and through my tutorials is something that I am both very proud of and very pleased about. For all the blessings I have received from landscape photography, I am happy to make this one contribution so that others can enjoy doing what I do, and they too can look forward to creating photographs of quality equal to (or better than) my work.

Quality, Not Quantity

The subject itself is of no account; what matters is the way it is presented.

RAOUL DUFY

Two separate opportunities were offered to us at nearly the same time: the first was moving from Chinle and the second was the end of the

◄ **Before our Time**
Coso Range,
California

El Tovar Show. Together, these two situations were exactly what we needed to make serious changes to our business; both in terms of focus and in terms of the direction we wanted to take. Both opportunities worked hand in hand in leading us toward a second start, so to speak, without losing the momentum we had gained during our previous years in business.

One of the most significant changes we made was to move from creating and selling artwork in quantity, to creating and selling quality artwork. I already touched upon this earlier, but I want to cover it now in greater depth.

When I started selling my work at the Grand Canyon, my goal was to sell at least one of my photographs to every Grand Canyon visitor and to, eventually, everyone in the world. While I did not succeed in selling one of my photographs to everyone in the world (who would!), I was so successful in selling a photograph to nearly every Grand Canyon visitor that, as I previously explained, it nearly killed me. It also nearly caused me to lower my standards to a point that I may never have been able to create quality work again.

Fortunately, we did not get there. However, we got close. We managed to keep our work at a high level of quality, but the toll placed on us by the demand for quantity work of high quality was nearly too much for us. That is why I was so elated when I learned that the Grand Canyon show was not going to be renewed. On the one hand, I was fully aware that a wonderful business opportunity had ended. On the other hand, I knew that, had the show not been cancelled by forces beyond my control, I would not have been able to stop doing this show myself. It was just too good an opportunity, and I had been taken in with the desire, the goal, to increase my income from the show

each and every year. It had become a maelstrom so to speak; one that, eventually, was bound to kill me.

And the thing that was going to kill me was quantity. You see, to simplify things to an extreme, there are two kinds of businesses: businesses that create a product and sell it wholesale, and businesses that buy a product and sell it retail. Certainly, some companies both create a product and retail it, but they are relatively few. However, when it comes to artists in business, nearly every artist both creates the product and then sells it themselves in retail locations, at shows or in galleries for the most part. There are exceptions to this rule, however the rule holds true with the vast majority of artists.

In this situation, which mirrored our situation, the variable that matters most is quantity, i.e., how many pieces we had to create in a year, using the tax year as a time frame. There is, inherently, nothing impossible in creating a product and selling it retail all by oneself. What is impossible is creating millions of products with a team of two (Natalie and I) and selling them retail all by ourselves. The demands on our time, in terms of producing and selling the product, then shipping the orders, getting the necessary supplies, and finally resupplying our stock in anticipation of our next show, were just too great. In fact, the demands were so great as to nearly overwhelm us.

I am personally convinced that we managed to keep our operation together only with an extremely focused and concentrated effort, and at the cost of the total elimination of our free time. How long we could have managed to continue in this manner is unknown to us, since we did not reach the breaking point. However, that breaking point was somewhere down the road, and in my estimation, the

▲ **Mists of the San Juan**
San Juan River, Utah

distance that remained to be covered until we reached it was not very far. In other words, we were almost there. We had nearly reached the breaking point when the show ended, and we were saved by the bell before we could say "no mas." In short, we were blessed that the show came to an abrupt end. I honestly don't think that I would have been able to stop doing the show myself, and it is only in retrospect that I now see how close we came to losing it all.

All this to say that my focus on quantity nearly killed me and nearly ruined our business. As things played out, we walked away unscathed, scared by the proximity of the storm, but with our holdings untouched by it. However, a change was needed, and when the opportunity presented itself to us we, unabashedly and without looking back, decided to focus our efforts on producing the finest quality photographs we could possibly create, understandably in small quantity and at a higher cost. At that time, we turned our backs on quantity once and for all.

New Shows

Natalie and I began doing shows in Phoenix very soon after moving there because the show season there takes place during the fall, winter, and spring, which are the cooler months. Since we moved in January 2003, we were there right on time for the spring show season, which worked great for us. In Phoenix there are no shows in the summer because the temperature soars to over 100 degrees Fahrenheit.

In other words, I didn't need to wait for the Fred Harvey Company to make up their mind. If Fred Harvey wanted me to give them a percentage of my sales, they should have been

on the ball. Now, they were going to have to forfeit that income. I was moving on.

Furthermore, by the time we moved we had a larger number of collectors who regularly purchased from us. However, the Grand Canyon show prevented us from staying in touch with these customers. We were just too busy for that. As soon as we moved, we changed this for the better, significantly increasing our sales made outside of a show situation. We also started developing and updating our website, another area that had suffered from our lack of time to do much more than the El Tovar Show.

Longer and More Thoughtful Chapters

In 1998, at the suggestion of Michael Reichmann, I started writing a series of articles that were published on the Luminous-Landscape website (www.luminous-landscape.com) in the context of a monthly series: "Briot's View." These articles were very well received. They focused on a variety of topics ranging from creating photographs to selling them, as well as on the equipment I used.

Because of the limited time available to me, these articles were usually rather short, from two to four pages, on average. When the El Tovar show ended, I found myself with more time available to write, and as a result I started writing longer articles. The chapter you are reading now, for example, is 36 pages long. Quite a stretch from the articles I wrote while doing the El Tovar Show.

I was also able to start writing about more complex subjects and on issues that required lengthy research and reflection. As a result, I enlarged the scope of my Aesthetics & Photography Series from the originally planned seven

parts to 13 parts, covering subjects that address the technical, as well as the philosophical and artistic aspects of photography.

Only when I was no longer doing the show did I find enough time to write.

New Projects

I went much further than simply writing on longer and more complex issues. I started a second series of articles entitled "Reflections on Photography and Art". This series gave me complete freedom about what subject I could write on. I also started a subscription-based approach to my articles, through which subscribers receive my latest chapters in PDF format the minute they are completed, while online versions may take weeks or months until they are available.

I also made my entire collection of articles available on CD. Currently, I have released two separate article CD's: "Briot's View CD-"1 and "Briot's View CD-2". I plan to continue adding to this CD collection by publishing one new "Briot's View CD" per year.

Finally, I created the "Beaux Arts Tutorial CD Series" that consists of several tutorial CD's, each focusing on a specific aspect of photography. I decided to focus on aspects not covered in other tutorials; aspects that take advantage of my specific expertise, which is "Photography as an Art Form", and of my specific training as artist, teacher and photographer. Currently, this collection includes three CD's: "Alain's Composition CD", "Alain's Marketing CD", and "Alain's Portfolio CD".

The cover of the Navajoland CD and DVD ▶
I designed the covers myself using my own photographs and layout concepts

Becoming a Music Producer

In 2004 I released the "Navajoland Portfolio", featuring 25 photographs created during the seven years we lived in Chinle. In many ways this portfolio is my legacy to the years we spent in Chinle. Many of these photographs could not have been created had we not lived there. We simply would not have had the access to or intimate knowledge of the locations featured in the portfolio. The "Navajoland Portfolio" was also the physical implementation of my decision to focus on quality rather than quantity. Every aspect of the portfolio was addressed with only one goal in mind: to create the finest quality product possible. No attempt was made to cut corners in any way, or to hasten the creation or production process. The end result is a collector's item that stands out as one of my proudest achievements.

In January 2006 I decided to create a DVD movie of the "Navajoland Portfolio" images. To this end I contacted Travis Terry, Native American flute player, whom I had met in Chinle and with whom Natalie and I have been friends for many years. Travis agreed to create a set of ten musical compositions for the DVD, each one based on and titled after my photographs.

In addition to the DVD, Travis and I produced a music CD, "Navajoland", so that collectors could listen to the music anywhere. In creating these two products, and in being in charge of the recording, copyright, and production of the "Navajoland" CD and DVD, I branched out of photography as my sole source of income and became a commercial music producer. I love being a music producer so much that I plan to produce several additional music CD's and DVD's in the coming years.

Setting up the Ideal Studio

An artist is not paid for his labor but for his vision.
ANDY WARHOL

Moving to a new location was also the opportunity to set up the "ideal" studio. Granted, ideals are challenging to reach, and perfection is not of this world, but the idea was to incorporate all we had learned during our years creating, optimizing, printing, matting, framing, packaging, and shipping our artwork into a convenient and efficient working environment. To this end I actually chose a floor plan for our house that accommodated our business needs as well as our living needs.

For one, I wanted the working and living spaces to be as separate as possible, so that we could get away from work when we wanted to, something that was not possible in Chinle. There, work was all around us all the time. We had supplies piled up in every available space, and everyday we had to "push" artwork aside in order to make room to have dinner, socialize, watch a movie, and so on. Artwork was dominating our lives and we wanted to remedy this situation.

We also wanted efficiency in our workflow. In a nutshell, after the photographs have been captured, I optimize and print them; mount, mat, and frame them; then package and ship them. There are basically three main steps, and I decided that each step would best be carried out in a room specifically designed for that use. Therefore, we searched for a house with at least three rooms we could use solely for business. We also looked for, and found, a floor plan that would accommodate these three main steps in succession, with each room being located in a row, so to speak, so that we could move quickly from one step to the next. Efficiency leads to saving time, which in turns leads to a more efficient business model.

As Dale Carnegie put it, and I paraphrase, "Hard work and long hours are not enough to generate success. You have to have an organized plan." We did. Our plan was to create an efficient, practical, and pleasant working and living environment. We were fortunate to be able to start from a blank slate and to pick the location where we wanted to live based on our personal needs rather than on the distance and driving commute to an outside workplace. In other words, wherever we were going to live, we would already be at work. No commute was necessary; hence we could live anywhere because we did not need to take into consideration how far we would be from

our workplace. The two things that concerned us was the layout of the house and the selling price. The first concern was taken care of by a careful analysis of our needs based on our years of experience selling tens of thousands of photographs. The second concern was taken care of by careful savings over many successful years in business. Things were moving right along.

Two Businesses in One

Natalie decided not to look for a teaching job in Phoenix, preferring to work with me full time. This business partnership (Natalie is one of the biggest assets to our business) meant that each of us could run a different part of the business, effectively dividing the workload in two. Before moving to Phoenix I had to take care of every aspect of the business while Natalie was at school teaching; I could now focus on those areas that interested me the most while Natalie did the same for the areas that interested her the most. We each have unique skills, and we each have areas in which we excel. With this arrangement, Natalie and I are able to utilize the skills at which we each excel. The end result is an increase in our level of success across all our business endeavors.

This arrangement takes the form of creating, in essence, two separate businesses. In short, Natalie began taking care of selling at art shows while I began taking care of sales on the Internet. With both of us working on different aspects of the business, we are able to optimize the use of our time while considerably increasing our business income.

From a creative perspective, I focus on creating new images, optimizing them and printing them. Natalie on the other hand, focuses on matting, framing, packaging, and shipping the photographs as well as on invoicing. You may not think that invoicing takes much time, but the fact is that it does take time. Invoicing can take an amazingly large amount of time. Here too, as with our experience at the Grand Canyon, the key element is volume. Our volume now is nowhere near what it used to be while selling at the Grand Canyon, because we now focus on quality rather than quantity. Yet, our volume is still considerable and adequate invoicing is very important.

Teaching is something Natalie and I do together, because we both enjoy teaching and because by teaching together we are able to offer a dual learning path to our students. Natalie and I each have a unique teaching approach, a unique focus, and unique taste when it comes to art. By each of us expressing these things, our students benefit from the two different approaches Natalie and I can offer.

Marketing is something I originally did myself. However, Natalie recently started working on marketing as well, again effectively increasing both our business and our reach.

Learning Never Ends

Have no fear of perfection; you'll never reach it.
 SALVADOR DALI

I am always surprised when I meet someone who believes that I know everything there is to be known in photography. Certainly, I would be the first to call myself an expert. If reaching the highest levels of success selling one's own art does not make one an expert on the subject, then nothing ever will. But I would also be the first to say that I am a student of photography, and that I am far from

**Canyons of the
San Juan 3 ▶**
San Juan River, Utah

having reached the end of the road in that respect. In fact, I truly believe that this road is a journey, and that where this road may lead is not what is most important. What matters most is what is learned along the road, not what one may find at the end. Art, like life, is a process; a continuous endeavor. It may, for all we know, not necessarily stop at the end of the road. For that matter there may not be one defined road. Instead, there may be a different road for each one of us; a road on which only artists and artists in business may tread.

So take it for what it is and enjoy the journey, for your road is bound to be different from mine. However, I am ready to bet there will be many similarities when it comes to the main stops, the main learning opportunities, along this road. The path may take others to places unknown to me, but what is learned in those places will most likely be very similar to what I learned. This is, in fact, the basis for this entire book, and for my writings in general. What each of us does and where each of us goes may differ, but eventually, the main lessons that life teaches us end up being quite similar. This is good news because we can, to some extent, learn from each other and avoid some of the pitfalls that would be ours should we not be able to benefit from what others have learned before us.

Conclusion

This is really a temporary conclusion because there is one more chapter in this book, "How You Can Do it Too". In the thirteenth and last chapter, we will look at how you can become an artist in business if you choose to.

So this is not really a conclusion. It is more like a page turning opportunity. The real conclusions will be reached in chapter 13. For now, let us simply reflect on what was covered so far, on the path that took me from a visitor-photographer in a land entirely new to me, to a successful photographer and business owner in this same land. This path can be yours too, or variations thereof, as the popular format of this statement goes. As I said, "How You Can Do it Too", will be both the subject and the title of the next chapter. This time, the focus of my chapter will be you instead of me.

How You Can do it Too

If you don't do what you love you are not going to be good at it.
And if you are not good at it you are not going to make any money doing it.

DONALD TRUMP

Introduction to How you Can do It

In chapters 11 and 12 we looked at the path I followed, intentionally and unintentionally, that led me to where I am today. However, this chapter is not just about me. It is also about you, and about how *you can do it too* if you are so inclined. – "How You Can Do it Too" is the subject of this final chapter.

In approaching this subject, my focus will be in drawing conclusions from my personal experience and outlining what I consider to be the most important aspects. I have learned an immense amount since I started doing what I do full-time. However, some lessons stand out as more important than others, and those are the ones I will bring to your attention.

As a preamble, I want to add that the list of recommendations about what to do and what not to do is much longer than the eleven items I selected for this chapter. So much so, that I originally wrote a list which included (and still includes) over 40 items. However, I decided to shorten the list to those points which I believe are the "Top Ten", so to speak. If you are interested in learning what the other 39 points are, they are available on my Marketing CD, in my Marketing workshop, and through my one-on-one consulting program.

Do What You Love

You might was well do what you love: Doing what you don't love will not be any easier.

At the beginning of my journey, which I described in the previous chapters, was the realization that regardless of what I chose to do in the world, as long as I wanted to be competitive in that endeavor, success was bound to come at the cost of a lot of work. I therefore determined, quite accurately, since I have not been proven wrong yet, that I might as well do exactly what I wanted – what I love to do – for it was not going to be any more work.

Plus, and this is where it gets really interesting, by doing what I love I would have the added benefit of doing exactly what I wanted to do right now, as opposed to hoping to do so at a later, and usually undefined date. I would also bypass counting the days, months, and years on the way to this uncertain time, when I would finally be free to do what I really wanted to do.

Where it gets even more interesting, is that the most energy you will ever have will be at times during which you do exactly what you want to do, without other motives in your mind, without regrets, and without thoughts of the things you would rather be doing.

If you look at the three elements I just mentioned – doing what you love, doing it right now, and doing it without a desire to be doing anything else – you will realize that these three elements make up the foundation for success. Granted, in isolation these three elements are not enough to guarantee success. More must be present, and we will get to some of those things (not all, but some) in a minute. But, the three elements I just listed are foundational when it comes to motivation. Doing what you love, right now, without thoughts of something else you would rather be doing, guarantees single-mindedness of purpose, excitement, and passion. With this, you will be able to give your best, give everything that you have, to the activity you chose to do. It goes way beyond photography, although for the time being, and for the purpose of this chapter, we will not stray beyond the field of photography. Note that we could stray, and

that maybe we will, but not yet, at least not right now.

From the discussion of how Natalie and I share our business responsibilities, each focusing on different areas, you can see that we implement this rule on a daily basis. You can also see that this implementation not only addresses our original decision to do what we like, but it also addresses our more "minute" decisions to focus on certain aspects of our business rather than on others.

In other words, after deciding to do what we love, which is practice and teach photography and art, we continue to make decisions about what we like most within this field. For example, Natalie likes to do matting and framing. She also likes to do art shows. Personally, I prefer to create images, optimize them, and print them, and to maintain our website. This is the way things stand right now, and I have no doubt that they will evolve from the present situation, as we continue to follow this rule when it comes to selecting what each of us wants to do.

Take Control of Your Own Destiny

Shallow men believe in luck, believe in circumstances – it was somebody's name, or he happened to be there at the time, or it was so then, and another day would have been otherwise. Strong men believe in cause and effect.

RALPH WALDO EMERSON

One of the first decisions I made was to take control of my own destiny. Rather than hope for the best and to get lucky, I decided to take actions toward achieving what I wanted to achieve. If luck came my way, great. If it didn't, no biggie, I was moving along just fine.

This is a very important aspect of doing what you love. By deciding to do exactly what you want to do, you also make the decision of being on your own, of being a freelancer if you will, although I don't like this term all that much. At that time you are no longer dependent on superiors to judge your progress and award you salary increases and upward advancement as gratifications for your hard work. Rather, you are dependent upon yourself and yourself only. To wait for someone else to take control is bound to be disappointing. No one wants to, no one will, and worst of all, no one knows you are waiting for that to happen. After all, if you wanted that to happen – i.e., someone to take control of your destiny – you would not have set sail on your own! Rather, you would be working as an employee somewhere, waiting for someone else to tell you what to do.

Fame or Fortune? Make a Choice!

At the same time I decided to take control of my destiny, I realized that two paths were open in front of me. One path to fame, the other to income and possibly fortune. At the time, I was a financially disenfranchised PhD student. It was clear to me that I couldn't afford to become famous. I needed to make money right now!

This statement does, I believe, need some explanation. It may be clear to some, but it may not make much sense to others, so let me explain.

A friend of mine is a world famous author on rock art research. He authored several best selling books in the field, books that are sold in just about every bookstore and gift store in the Southwest and in many other places. A

▲ **Navajoland Cloudscape**

I continue to create images of Navajoland that, in my estimatation, do not duplicate the images in my best-selling Navajoland Portfolio. I create these images for no other reason than to be creative and to express how I feel about this place that I love to visit over and over again. I could, quite easily, sell the photographs in the Navajoland Portfolio and stop creating new images. However, doing so would make me a businessman, rather than an Artist in Business.

couple of years ago he did not file an income tax return because he did not make enough money that year to require doing so. Famous? Certainly. You most likely know his name if you have an interest in rock art or archaeology. Rich? Far from it.

Fame and fortune are two different things. The reason why we frequently consider them to be inseparable is because we look at examples from the media; examples featuring essentially people in show business, actors, entertainment personalities, or athletes in a variety of sports. Yet, if we look at the statistics regarding how large of a percentage these represent in comparison to the entire US population, we find that it is less than one percent. Furthermore, if we compare what percentage of "famous" people the rich-and-famous represent, we again find out that it is quite low. What does that mean? Simply this: being rich and famous is the exception rather than the norm. It is far easier to be rich, or to be famous, than to be both. The conclusion, or at least my conclusion: pick one. As I said, my decision was simple. Believing I couldn't have both, I chose the one most pressing, which was the necessity to derive an income from my activities, from my passion, rather than deriving fame. Fame would come. If it did. I could afford to wait. Money, on the other hand, was needed right now.

Confront Your Fears

Courage is resistance to fear, mastery of fear – not absence of fear.

MARK TWAIN

Deciding to do what you love is scary. I was going to write, "can be scary", but the fact is that it is scary, not that it can be. So I will leave this statement as I originally wrote it.

The only solution, provided you decide to go through with it, is to face your fears. To do so, a healthy amount of courage is useful, if not altogether necessary. But more than courage is needed, and the following tips may prove helpful as you get ready to embark on this journey.

The first thing is to lower your expectations. I believe that, more than anything else, this is what enabled me to succeed. I did not know it then, but I know it now. Let me explain.

What I think helped me the most, in retrospect, was my financially destitute situation. When it came to setting up expectations, or a "business plan" if you will, I simply divided what I made ($500 a month) by 30 (the number of days in a month) and used this figure (less than $20) as my daily income goal. As I explained earlier, if I made twice that amount, or more in a day, that meant I did not have to work for several days, at least not in the sense of selling my work.

Had my income had been in the six-figure range, my job would have been that much tougher. If I had been a millionaire, it may have been nearly impossible. If I had been a billionaire, I wouldn't have needed to make an income, and the whole point would be moot. But I wasn't, so the problem did remain.

Setting up lofty expectations is often cause for disappointment, if not for failure. For this reason I recommend that you lower your expectations, at least initially. This doesn't have to be for long (I know we all have high expectations and want to achieve as much as we can, or at least many of us do). The goal for doing so is to build confidence, get some notches on whatever "weapon" you decide to use, and get some mileage under your belt. In other words,

get some experience, get used to making a certain amount on a regular basis; then regroup, set new goals (again, with reasonable expectations), and get going again.

Confronting your fears is not easy. For artists, it is particularly difficult because these fears often have to do with how our work is received by our audience. Common fears faced by a multitude of artists include fear of rejection, fear of people not liking our work, or fear that we have nothing to say.

How to overcome these fears is beyond the scope of this chapter. However, what is important to understand is that, although we are dealing with how to be artists in business, these fears are present in the artistic, as well as the business sides of our lives. Rejection by a gallery owner, or by a store-owner to whom we are trying to sell our work, is just as painful and demoralizing as being rejected by an audience that does not like our work.

This leads me to the second tip I can give you, which is to not give up after your first attempt. Why? Because, and I am trying to remain positive here, I have to tell you that this first attempt is likely to fail: not necessarily, but likely. I wish it was not so, but it turned out that way for me. Why? Because I didn't know what I was doing. It would have helped had I sought guidance from someone who was already where I wanted to be, but I didn't (more on this later). The bottom line? Regroup and try again. If it still doesn't work, try a third time, then a fourth time if necessary. Then try some more. Those who succeed are not necessarily those that are the most gifted, or the best at any given endeavor. Those who succeed are often the most tenacious, the ones who don't give up easily, or at all. As Winston Churchill said, and although there is debate about how many times he repeated it, "Never,

never, never give up." If you remember that, you are already much further along than you may think. Personally, I keep this in mind. It frequently comes in handy, usually at the least expected time.

"Courage", so said Mark Twain, "is not the absence of fear. Courage is superb knowledge of fear" (I paraphrase). Courage is intimate knowledge of fear. Confronting your fears does not mean removing them (personally, I couldn't even if I tried). No. confronting your fears is becoming comfortable with the knowledge that, first, they are there, and second, you know exactly what they consist of. From there you can go to work. Armed with these two elements, you are ready to face the enemy. Whatever fears we each have to confront, learn about, and put to rest, varies from individual to individual. But fears there are, and fears there will be. What makes the biggest difference is how much we know about our own fears.

Seek Help from People Who are Where You Want to Be

No one can do inspired work without genuine interest in his subject and understanding of its characteristics.

ANDREAS FEININGER

I mention "the school of hard knocks" – my metaphor for unpleasant experiences that, should we get over them, make us better at what we do – several times in the course of this chapter. I also mention that it is best to enroll in a minimum number of classes at that school. No matter how few you willfully take, their number is bound to grow. At any rate, it



is an unpleasant experience, and no one said that learning had to be unpleasant.

My recommendation, in order to minimize the number of classes you are taking at the school of hard knocks, is to seek help from people who are where you want to be. As they say "don't try to re-invent the wheel". Somebody has already done so. Find out how they did it, then follow their instructions and do it yourself. In other words, whatever you do, don't start from scratch. Instead, learn how others did it before you and then improve on what they did.

How else would you do it? Well, believe it or not, many, when it comes to selling art, start from zero and want to invent it all over again. After all, so they believe, how hard can it be? People will buy my work because they love it. It's that simple. Therefore, all I have to do is put my work out there for all to see, with the finest display, the finest image, and the finest framing quality I am capable of, and off we go. Simple plans are the best. There is no way I can fail.

But the truth is that fail you will, most likely, because there is much more to it than that. Exactly what is involved is beyond the subject of this chapter as it addresses "how to market fine art photographs," a subject I teach and write about in another series. Those who succeed are not those who got started last week, at least not normally. Those who succeed belong to one of two categories: they have either been at it for years, if not decades, or they have been getting help from someone who is where they want to be. Sometimes, they belong to both categories: they have been at it for years, if not decades, then, because they were unsuccessful, they sought the help of someone who is where they wanted to be and things got better for them.

I know what you are going to ask: Did I seek the help of people who were where I wanted to be? You bet. I didn't find all the answers myself, though at a certain point I did find answers that these other people, those who I sought help from, did not find. I did essentially, because the questions I was asking were different from the questions they were asking. But that is a different matter altogether, again material for another book somewhere down the road.

So yes, I did get help from people who were where I wanted to be. As I mentioned earlier in the book, I attended a class entitled "Taking care of your own destiny: the Artist in Business." Later, I hired a marketing consultant to help me with severely pressing issues I was encountering in my business. And finally, I studied how others had done what I wanted to do. No, I did not reinvent the wheel, though I frequently had to adapt materials, approaches, techniques, and more that had originally been developed for a field other than fine art photography.

What I have done since is design a course on marketing fine art photography, in particular fine art prints, but other materials as well, because of my awareness of the lack of such a course. The goal was twofold: Firstly, to share the unique materials I developed, materials which had been partly adapted from other fields, partly discovered by myself, and partly learned from others: Secondly, to prevent others from following the rocky road I traveled on my way to where I am now.

◄ **Spiderock, Spring 2006**

Opportunities Often Come Under the Guise of Hard Work

Opportunities are usually disguised as hard work, so most people don't recognize them.

ANN LANDERS

Indeed. You most likely know that already but I thought it wouldn't hurt to mention it. Plus, it's an important item on my list. And, finally, I am regularly amazed at how frequently some dismiss it, or overlook it altogether. Fact is, being successful is going to be a lot of work, regardless of the occupation we choose to do, as I explained before. That's why, in my view, we may as well do what we love.

However, just because we now do what we love means it is going to be a piece of cake. No sir, it's going to be a lot of work, just like it was before, and just like it would be if we did anything else with the goal of being the best at what we do. So it makes sense that any opportunities that come our way will require a lot of work. In fact, opportunities that come our way usually require even more work because they come on top of everything we are already doing. In other words, when opportunities come knocking at our door, they are added to our current workloads. Opportunities are extra work: that is the truth. If you are not willing to work harder than you are already working, then you will be unable to take advantage of these opportunities. Opportunities may come knocking on your door, but you will only be able to answer them if you are willing to work harder than you already are. Otherwise, they will pass right by you on their way to someone else. And that someone else is called your competition. Food for thought.

Press On Regardless

Business Art is the step that comes after Art

ANDY WARHOL

Doing what you love can be challenging at times, and when things get hard it is easy to feel down or depressed. Natalie and I have had our share of such situations. What has saved us, what has got us to where we are now, and what will most likely take us to where we are going next, is to not give up and, most importantly, to *press on regardless*.

Press on regardless is an interesting concept, based on the notion that it is when things look their worst that you should move forward with all you have. In other words, don't give credit to the difficulties or to the challenges that you are faced with right now, no matter how severe they might appear to be. Instead, continue to do what you would normally do, in fact work on whatever you need to work on even harder, because doing so is the best remedy. Adversity finds energy in your willingness to acknowledge it, listen to it, and give it importance. Disregard adversity and it shrivels down to nothing in an amazingly short time.

Granted, adversity is not a person. It is not even a thing. It is an event. But events, like anything else in this world, are set into motion by people. In other words, behind the events you are facing are individuals who either caused these events or are bound to benefit from these events. And it is those people who, eventually, benefit from the depression, despair, or overall downtime that is the result of you giving too much importance, or any importance at all for that matter, to adversity.

Therefore, I recommend that you treat adversity as you would a dog barking at your heels. Let them bark and move onward,

unencumbered. The dog barks, the experienced businessperson moves forth. And moving forth – regardless – is what business is all about. There is, after all, but one way in business and that is forward. Any backward motion is a step toward regression and, eventually, withdrawal and business losses.

It's About You

Absolutely. Who else could it be about? Since you do what you love, it's about what you love, why you love it, and who you are to love it. Many make the mistake of thinking it is about their audience, or about the gallery owners, or the stores to which they sell their work, or again about the shows at which they display their artwork. Certainly, these all play a very important role, but you do not do what you love because of them. You do what you do because of you. And therefore, all of this is primarily about you, and the factor that plays the most important role of all is yourself.

The proof is in the pudding, and in this instance the pudding is art, namely fine art photography. And in art, what matters most is the artist. In a recent poll I conducted on my website, over 75 percent of the voters said that the number one reason they buy art is because of the artist's vision, inspiration, and personal style. The second reason is because of print quality. Both these reasons are determined by you, the artist. You are responsible for your vision, your inspiration, and your style. And you are equally responsible for the quality of the print you create.

Don't make the mistake of thinking that this attitude is selfish. It is about you, and accepting this is not selfish. Rather, accepting this is the key to success. Your audience has no

clear idea about the artwork they expect you to create. Stores and galleries that sell your work do not know what quality you can produce or what vision you have for your work. Only you have an idea about that. Your work is about sharing this idea; sharing your vision, your inspiration, your style, and the print quality you are capable of producing with your audience.

Quality or Quantity? Make a Choice!

Quality is never an accident. It is always the result of intelligent effort.

JOHN RUSKIN

You need to decide whether you want to sell quantity or quality. Sorry, you can't have both. As I explained in the two preceding chapters, I wish it wasn't so. I wish I could create a countless number of pieces of the highest quality possible. I wish I could "crank out" as many pieces as I would like and that all of them would be world-class. Unfortunately, this is not to be. As quantity increases, quality decreases. This seems to be an unchangeable equation; one that holds true no matter what.

Furthermore, a part of you goes into each piece you create, and that part diminishes the more pieces you create. You get to a point, when you go in the direction of quantity, that part of you which is in each piece becomes so small as to be unnoticeable. In essence, your work is no longer yours. It is a production piece, the result of an assembly-line approach. You may be the creator of the original piece, but the product your customers receive is one with which you had little, if any, contact.

Which one you chose – quality or quantity- - is up to you. You already know which way

I went and you know that I won't go back. I tried quantity, and it nearly killed me. I now know that quality is my salvation. I also know that quality is the only way I can share the message of beauty I want to share with my audience.

Do a Little Bit Every Day

In the US Southwest, and more precisely in the Sonoran Desert where I currently live, there is a plant called the Agave Gigantis. This plant grows for about 50 years without ever producing seeds. When it reaches the apex of its life, it grows a stalk 20 feet high and over a foot in diameter, then drops a million seeds. Having used all its strength and resources in this endeavor, the plant dies shortly afterwards.

The Agave Gigantis relies on the "big bang" theory of reproduction: its "win all or lose all" approach may work and some of the seeds germinate. But, if something goes wrong regarding the weather, the soil, the moisture, the wind direction, or whatever else may be playing a role in this process, all is lost and no seeds germinate. By using this approach the plant does not give itself a second chance. Things either work or they don't.

I call this the big bang theory of reproduction. If the seeds grow into adult plants, the Agave Gigantis has been successful. If the seeds do not germinate, the plant has been unsuccessful. Unfortunately for the plant, there is no second opportunity for success.

Clearly, this chapter is not about reproduction or botany, it is about being an Artist in Business and about how to reach success in business. If we compare this plant to business endeavors, the Agave Gigantis big bang theory

approach is comparable to creating a "master" business plan (which often is over-ambitious, expensive, and unproven), implementing the plan, and waiting for success. If it works, great. If it doesn't, discouragement usually follows and sometimes precedes going out of business altogether.

I see this all the time with students and other photographers. At first, ideas fly, motivation is high, and ideas are implemented rapidly. But, unless success follows in amounts comparable to the photographer's initial efforts, discouragement sets in and things come to a stand still. For example, web sites remain in their initial "start up" configuration for years and no news, photographs, or features are added. Mailing lists are not built up. Web traffic is not increased. At shows the display booth remains the same year after year, usually featuring major mistakes in terms of display, traffic, prices, target audience, or other areas. Marketing is either never implemented or is cut off quickly, usually with the excuse that it takes too much time and money with not enough financial return. In short, the big bang theory was implemented and failed, and as can be expected, nothing was left for a second attempt.

Certainly, you may say that the Agave Gigantis "big bang" approach works since the plant has been around for millennia. But the fact is that this plant is not working alone. The Agave is not after personal success. It is after survival of its species. In this respect, while numerous individual plants may be unsuccessful at producing a single new plant from millions of seeds, most likely, one or several plants will be successful. Even in years of particularly dry weather, when not one plant will produce siblings, other plants, not having reached maturity yet, continue to grow, insur-

◄ **Playa Reflections, Death Valley National Park**

◄ I made an artistic breakthrough during my visit to Death Valley in the spring of 2006, only a few months ago. During this visit I created several images that I had never thought of, or "seen" before. Whether or not this will make a difference in my business remains to be seen. Let's just say that it can't hurt. What matters is that it certainly made a difference in my artistic life. Reaching a balance between art and business is very important.

ing that the next year, or the year after that, seeds will germinate. Since only some Agave Gigantis produce seeds in a given year, in the following years some plants will succeed in creating germinating seeds.

As an Artist in Business, unfortunately, we are more concerned with personal gain than with survival of our species. Certainly, the wellbeing of other photographers arguably should be a concern, and so should the laws that regulate our operations. But really, if we do not do well, it is we who, individually, will go out of business, not the other businesses. For this reason, the big bang theory does not work for businesses. We cannot hope to prepare ourselves for years, get the results of our efforts on the market, and hope for the best. To follow this approach is unrealistic at best and suicidal at worst.

Instead, I recommend we do make our best effort initially, and then – and this is really the most important factor – make sure we continue this effort every working day. What I recommend is a strong start in the right direction, then a continued effort day in and day out, to further complement, refine, redirect, and fine-tune the direction we initially took.

I, myself, make sure that each day I do something to improve my business, and this on any level of my operation, from the creation of new images and products, to the delivery of these products, and of course, including every step in between. Doing something each day means that each thing I do can be relatively minor. I have 365 days in a year to make significant changes, so I am looking at the sum of the parts as being the final improvement. Rather than attempting to make a huge change all at once, I make many small changes year-round. This approach serves me remarkably well in regard to reducing stress.

It also keeps me focused on the day-to-day operation of my business. A little bit a day, every day: Try it – you might like it.

I follow the exact same approach when it comes to running my business on a day-to-day basis. By this I mean printing, matting, framing, and shipping orders, as well as taking care of all other business related aspects: paper work, ordering supplies, upgrading and installing new equipment, learning new techniques, answering email, paying bills, etc. I cannot apply this to taking orders since they come when they come, but I do apply it to marketing, preferring to do a constant, year-round marketing approach rather than a bi-yearly or quarterly marketing approach. A little bit everyday works for me. It allows me to pace myself and get into a rhythm, rather than cruise along slowly then work like crazy for a week, before going back to slow-cruising speed. I don't like sudden changes in rhythm. That's me. Your taste may be different. Remember, being in business is also about character and personality, just like personal style is. My way, as always, is not the only way.

Integrity

Integrity has no need of rules.

ALBERT CAMUS

Integrity is the last item on this list, before moving on to the Skill Enhancement Exercises designed to help you get started doing what you love. As they say, it is last, but not least. The last item in a list is often as important, if not more important, than the first one. In short, and in regards to being in business, it is important to maintain integrity in order not to lose your vision, personality, sense of eth-

▲ **Upper Antelope Canyon**

ics, and your belief in what is right and wrong, to financial considerations.

In regards to sales, I recommend you make sales by being completely open with your customers. If you have to lie, disguise the truth, or tell only part of the story, you are not doing it right, in my opinion. If I were to do so (i.e., lie, disguise the truth, etc.) it would make me feel totally uncomfortable. I do what I do because I want to be who I am, not because I want to disguise who I am. In my opinion, if you explain how you do what you do truthfully to people, most will understand and it will not hurt your sales. And if you tell them the truth and they don't like what you say, they are basically saying they don't like you. In that case, I

don't know about you, but in my experience, no one ever buys artwork from an artist they dislike.

The whole challenge is knowing how to explain what you do and who you are. This will take time to learn and to figure out. What we admire about Ansel Adams is that he was very successful doing exactly what he wanted to do while explaining to all who wanted to listen exactly what he was doing. He was able to present things in such a way that he caused people to be on his side, understand why he was doing what he was doing, and want to support what he was doing as well as do it themselves. Adams knew how to present. Others, who didn't know how to do that, were not as successful or did not have as good a rapport with their audience. Of course, this is only one aspect of success, but it is a very important one, much more important than many people believe.

In regards to financial success, in my opinion, financial success is meaningless if it comes at the cost of your integrity. I have seen many photographers succeed at the cost of their integrity and I do not have respect for that type of success.

Best Sellers

Being successful in business hinges upon having products that are guaranteed to bring in a solid and regular income. In other words, and to relate this to photography, being an artist in business is about being able to create best sellers.

I am often asked if and when I create bestsellers. The answer is yes. In fact, I often say that the sales of one of my images singlehandedly paid for the house I currently live in.

Those that visit my studio get to see this image as I have it prominently displayed, as I should. After all, I owe a lot of thanks to this one image. So yes, I do have bestsellers. In fact, all the photographers who have been successful selling their work have bestsellers.

The real question is how do you create a best seller, and this is what I want to focus on in this section. Following on the heals of a section on integrity, you may have an idea where this is going: If you don't, read on. After the next few paragraphs, you will know.

There are two ways to create bestsellers, in my opinion. The first involves finding out what the public wants and giving it to them. This, after all, is a relatively simple process. Take the Grand Canyon for example. All you have to do is find out which image(s) sell best in the stores and copy them. After all, the landscape of the Grand Canyon isn't copyrighted (at least not yet), so taking your own photo of a specific place at a specific time in a specific situation, even if it comes so close to someone else's work as to confuse your work and their work, isn't punishable by law. In fact, many photographers do just that. Do I recommend this approach? Not in the least. I personally despise this approach and I consider it borderline in regard to integrity, and absolutely pointless in regard to developing a personal style. However, in regard to business it can be quite lucrative, provided only you do it. If numerous photographers start to use this approach, then competition can get very nasty.

The second approach involves finding out what you like and creating it for yourself. This approach is more complex, takes more time, and involves finding out what kind of images you like, what vision you have, and what your source of inspiration is. The results are images that are unique; photographs that are truly

yours. If someone copies someone, it will be someone else copying you. While you cannot prevent this, and while it can be upsetting when it happens, you can at least feel secure in the knowledge that your integrity remains unscathed.

One might say that approach number two is less reliable than approach number one in regard to sales. After all, approach number one can be quantified, sales-wise, before the photo is created, simply by looking at the current and past sales for a given image (provided you can get access to this information). Approach number two, on the other hand, is a complete shot in the dark in regard to business. No one knows if the image will be successful, and if it is successful, no one can predict how successful it will be or what kind of income it will bring.

This is all true and fairly easy to analyze after all. What is more interesting in my eyes is comparing these two approaches to draw some conclusions. Regarding approach number one, the fact that potential sales can be charted ahead of time means that, at best, you will be able to reach the same sales level as the images you copied. In other words, you are looking at a finite target.

Approach number two on the other hand, despite all the unknown variables that surround it, does not suffer from such limitations. If your photograph becomes successful, it may potentially exceed the sale of any photograph ever before created. In other words, you are looking at a target with infinite possibilities.

Which approach you choose is up to you. Personally, I have never been able to go for approach number one. Firstly, I don't like being a copycat. Secondly, I am too strong-headed not to do exactly what I like, which foregoes du-

plicating what someone else has done before me. And finally, I place integrity very high on my list, and just that part alone would bother me enough to stop me from trying to copy another's work should I be tempted to. But ultimately, it is the limitless income aspect of creating a best selling image on my own that has always attracted me. In this sense, maybe I am more ambitious than if I was simply trying to achieve what others have already achieved. Or maybe I like to make things more difficult than I could make them.

At any rate, this is not really for me to say or to find out, but in fact, this approach works for me. Granted, the landscapes I photograph have been photographed by others before me. However, I create my photographs based on the images I see in my mind's eye, not based on those I see in coffee table books, posters, calendars, postcards, and the like. In fact, at the present time I have all but stopped looking at such materials. I find them utterly boring, save for a few, and I find my own work much more exciting. Call me narcissistic. At least my endeavors are not geared towards copying someone else's work.

Photographic Skills Enhancement Exercises

Exercise 1
Are you doing what you love?
a. If yes:
 • Make a list of why you are doing what you love.
 • Make a list of the specific things you love that you are already doing.
 • Make a list of the specific things you love that you are not doing now.
b. If no:

- Make a list of why you are not doing what you love.
- Make a list of the specific things you love that you are already doing.
- Make a list of the specific things you love that you are not doing now.

Exercise 2
Make a list of people you believe are Artists in Business.

a. Next to each name, write what percentage of their work is art, and what percentage is business (by business I mean the totality of their occupation as you perceive it, i.e., the sum of all their efforts at creating art and marketing it). This is your opinion and no one else's. There are no right and wrong answers, just what you believe to be the truth.

b. Did you find out, after close inspection, that some of the people on your list are really 100% artists or 100% business? If yes, cross these out.

c. Are there any people who are 50% business and 50% artists?

d. Re-write this list. At the top, list the people who are 50-50, and, going down the list, people whose percentage moves further from this balanced state. At the bottom write the names of those who are close to, or at, 100% of one or the other side, business or art. Next to each name, use this writing format: 40% art, 60% business, using the percentages that you have previously defined.

e. What are your own percentages of art and business?

f. If you were on this list, where would you fit in terms of percentages? Would you be at the top, at the bottom, or in the middle of the list?

Exercise 3
Make a list of your art that you are comfortable selling.

a. List all the items you can sell either now or within a week.

b. List all the items you intend to make and sell within a month.

c. List all the items you intend to have for sale within a year.

d. List all the items you want to have for sale eventually.

Exercise 4
Design a business plan.

a. Make a list of all the goals you want to reach.

b. Make a list of attainable goals you can reach in:
- One month
- Three months
- One year
- Five years

Exercise 5
Make a list of what you know about marketing.

a. Make a list of everything you know about selling fine art photography.

b. Make a list of everything you would like to know about selling fine art photography.

Exercise 6
Decide who you will be modeling your business after.

a. Make a list of people who are where you want to be.

b. Make a list of people who are not where you want to be.

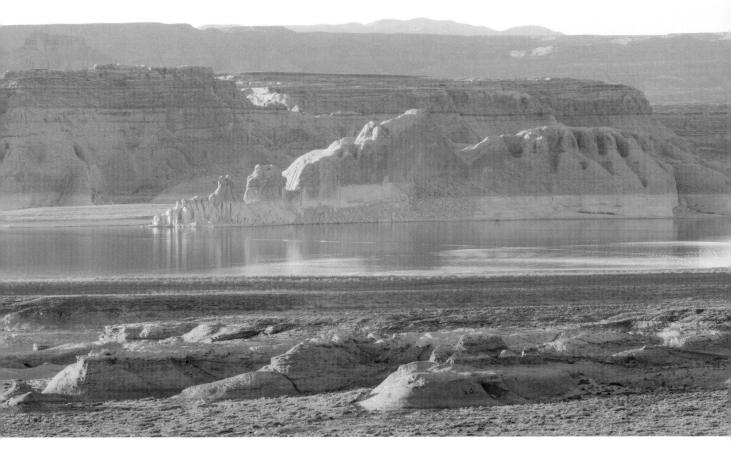

▲ **Wahweap Bay, Lake Powell**

Conclusion

The true challenge of being an artist in business is becoming financially successful while striving to achieve the highest level of artistic achievement. On the one hand it is all too easy to become just a business person and to forget about artistic achievement. On the other hand it is also all too easy to remain an artist and not become successful in business.

Ultimately, on one level it depends what you personally consider the definition of success to be when it comes to your photography.

It is entirely possible that, after reading this book, you may decide that being an artist in business is not something you want to engage in. In that case, you may decide that much (if not all) that is written here, and particularly in this third and last chapter, is superfluous. If you are not interested in being an artist in business, the conflict between art and business is not yours. Yet hopefully, my story will be one you will remember; the story of someone who did something you do not intend to do. There is, after all, much to be learned from reading what others did that we won't

do. Personally, I did not climb Everest, and I have no plan to do so, however, I learned a lot from reading books by and about those that did. I am thankful those accounts were written, even though they convinced me that my decision not to climb Everest is the right one for me.

On another level, you may decide that you do want to become an artist in business. In this instance, much of what I wrote in these final chapters is relevant to you. In fact, much that I have not talked about here is relevant to you, as well. So, to leave no stone unturned, let me briefly address what else you need to consider. And, before you ask why I didn't talk about it before, let me say that it is simply because this chapter would no longer be a "chapter", nor would it be an introduction to "Being an Artist in Business"; rather it would become a final body of work on this subject, something this chapter was never meant to be.

What I have not talked about, looking at the business side of things, is how to advertise and market your work. Advertising and marketing are very important. As the saying goes, "If you do not advertise, one thing will happen: nothing." Indeed. While a discussion of marketing is beyond the scope of this chapter, I do recommend that you study marketing carefully, either through my other tutorials and workshops, or on your own. Natalie and I both devote a large amount of time to marketing. Without doing so we would not be where we are today.

What I have not discussed in respect to the artistic side of things is image, print, framing, and presentation quality. This is also a matter that is beyond the scope of this chapter, and one that I also teach through my tutorials and my workshops. Again, I encourage you not only to study this subject, but to become an expert in the matter.

The reason I bring up quality in this chapter is because it is all too easy to spread a banner over a show booth, or to announce in large type on a website, "Fine art photography." I see it all the time these days. But the fact remains that only a very small percentage of artists who claim to offer fine art photography actually do so. For the majority, this is an empty statement, a hollow claim. When looking at the print quality of their work, or at how their work is matted, framed, and presented, it is evident that the quality of their work is far from the claims they are making. Words are cheap and actions speak louder than words. In this instance, there is a conflict between what these artists say and what they actually do. If you don't believe me, visit an art show in your area or visit several galleries that represent up and coming artists. If you know what to look for, what you see will open your eyes to this issue.

My point is this: Don't be one of these artists. Make sure the quality of your work matches the claims you make about your work. I recommend that you produce only the finest quality work. However, you may have a different opinion on this, and you may sway toward quantity. After all, it is a free country and you can do whatever you please. But you shouldn't overstate the quality of your work, or sell something on the basis of what it is not. To do so is asking for trouble, and it will come back to bite you down the road. Again, I don't want to expound on this any further than I already did. I just want to mention that it is a very important aspect of being an artist in business.

In closing, I want to leave you with this thought. There is a conflict between being an

artist and being a businessperson. For the artist, success is reaching an aesthetic ideal, which when reached, embodies the entirety of the artist's vision. For the businessperson, success is reaching a financial goal, which when reached, fulfills every material dream that person ever had. For the artist, success is immaterial, ethereal one might say. For the business person, success is materialized by the possession of money and of all the things money can buy.

Can one have both? Can one fulfill his artistic vision and through this fulfillment earn sufficient money to fulfill his material goals? At first, it seems unlikely. The pursuit of one seems to be in direct conflict with the other. But, upon closer inspection, there is nothing impossible about reaching either of these two goals, and there is nothing that dictates that they cannot coexist.

Certainly, for many artists this proves to be a difficult endeavor; an endeavor in which either art or business triumphs, but not both. However, for some artists in business, it is a reality. How this reality may come to be was the subject of these last three chapters. It was a long road that we followed, and we are now at the end of it, or at least at the end of the path I have followed until now. I hope that sharing my journey will prove helpful in guiding you on your own journey down this road.

Just keep in mind that how you get there is probably just as important as the destination you reach. As with most journeys, at least the ones I have been on, the journey is as important, if not more important, than the destination.

Conclusion

My favorite thing is to go where I've never been.
DIANE ARBUS

This book showed you how you can become a master landscape photographer. Having completed your first reading of this book, I recommend you study each concept in depth and complete the Photographic Skills Enhancement Exercises that are found in nearly every chapter.

Some of you may want to study with me further. If such is your desire, I offer a limited number of opportunities to do so through workshops, seminars, and one on one consulting. I also offer CD Tutorials that expand on the concepts introduced in this book.

To find out more about these opportunities, and to continue your journey toward becoming a master landscape photographer, simply visit my web site at www.beautiful-landscape.com. There you will find detailed descriptions of the various workshops and tutorials I currently offer, as well as see a selection of my latest work in my online photographic portfolios.

For those of you who are interested in hearing additional aspects of my story, such as how I applied and was accepted at the El Tovar Show, or how I handled competition with other artists at the El Tovar, additional information is available on my "Briot Speaks CD-1". "Briot Speaks CD-1" is a 4-hour audio CD consisting of conversations between Natalie and I on the subject of Being Artists in Business. I decided not to include part of this material in this book due to considerations regarding the length of the "Being an Artist in Business" chapter. In other words, in this book you get the gist of the story. However, should you want to know all the facts, these are available on "Briot Speaks CD-1."

Mastering landscape photography requires, above all, personal commitment. Some photographers can do it on their own, and others prefer to do it under the guidance of Natalie and me. While I encourage you to practice on your own, I also encourage you to attend one of my workshops. Workshops are a wonderful opportunity to work on specific aspects of photography while conducting Photographic Skills Enhancement Exercises. Workshops are also an opportunity to work with other photographers, compare photographic approaches and equipment, have your work reviewed, and get answers to specific questions. I regularly announce new workshops, each of them conducted in some of the most photogenic locations in the world. There may be one just for you, and if so, I look forward to meeting you in person.

Alain Briot
Arizona,
July 2006

Index

A

Abbey, Edward, 181
Adams, Ansel, 17, 137, 164
aesthetics, 14
Afga, 121
Alice in Wonderland, 64
analog light meter, 96
Antelope Canyon, 113
Antelope Wall, 53
Apollinaire, Guillaume, 166
Apostle Islands National Lakeshore, 190
Arbus, Diane, 181
Arca Swiss, 100
Arches National Park, 182
artist statement, 176
Avedon, Richard, 147

B

background, 35
Barthes, Roland, 172
beautiful-landscape.com, 124
Beaux Arts, 131
Benjamin, Walter, 172
Berger, John, 172
Bergerac, Cyrano de, 175
Bestfile, 105
Big Sur, 140
binocular vision, 18
Bisti Badlands, 196
bracketing, 88
Bravo, Manuel Alvarez, 104
Bresson, Henri Cartier, 141
Bridge Mountain, 100

B

Bright Angel, 149
Bright Angel Lodge, 201
Bright Angel Trail, 201
Bryce Canyon, 196

C

Calumet, 64
Canon, 85
Canyon de Chelly, 38
Capitol Gorge, 39
Capitol Reef National Park, 39
Capture One, 67
Carnegie, Dale, 222
Carroll, Lewis, 64
Cartier-Bresson, Henri, 22, 133
Cezanne, Paul, 171, 174
Chaco Canyon, 196
China Lake Naval Weapons Station, 121
Chinle, 63
Churchill, Winston, 231
Cibachrome, 66
clipping, 85
color print film, 24
composition, 23
compression, 35
Comte, Auguste, 108
contrast, 49
contrast range, 80
Cronkite, Walter, 146
cropping, 24
Cunningham, Imogen, 137

D

Daguerre, 64
daguerreotypes, 63
Dali, Salvador, 174
de Niro, Robert, 198
Death Valley National Park, 237
Degas, Edgar, 161, 168, 180
Demosthenes, 174
digital camera, 66
digital capture, 83
digital light meter, 96
Disc Catalog, 107
Dufy, Raoul, 216
duotone, 69
Dyke, Willard Van, 137
Dykinga, Jack, 142
dynamic range, 84

E

Edison, Thomas, 209
Edwards, John Paul, 137
Ektachrome, 65
Emerson, Ralph Waldo, 228
emulsion, 63
Epson, 119
Epson R800 Ultrachrome printer, 119
Escalante-Grand Staircase, 196
EV, 97
exposure, 14
Extensis Portfolio, 106

F

f-stop, 26, 34
Faure, Jean-Baptiste, 161
Feininger, Andreas, 231
field of view, 33
film speed, 70
focal length, 15
foreground, 35

France, Anatole, 183
Fred Harvey Company, 204
Frost, Robert, 181
Fuji 617, 156
Fuji Provia, 65
Fuji Velvia, 49

G

Genn, Sara, 184
Gillepsie Dam, 54
Gitzo, 153
Gitzo tripod, 153
glass plates, 63
Glen Canyon NRA, 19
golden rule, 28
Gossen, 96
GPS, 99
Grand Canyon National Park, 114
Grand Canyon Railroad Terminal, 199
gray cards, 78
grayscale, 75
Group f/64, 137

H

Haas, Ernst, 130
hand held light meters, 97
Harper Collins, 186
Hasselblad, 101
heliography, 47
high contrast remedies, 92
histogram, 82
Hoodoos, The, 103
horizon, 40
Horseshoe Bend, 19, 177
Huyghe, Rene, 204

J

Jackson, A.Y., 194
Jackson, William Henry, 63
JPEG, 84

K

Kaibab Shuffle, 201
Kandinsky, Wassily, 157
Karsh, Yousuf, 32
Kodachrome, 65
Kodak, 64

L

Lake Powell, 27, 103, 243
Landers, Ann, 234
large landscapes, 34
latent image, 65
leading lines, 31
Lees Ferry, 41
Light impressions, 125
light table, 24
Linhof, 103
Linhof Multifocus Viewfinder, 26
Little Petroglyph Canyon, 121
Lomali Ruin, 81
Louis XIV, 47
Lower Ruin, 94
Luminous Landscape, 108
Luminous Landscape Video Journal, 25

M

Magritte, Rene, 174
Maisel, Eric, 187
McLeay, Scott, 47
medium landscapes, 34
mercury, 64
Mesa Verde, 196
Michelangelo, 194

Michigan Technological University, 164
mid-tones, 90
middle ground, 35
Minnaert, M.G.J., 60
Minolta, 96
Monet, Claude, 162, 213
monochrome, 82
monocular vision, 18
Monument Valley, 50, 164
Mozart, Wolfgang Amadeus, 174
Muench, David, 135, 140
Muir, John, 46
Munch, Edvard, 159

N

National Register of Historical Places, 199
Navajoland, 163
Navajoland Portfolio, 128
negative film, 24
neutral density filter, 49
nigrometer, 59
noise, 87
normal lens, 33
Northern Arizona University, 164, 183
Noskowiak, Sonya, 137

O

O'Neil Butte, 44
O'Sullivan, Timothy, 63
overexposure, 78

P

Panalure, 67
panoramic camera, 26
Panovsky, Edwin, 172
Paria Riffle, 41
Paris, 93, 119
PDA, 98

PDF, 117
Peak, 65
Pentax, 97
perspective, 18, 31
Phase One, 106
photographic style, 15
Photoshop, 65
Photoshop Raw, 67
Pictorialist movement, 137
Pissarro, Camille, 215
polarizing filter, 65
Polaroid, 100
Porter, Elliott, 31
portfolio, 13
positivism, 108
Print of the Month Portfolio, 124
print size, 110

Q

quadritone, 69

R

raw, 77
raw conversion, 65
Ray, Man, 116
Rébuffat, Gaston , 145
reflectance, 48
Reichmann, Michael, 87
Rodenstock, 100
Rostand, Edmond, 175
Round Rock, 163
Royale National Park, 122
rule of thirds, 28
Ruskin, John, 235

S

Salieri, Antonio, 174
Sand, George, 147
sandwiching, 95
San Juan River, 208
saturated, 49
seeing photographically, 17
Sekonic, 96
Sexton, John, 43
shadow, 48
shadow-clipping, 86
shutter speed, 26
single-channel histogram, 85
SLR, 24
small landscapes, 34
Somerset, 118
Sony, 98
Sony Clie, 98
Spiderock, 63
split neutral density filters, 92
spotmeter, 60
Squaw Creek Ruin, 36
Steichen, Edward, 12
Stevenson, Robert Louis, 206
Surprise Pool, 182
Swift, Jonathan, 16

T

T-Max 100, 70
Tear Drop Arch, 30
telephoto, 20
Tonto National Monument, 94
transparency film, 24
tri-channel histogram, 85
tri-color, 82
tripod, 24
tritone, 69
Trump, Donald, 226
Tsegi Overlook, 152, 195
Twain, Mark, 230

U

Uelsmann, Jerry, 135
underexposure, 78

V

viewfinder, 24
viewing filter, 64
Virgin River, 29
visualization, 33
visual rhetoric, 183

W

Wahweap Bay, 243
 Warhol, Andy, 211
Watchman, 21
Watkins, Carleton E., 63
Weber, Al, 165
Welles, Orson, 62
Weston, Edward, 24, 76, 137
White Sands National Monument, 108
wide-angle, 20
Wupatki National Monument, 81

X

Xanterra Parks and Resorts, 204

Y

Yavapai Point, 44, 114
Yellowstone National Park, 182

Z

Zeiss, 121
Zion NP, 21
Zola, Emile, 154
Zone VI studios, 65
zoom lens, 26

rockynook

Uwe Steinmueller · Juergen Gulbins
Fine Art Printing for Photographers
Exhibition Quality Prints with Inkjet Printers

Today's digital cameras produce image data files making large-format output possible at high resolution. As printing technology moves forward at an equally fast pace, the new inkjet printers are now capable of printing with great precision at a very fine resolution, providing an amazing tonal range and significantly superior image permanence. Moreover, these printers are now affordable to the serious photographer. In the hands of knowledgeable and experienced photographers, they can help create prints comparable to the highest quality darkroom prints on photographic paper.

This book provides the necessary foundation for fine art printing: the understanding of color management, profiling, paper, and inks. It demonstrates how to set up the printing workflow as it guides the reader step-by-step through the process of converting an image file to an outstanding fine art print.

October 2006, 246 pages
ISBN 1-933952-00-8, $44.95

"You can't depend on your eyes if your imagination is out of focus."

Mark Twain

Rocky Nook, Inc.
26 West Mission St Ste 3
Santa Barbara, CA 93101-2432

Phone 1-805-687-8727
Toll-free 1-866-687-1118
Fax 1-805-687-2204

E-mail contact@rockynook.com
www.rockynook.com

Brad Hinkel
Color Management in Digital Photography
Ten Easy Steps to True Colors in Photoshop

Color management is one of the essential elements in digital photography, yet it is a major stumbling block for many. The vast majority of digital photographers wish they didn't have to be concerned with color management, yet the basic process of moving images from capture to print becomes impractical without it. The more sophisticated the photography workflow becomes, the more important it is to manage colors from capture to print. In this book, Brad Hinkel simplifies the language of color management. It is based on classes and workshops the author has given to hundreds of students of digital photography. His process for color management is intended to provide enough information to create a simple and effective system allowing the user to get on with photography and to focus on creativity instead of technology. The fact that this book suggests a simple approach to color management does not mean it sacrifices quality and effectiveness. Simpler is usually better – if it works.

October 2006, 116 pages
ISBN 1-933952-02-4, $29.95

Rocky Nook, Inc.
26 West Mission St Ste 3
Santa Barbara, CA 93101-2432

Phone 1-805-687-8727
Toll-free 1-866-687-1118
Fax 1-805-687-2204

E-mail contact@rockynook.com
www.rockynook.com

rockynook

Sascha Steinhoff

Scanning
Negatives and Slides

Digitizing Your Photographic Archives

Sascha Steinhoff
Scanning Negatives and Slides
Digitizing Your Photographic Archives

Many photographers have either moved into digital photography exclusively or use both analog and digital media in their work. In either case, there is sure to be an archive of slides and negatives that cannot be directly integrated into the new digital workflow, nor can it be archived in a digital format. Increasingly, photographers are trying to bridge this gap with the use of high-performance film scanners. The subject of this book is how to achieve the best possible digital image from a negative or a to make this process efficient, repeatable, and reliable. The author uses Nikon film scanners, but all steps can easily be accomplished while using a different scanner. The most common software tools for scanning (SilverFast, VueScan, NikonScan) are not only covered extensively in the book, but are also provided on a CD, which also contains other useful tools for image editing, as well as numerous sample scans.

Dec 2006, approx. 300 pages, Includes CD

Rocky Nook, Inc.
26 West Mission St Ste 3
Santa Barbara, CA 93101-2432

Phone 1-805-687-8727
Toll-free 1-866-687-1118
Fax 1-805-687-2204